Māori Art and Design

A guide to classic weaving, painting, carving and architecture

JULIE PAAMA-PENGELLY

NEW
HOLLAND

Māori Art and Design is dedicated to Te Hau (Ching) Tutua 1933–2008, greatly missed in this world. And to my tamariki, Te Rangi Kaiwhetu and Te Hekerangi o Tamarau, this being a small part of a much greater inheritance.

Acknowledgements and special thanks to Katie Tua for reading, hearing and advising accordingly. And to Professor Robert Jahnke, Rangi Kipa, and Stephen Barnett, for each share of the journey.

First published in 2010 by New Holland Publishers (NZ) Ltd
Auckland • Sydney • London • Cape Town

www.newhollandpublishers.co.nz

218 Lake Road, Northcote, Auckland 0627, New Zealand
Unit 1, 66 Gibbes Street, Chatswood, NSW 2067, Australia
86–88 Edgware Road, London W2 2EA, United Kingdom
80 McKenzie Street, Cape Town 8001, South Africa

Concept and general editor: Stephen Barnett
Publishing managers: Matt Turner and Christine Thomson
Design: Nick Turzynski, redinc., auckland
Maps pp12–13: Nick Turzynski
Drawings pp20–3: Kereama Taepa
Front cover photograph: Taiaha kura, Museum of New Zealand Te Papa Tongarewa
Page 2 illustration: 'the head of a Māori chief' by Sydney Parkinson,
Alexander Turnbull Library

National Library of New Zealand Cataloguing-in-Publication Data

Paama-Pengelly, Julie.
Māori art and design : weaving, painting, carving and architecture / Julie Paama-Pengelly.
Includes bibliographical references and index.
ISBN 978-1-86966-244-8
1. Art, Maori. [1. Mahi toi. reo] I. Title.
704.0399442—dc 22

1 3 5 7 9 10 8 6 4 2

Colour reproduction by SC (Sang Choy) International Pte Ltd, Singapore
Printed in China at Everbest Printing Co, on paper sourced from sustainable forests.

Contents

Foreword

Any contemporary publication on Māori visual culture must attempt to rewrite eurocentric notions of Māori cultural practice by addressing inappropriate and inadequate art/design terminology that undermines the mana (integrity) of Māori visual culture. There is also the need to utilise Māori-centric visual culture frameworks and timelines that accommodate Māori sensibility in terms of cultural resonance. Both of these imperatives are evident in the writing of this book.

Māori Art and Design makes a number of assumptions on the inseparability of art and culture: that there is an inexorable interrelationship between utilitarian and mediatory function of historical visual culture products, and as a result an inevitable incompatibility of eurocentric terminology in capturing the essence of historical Māori visual culture. One of the critical tasks for this publication has been to select 'art' and 'design' terminology that is relevant to the subject.

From a Western perspective, design 'refers to the process of bringing together independent elements in a coherent and functional manner'; from a Māori perspective, the meaning of design must be expanded so that *coherence* and *function* reflect the world view at the time the design was conceived and created. For much of the historical period *coherence* and *function* must account for the elaboration of form beyond utilitarian function in objects whose primary role was related to mundane tasks like hunting, fishing and agriculture. For example, why was it necessary to include a carved figurative form on the teka (footrest) of a kō (spade), unless it was to increase its mediatory function beyond the level of efficient tilling of the soil. Similarly, weapons of war, whose main function was to dispose of foe expeditiously, are often elaborated with figurative form, and in extreme cases, are transformed to assume human attributes albeit in stylised form like a taiaha (long-handled fighting staff).

The point is that Māori carvers, painters and weavers invested their design process with mediatory functionality through the visual enhancement of objects with figurative form and pattern, and ritualised intercession with deity through all stages; from conception to material collection to fabrication and public presentation. For major visual culture items, like the meetinghouse, public presentation extended beyond the confines of hapu/iwi responsible for the product to often include neighbouring communities. In such cases ritualised intercession was indispensable to free the spaces of tapu (cultural prohibition) to allow public access.

It is worth reiterating that the concept of 'art' did not exist in historical Māori visual culture. The European definition of art is the 'product or process of composing elements in such a way that has aesthetic or creative appeal'. This conflation of the aesthetic over cultural mediation continues to be an anathema for Māori even in the contemporary context. Consequently, this book privileges ritual intercession and cultural signification as important cultural mediators in the creative process. For example, the personification of the meetinghouse as an ancestor.

Māori art and design have tended to be described with euro-centric terms that undervalue the

importance and significance of historical Māori visual culture. Terms like *decoration* and *ornament* presume that *meaning* in Māori visual culture is irrelevant. Many Māori writers perpetuate this in their descriptions of Māori carving, painting and weaving, including, sadly, some of our most senior and respected writers on art and visual culture.

Much of the problem has been the inadequacy of Western terms to describe Māori visual culture. This book addresses this problem by selecting Western terms that maintain the mana of historical visual culture practice while sustaining a sense of integrity in the present. For example, *pattern* or *surface pattern* has been used in place of *decoration* and *ornament*. Also *shape* and *form*, *pattern* and *design* according to the context of their analysis or description.

Significantly this book scopes Maori visual culture across all forms of customary practice while contextualising these forms within the contemporary period. This approach has not been seen since Augustus Hamilton's compendium on Māori art *The Art Workmanship of the Maori Race in New Zealand* produced between 1897 and 1900. In this respect it is an ambitious undertaking that attempts to thread together recent scholarship across disciplines like archaeology, anthropology and art history.

For the first time a comprehensive vocabulary of Māori visual culture terms is presented across a range of Māori visual culture practices. Like all attempts to reinstate language, and art language in particular, there will inevitably be dispute over the relevance of terms within and across tribal boundaries. To this end Chapter One compares Hirini Moko Mead's chronological framework of Māori periods to an archaeological and anthropological chronology. This is followed by tables detailing *Key design conventions*, *Common (Māori) symbolic elements* and *Figurative representations in (Māori) design*. An appendix of tables includes Māori terms associated with *Personal adornment*, *Personal items*, *Food collection* and *Architectural structures*. The list is comprehensive but undoubtedly there will be some tribal specific terminology that will have been omitted.

The subsequent chapters navigate the woven arts, the painted and pigmented arts, the architectural and structural arts and the sculpted and carved arts. These are examined chronologically relative to narratives of origin, design, technological change (where processes and materials are named) and stylistic adaptation within the context of Aotearoa New Zealand. In this respect, *Māori Art and Design* offers a valuable educational resource for both Māori immersion and art and design programmes across the country, not only today, but also into the future.

Professor Robert Jahnke
Chair and Head of Te Pūtahi a Toi, the School of Māori Studies, Massey Univerisity,
Palmerston North

Introduction:
The Character of Māori Art

The origins of Māori art

Māori traditions name their Polynesian homelands as Hawaiki-nui, Hawaiki-roa and Hawaiki-pāmamao. From these places, their tūpuna — their ancestors — bravely voyaged to Aotearoa New Zealand, the land of the long white cloud. Navigating their waka according to the stars and the sun, and by observing tidal currents and the migratory patterns of birds, they arrived at these islands sometime between AD 900 and AD 1300.[1] The way of life these ancestors brought with them to Aotearoa laid the foundations for what has become a distinctly Māori culture.

The shared whakapapa, or genealogical relationships, among Pacific people who share the area defined by the 'Polynesian triangle' is clearly evident in the beliefs and practices they have in common. The nearest neighbours are the inhabitants of the Cook Islands, who share at least 80 per cent of their language with Māori.[2] But Aotearoa was markedly different from the islands they had left behind, and this was to have a profound effect on how they lived their lives, and the way their art practices developed.

> Te toto o te tangata he kai. Te oranga o te tangata he whenua.
> *Food is the source of man's bodily strength. The land is the source of his spiritual wellbeing.*[3]

Māori believed that Papa-tū-ā-nuku, the earth mother, and Rangi-nui, the sky father, were joined in loving union, but forcibly separated by their children who did not want to live in darkness between them. The space resulting from the separation of these two primeval ancestors is known as Te Ao Mārama — the world of knowledge and light — in which humans live. Tribal history is written over and upon every part of that world. Placenames mark the significance of each location, and Māori are physically connected to their primary ancestress. When a child is born, the whenua or placenta is buried in a special place; 'whenua' is also the term used for land. The origin of individual art forms is attributed to ancestors who overcame certain obstacles in order to acquire art knowledge from the deities, or atua, so that the requisite skills and information could be made available to those in the mortal world.

The members of each generation of Māori that grows up in Aotearoa, as they adapt to new environments, ideas and challenges, continue to contribute to this knowledge and belief system. This has led to rapid and significant changes for Māori, evidenced by particular art developments, and these adaptive challenges are summarised in Chapter 1. While there have been notable periods of Māori cultural revival since the formal annexation of this country by Britain in 1840, the traditional contexts in which Māori art was practised are continuing to shrink. Yet at the same

time, Māori are embracing new opportunities to expand their art practice. An important event in which Māori celebrate their historical cultural connections is the Festival of Pacific Arts, hosted by a different Pacific country every four years since 1972.[4]

Māori tradition and the historical record

Māori had a long-established history of art production before European contact, and this was shared among them through oral, visual and expressive traditions.[5] Art was the way Māori communicated knowledge, ideas and values, rather than by written language, and together the arts constituted a vital communication system. In Western art history, on the other hand, the written word has meant learning about art is not limited to viewing the work, and art historians can be considered authorities on meaning, technique and historical context.

Missionaries were attempting to transcribe the Māori language as early as 1814, and in 1820 Professor Samuel Lee of Cambridge University worked with the chief Hongi Hika and his relative Waikato to systematise written Māori. By the early 1860s, when the British population was beginning to outnumber Māori, English had become the dominant language in New Zealand. Increasingly, te reo — Māori language — was confined to Māori communities. From the 1880s Māori were being taught to write and read solely in English and discouraged from using their own tongue.[6]

Government officials, missionaries and anthropologists were making written observations on Māori life before many of those being observed could read what had been written about them. Some writers used Māori informants, and this required a translation process, resulting in conflicts between intended and perceived meaning. Māori adept at translation were often recent converts to Christianity, and therefore likely to be embarrassed about pre-Christian traditions; in addition, Māori informants would almost certainly provide information specific to their own iwi, or tribal group. In Māori tradition the mātauranga, or knowledge, aspect of art was imparted in several ways: kōrero, or talking; waiata, or song; and karakia, or incantations. Tohunga — tribal experts — would pass on specific art skills in these ways to their students in the whare wānanga, the house of learning and teaching, as well as imparting a practical grasp of the technical, design and mnemonic devices associated with the particular art form.

Māori conceived of time in a non-linear manner. Changes in style within the arts, however, can at least provide clues to social development across time periods. It must be remembered that many Māori traditions were almost extinguished by colonisation, and in the absence of written records we need to approach the authoritative tone of historical texts with some caution.

Te Kauwae-runga, Te Kauwae-raro

The literal translations of Te Kauwae-runga and Te Kauwae-raro are, respectively, the upper and lower jaw. They also describe the Māori conceptualisation of knowledge as being of either celestial or terrestrial nature, although the divisions are not always clearly defined. Te Kauwae-runga includes those things pertaining to the gods, the heavens, the origin of all things, the creation of man, the science of astronomy and the recording of time. Te Kauwae-raro concerns the historical

deeds of the people, their genealogies, migrations and tapu knowledge of the human world. These understandings pertain to the whare wānanga, where higher and sacred knowledge was learned; other houses of learning existed to serve specific bodies of knowledge, for instance the whare maire for knowledge pertaining to men, and the whare pora for the teaching of weaving skills.

Māori philosophy is grounded in the whare wānanga, and the art forms that evolved within Māori society are said to have their origins in the celestial realm. These are not considered to be merely 'stories' of origin, but actually affirm a whakapapa or genealogical link or bridge between the deities and humankind. For example, the Mataora tradition of the art of tā moko, or permanent incised skin marking, was established when Mataora brought the knowledge of the deities Whakarū-au-moko and Hine-nui-te-pō from the sub-terrestrial world. The whakapapa connection is made between the tohunga-tā-moko, the priestly expert, Uetonga through his marriage to Manutonga. She was the granddaughter of Whakarū-au-moko, and Niwareka, the wife of Mataora, was also the daughter of Uetonga.[7]

These are the connections that affirm special relationships between the artist, the art object, and the people. Art mediates between established knowledge and current practices; between the spirit and the material worlds; and between the individual and unforeseen dangers — especially so because adorned objects also had practical functions upon which livelihoods depended.

Whakapapa Māori

Blood kinship or whakapapa lies at the heart of Māori tribal society, and survival historically depended on successful group relationships based on the binding force of whanaungatanga, or kinship. The basic social unit was the whānau, or family, although this was a far more extensive grouping than the modern nuclear family. The whānau included grandparents, parents, children and spouses from related tribes or sub-tribes. The iwi, or tribe, was the largest group, consisting of a number of hapū or sub-tribes, and made up of many whānau clusters. Descent could be traced through either male or female lines, and the tribes traced their common descent back to the ancestors who came to Aotearoa in the first wave of waka. Recognition of descent from a common ancestor several generations back gave rise to the hapu or iwi name. For example, Tūwhiwhia was the ancestor after whom Ngāi Tūwhiwhia hapu is named.

Loose kinship also existed across tribes, and this could be cemented by marriage. However, warfare over territory also commonly marked intertribal relations. By the end of the eighteenth century, the nature of tribal allegiances, and the existence of fixed tribal groupings, had become evident in the stylistic differences between the art of various tribes.

The marae or meeting ground is central to Māori. Here the whare whakairo or carved meetinghouse, named after an important ancestor, stands as a potent manifestation of whakapapa. As the focal point for Māori tribal affairs, the marae provides a tūrangawaewae — a place to stand — for tribal descendants, and remains subject to kawa or protocol. Inside the meetinghouse all the art forms come together to provide the most comprehensive education in iwi or hapū knowledge. Stories of origin and of departed ancestors are present on carved posts, bringing the powerful spiritual forces of both deity and forebears together with the people living in the present.

Defining and describing art

'Toi' refers to knowledge, origin and source, and is used to denote art in general. It is commonly used in combination with other words to describe arts, Toi Māori being the usual term to describe a range of creative activities. Toi Māori includes all the traditional visual arts, including whakairo or wood carving; kōwhaiwhai, or painted patterns; raranga, or plaiting; tukutuku, or lattice work; and tā moko, or permanent skin marking. It is also used to describe the expressive arts, such as waiata, or songs and chants; haka, or dance; taonga pūoro, or traditional musical instruments; karanga, the traditional call of welcome; whai kōrero, or oratory; and mau rākau, the art of weaponry. Toi Māori has also come to refer to the new art forms that Māori artists are exploring, such as writing, contemporary dance, film, ceramics and sculpture.

Māori did not separate art from other aspects of culture; art was central to all activities and all objects. The word taonga, or taonga tuku iho[8] described precious objects that could be admired as art, but as they had mauri — life force — and wairua — spirit — of their own, they also functioned on another level, one associated with mana, tapu and whakapapa. While the use of the objects was often utilitarian, they were enhanced with visual iconography to show reverence and dedication to more powerful beings, and rituals contributed to the process of spiritual activation. The addition of carved figures enhanced the mana or power of artworks, and when divine intervention was sought, feathers and other objects were bound to the object and karakia were recited.[9]

Māori art conveys certain ideas about the fundamental assumptions that underpinned Māori society, the real nature of Māori people and the perceived place of Māori in the natural universe.[10] But while this current survey may present detail on Māori motifs and meanings, materials and techniques, and the historical factors that have been influential, it cannot replace the reo — the language — of the artist and of the Māori people, who give voice and meaning to the art.

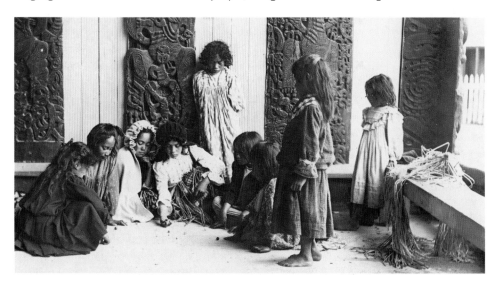

Children in Western clothing and flax skirts, playing marbles, in the porch of Tamatekapua meetinghouse at Ohinemutu, c1905.
[Alexander Turnbull Library]

IWI TRIBAL AREAS AND REGIONAL GROUPS

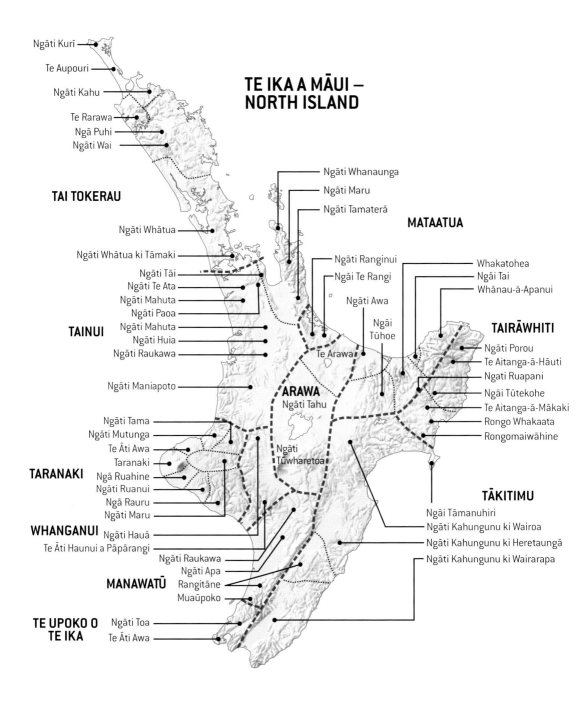

Ngāti Kurī

Te Aupouri

Ngāti Kahu

Te Rarawa
Ngā Puhi
Ngāti Wai

**TE IKA A MĀUI –
NORTH ISLAND**

Ngāti Whanaunga

Ngāti Maru

Ngāti Tamaterā

MATAATUA

TAI TOKERAU

Ngāti Whātua

Ngāti Whātua ki Tāmaki

Ngāti Tāi
Ngāti Te Ata
Ngāti Mahuta
Ngāti Paoa
Ngāti Mahuta
Ngāti Huia
Ngāti Raukawa

Ngāti Ranginui
Ngāi Te Rangi

Ngāti Awa

Whakatohea
Ngāi Tai
Whānau-ā-Apanui

Ngāi
Tūhoe

TAIRĀWHITI

Ngāti Porou
Te Aitanga-ā-Hāuti
Ngati Ruapani
Ngāi Tūtekohe
Te Aitanga-ā-Mākaki
Rongo Whakaata
Rongomaiwāhine

TAINUI

Te Arawa

Ngāti Maniapoto

ARAWA
Ngāti Tahu

Ngāti Tama
Ngāti Mutunga
Te Āti Awa
Taranaki
Ngā Ruahine
Ngāti Ruanui
Ngā Rauru
Ngāti Maru

Ngāti
Tūwharetoa

TARANAKI

TĀKITIMU

Ngāi Tāmanuhiri
Ngāti Kahungunu ki Wairoa
Ngāti Kahungunu ki Heretaungā
Ngāti Kahungunu ki Wairarapa

WHANGANUI
Ngāti Hauā
Te Āti Haunui a Pāpārangi

Ngāti Raukawa
Ngāti Apa
Rangitāne
Muaūpoko

MANAWATŪ

**TE UPOKO O
TE IKA**
Ngāti Toa
Te Āti Awa

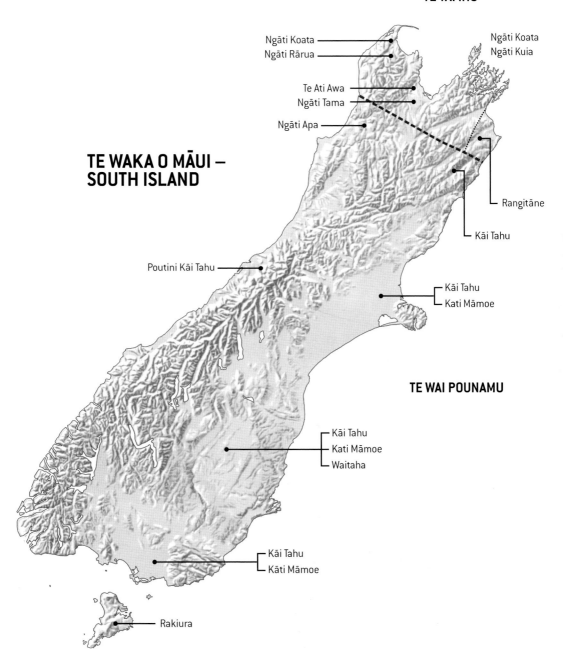

TE TAI IHU

Ngāti Koata

Ngāti Rārua

Te Ati Awa

Ngāti Tama

Ngāti Apa

Ngāti Koata
Ngāti Kuia

TE WAKA O MĀUI – SOUTH ISLAND

Rangitāne

Kāi Tahu

Poutini Kāi Tahu

Kāi Tahu
Kati Māmoe

TE WAI POUNAMU

Kāi Tahu
Kati Māmoe
Waitaha

Kāi Tahu
Kāti Māmoe

Rakiura

CHAPTER 1

The Nature of Māori Art and Design

Development periods in Māori art

There are no written historical records of Māori settlement in Aotearoa prior to European contact, and only a small number of art objects have survived to tell their story. So a retrospective view of Māori art is all we have, and presenting it in a linear way may not accurately reflect the artistic high points that must have occurred as part of its cyclical nature. Neither is it valid to assume there was only a single period in which creativity blossomed.[1]

The table opposite therefore can provide no more than a convenient overview of the development of Māori art before and after contact with Europeans.

The 1840 Treaty of Waitangi assured Britain of the right to govern, and the rapid influx of settlers that followed brought previously unknown diseases and social problems. Māori soon became a minority in their own country, and their welfare and cultural concerns were quickly subordinated to settler needs. The post-contact Te Huringa style period spans an extremely turbulent time of socio-political change, and one which had a profound effect on how art was viewed in Māori society. Most interpretations of Te Huringa may now be too generalised to adequately describe the complexity of Māori art development from the mid-1800s to the present day.

The functioning of Māori arts

For Māori, all elements of the universe are inextricably connected: whakapapa sets up a series of relationships between all things in the universe. The conjoined primeval parents, Rangi-nui and Papa-tū-ā-nuku, provided the template through descent relationships with other atua or gods, and this is expressed through the regulatory mechanisms of tapu and noa. Tapu is inherited from the atua, and described as an 'awareness of the divine' or 'the application of caution'; it results in restrictions being placed on certain objects, localities, or particular persons. Noa, on the other hand, makes those things that are restricted available or accessible once again for common use or contact, but can also simply refer to mundane objects or areas. Noa is particularly related to the power of women as whare tangata, referring to their ability to bear children. The adherence to the principles of tapu and noa are governed by a series of tikanga, conventions or rules.

Art objects had an important part to play in these regulatory processes within Māori society. Their function was overseen by atua, and the adornment of art objects ensured the favour of atua. Whakairo, or carving, expressed whakapapa, particularly the descent of chiefs from atua, through representations of ancestral tiki and spiritual manaia. The carvings themselves provide an historical record. The kawa, or protocol, surrounding tapu ensured that objects were often made ready for ceremonial purposes by additional adornment, and certain art objects became more potent in their tapu because of their function.

Waka taua — war canoes — came under the domain of Tūmatauenga, god of war, and were designed to reflect the human journey through life towards death. The tauihi or prow expressed genealogical origins, from Rangi and Papa and their children. Warrior whakapapa connections were presented along the rauawa, side strakes. The taurapa, sternpost, completed the journey with a conjoining of ira atua and ira tangata, spiritual and human aspects respectively. In this way, the carving of the waka taua had both utilitarian and spiritual functions. The designs brought spiritual and mundane realms under the auspices of the maker or owner(s). The design formalities reflected specific beliefs, and were

Archaeological prehistory[2]	Māori culture and society[3]	Māori art sequences[4]	
Settlement phase AD 900–1100	Initial settlement from Eastern Polynesia with no European contact Adapting to new environment but culture closely allied to Polynesia; use of stone tools (All evidence for this period is from archaeological excavations)	Nga Kākano (The Seeds) style period AD 900–1200	Seeds of Māori art with Polynesian traits transplanted to Aotearoa. The few available examples of art produced in both the North and South Islands resemble early objects found in Eastern Polynesia
Development phase AD 1100–1350		Te Tipunga (The Growth) style period AD 1200–1500	Art becomes increasingly localised due to isolation from the rest of Polynesia. Adaptation to conditions of different regions encourages regional style developments. Knowledge is based on a few available rectilinear-style objects. However an emergent curvilinear development is evident
Experimental phase AD 1350–1450	Great era of Polynesian sea voyaging — evolved distinctly Māori variant of Eastern Polynesian culture Full utilisation of local resources of wood, bone, stone and flax High status of artists and the creation of ancestral images. Polynesian beliefs and ritualised practices. Variety of objects and forms		
Proto-Māori phase AD 1450–1650		Te Puāwaitanga (The Blossoming) style period AD 1500–1800	Flowering of local development, evolution of curvilinear designs in tā moko and whakairo. Many ethnographic collections available show a high level of artistry and style had evolved
Classic Māori phase AD 1650–1800			
Early European phase AD 1800–1850	Abundant observation of Māori culture but steady decline in traditional values under Christianity and other Westernising influences. Increasing integration into the nation state resulting in ongoing erosion of Māori culture	Te Huringa (The Turning) style period AD 1800–the present	Introduction of Western steel tools increase elaboration of pattern in whakairo. Figurative painting and other innovations. The rise of the meetinghouse in the nineteenth century. Overall decline in status of the arts, increased separation due to disruption of colonisation However, in recent decades Māori art has acquired a range of innovative expressions in new contexts
Late European phase AD 1850–the present	Transformation of Māori society, further elaboration but declining art and culture, much copying and decreased originality		

carefully guarded by tohunga. The balance between patterned and plain areas, of figurative forms with abstract patterning, of tiki figures with abstract manaia — the overall balance of space against pattern — reflects deeper cultural concepts. Waka taua underwent further physical and spiritual transformation in preparation for war, through the application of feathers and ochre, or charcoal pigment.

The scope of Māori arts

Those in Māori society closest genealogically speaking to the gods were considered to be ariki, high-ranking nobles. The principle of chieftainship was both inherited and ascribed, and rangatira could be male or female.

The chiefly classes commanded the best art practitioners, and the finest personal items were associated with the chiefs. Art was a measure of wealth but was also, due to its spiritual power, associated with the protection and prestige of the chief. The artist also had a particular status: some were tohunga, or chiefly experts (tohunga-whakairo denoting the woodcarver and tohungatā-moko the tattooer).[5] Naturally the tools of a tohunga were also highly tapu, and required careful handling. *See Personal Adornment and Personal Items tables 1 and 2* in Appendix.

Food also had special status in Māori society and manaakitanga, or open-handed hospitality, enhanced chiefly mana. Specific tapu applied to food and food tools; the food of rangatira was never to be handled. Rituals of whakanoa, making safe, were conducted to remove the tapu from food. Artistic embellishment was associated with carved items used for food gathering and the harvest, and ensured the continued goodwill of the gods in providing food. The first fruits were returned to the gods as an acknowledgement for their protection. *See Food collection table 3* in Appendix.

A tribal community's affluence and prestige could be measured by the number of its large communal structures. The waka taua or war canoe, pātaka whakairo or storehouse, and whare whakairo or meetinghouse, were the most elaborate of these, and construction methods reflected the importance of tapu observance. The universal presence of both mauri, life force, and wairua, spirit, were acknowledged through ritual. For example, in the forest of Tāne Mahuta, the god of forest and man, karakia or ritual incantations were recited by the tohunga before the felling of a tree.[6] *See Architectural structures table 4* in Appendix.

Defining art and design

'Design' refers to the process or product of bringing together independent elements in a coherent and functional manner. The utilitarian function determined the form of the objects and structures, and carved form and pattern was worked in such a way that complemented the overall object or structure.

Art is the process or product of composing elements in such a way that has aesthetic or creative appeal. There are no words or concepts in the Māori language for art or design, and while such terms are useful for comparative purposes, it is important to remember that foreign conventions are being applied to Māori visual culture.[7]

Key design conventions		
	Definition	**Application to Māori art**
Symmetry	Two halves as mirror images of each other	Apparent symmetry in Māori art is broken by asymmetrical elements
Bilateral symmetry	Corresponding in size, form, and arrangement of parts on both sides of an axis of symmetry	Common in whakairo, tā moko and kōwhaiwhai
Translational symmetry	An object that looks the same after a shift along a longitudinal or latitudinal axis	Applied to the translation of kōwhaiwhai designs
Slide reflection	A unit of design is reflected after a shift along a longitudinal or latitudinal axis	Transformation of kōwhaiwhai units
Slide rotation	A unit of design is rotated after a shift along a longitudinal or latitudinal axis	A transformation process of kōwhaiwhai units
Perspective	Appearance of objects allowing for the effect of distance from the observer	Spatial device used in whakairo after European contact
Aspective	Strict frontal or profile presentation or a combination of the two	Convention used in whakairo to create a conceptual view of anatomy
Simultaneity	Where profile and frontal aspects feature together on the same figure, i.e. occurring simultaneously	Device used in whakairo to show multiple viewpoints
Cyclical patterns	All main structures of pattern are moving in a circular (clockwise) direction. ('Anti–cyclical' refers to the situation where sub-structure patterns oppose the cyclic rhythm of the main pattern structure)	Describes nature of kōwhaiwhai and tā moko design units
Curvilinear patterns	Curved or having curved parts as opposed to straight lines. ('Rectilinear' or 'geometric' shapes consist of or are bounded by straight lines)	Used to describe the dominant style of carving or composition in carving
Figurative representational	Form that references the real or man-made world. Non-figurative is essentially the opposite of figurative. However, non-figurative patterns in Māori art can reference ideas or concepts that allude to form in the real world.	Figurative and non-figurative forms have their expression in the arts of the Māori
Representation	Signs that are used as a substitute for something else. That is, the sign can resemble in a mimetic sense or allude to in the symbolic sense	Māori art is representational both in the mimetic and symbolic sense
Realistic, naturalistic	Lifelike representation of people and the world	Rare in Māori art but part of figurative painting traditions
Symbolism, iconography	To represent something abstract with something concrete	Māori art uses predominantly symbolic language

	Definition	Application to Māori art
Mnemonic	A visual aid which allows the viewer to read the image	Carving has a mnemonic function in recalling ancestral deeds
Perpendicular	Upright or at right angles.	Used in the geometric weaving and plaiting arts
Split representation/ notional ambiguity	Split at midline between two sides, or bilaterally represented by overlapping parts in each side	Presentation of split views of two face halves in whakairo

A number of the art terms used throughout this book are derived from the conventions of Western art history, but they do not constitute the only way of looking at Māori art. Such conventions are useful especially when applied to design. The terms allow for a general understanding of the formal structures and patterns in Māori art. The artistic elements and symbolism employed, however, were principally derived from the pre-contact era, making it particularly difficult to accept generalisations as a valid evaluation of what was a diverse and dispersed tribal culture.

But there are many symbolic design elements that appear consistently across a number of art forms. While technology often influenced form and pattern, it is also evident that function determined the type of symbolism employed. For example, baskets frequently embodied symbolic references to the abundance of food sources, such as pātiki or pātikitiki — that is, the star constellation that appears at harvest time.

Common symbolic design elements			
	Element description	Symbolic meaning	Application to art form
Koru or pītau	Curved stalk with bulb Based on unfolding fern frond and in elaborate compositions, tendrils of the hue or gourd plant	Whakapapa genealogical relationships. Extended symbolism when combined with more koru and in combination with other pattern elements	Kōwhaiwhai on pātaka, wharenui and waka and an element of tā moko
			Incised on wood and hue items, simple pītau elements
Kape or Ngutukākā	Eyebrow or beak Crescent shape with small circular indentations along the edge	Associated with eyebrow or the beak shape of the kākā plant	A basic element of kōwhaiwhai and also used in figurative painting
Rauru	'S'-shaped spiral Single and multiple spiral form, may be combined with haehae	Representing light and knowledge coming to humankind through the separation of celestial parents	Pierced spiral stone and bone necklaces, significant use in wood carving
			Very old tāniko border design on cloaks where the spiral is rectilinear
		Also called Māui and Takarangi Takarangi means to stagger or reel	The spiral is a significant design element in kōwhaiwhai and tā moko

	Element description	Symbolic meaning	Application to art form
Haehae	*Linear* To lacerate, tear or cut a continuous gouge or line, but takes on different shapes depending on the art form	Historically associated with the practice of gouging or scratching the skin to express and emphasise grief, *Haehae* — gouge — is when associated with *Raumoa* — ridge — also called *Haehae*	Carved grooves of whakairo that define areas of pattern
			Kōwhaiwhai embattled lines and tā moko grooves or cuts
Niho taniwha	*Triangle* Tooth-like, saw-edged, triangular pattern, described as a dragon or monster tooth	A principal motif in weaving that represents the realm of cosmology and a chief's lineage from the gods. Also important in whakairo *Whakanihoniho* — toothlike	Common to raranga, tukutuku and tāniko borders
			Rare in kōwhaiwhai but appears as minor element
			A common pākati notch of whakairo, an overlapping triangle
Unaunahi	*Crescent* A crescent-shaped pattern used between haehae to create a fish scale effect and used to accentuate curves	Also called *Te ika a Tangaroa* — Tangaroa's fish, representing the domain of Tangaroa	Embattled lines of kōwhaiwhai are crescent-shaped
			Crescent-shaped pākati notch, used extensively in whakairo
Kaokao	*Zigzag* A rib-like pattern of the rectilinear arts which may be expanded to create a zigzag effect	Armpits representing strength dedicated to the war god Tūmatauenga and placed next to warrior tupuna, strong associations with the sea. *Kōeaea* — young whitebait *Aramoana* — pathway to the sea	Increased use of zigzag motif in figurative painting to depict the ribs
			Variations of zigzag designs appear in early tāniko, tukutuku, and raranga
Pātiki, pātikitiki	*Diamond* A diamond element of the geometric arts, may appear as double triangles	Based on the group of stars that herald appropriate harvest time of the flounder — symbolises abundance Also: *Whakarua kōpito* — umbilical cord *Waha rua* — double mouths	A minor motif in the painting of kōwhaiwhai
			Prominent design in tukutuku, tāniko and raranga

Figurative representation is seen in the earliest found objects, stone and bone carvings, rock drawings and paintings. Māori preference for figurative over abstract appears to have been guided by the associated ancestral relationships and their whakapapa connections to atua. Evidence indicates that both figurative and non-figurative conventions were further elaborated with the development of more sophisticated tools.

Figurative representations in design			
	Motif description	Symbolic meaning	Application to art form
Tiki	Images of human form, representing ancestors; conspicuous sexual symbolism, male/female	The first man created, spiritual protection for the living. In challenged haka stance or representing descent, with birth figures between the legs	Tiki — dominant in carving, the main human figure depicted
			Tiki increasingly explored in kōwhaiwhai and figurative painting
Manaia	Profile view of distinctive form (possibly bird or tiki). Ambiguous arrangements of limbs and mouths	Connected to the tiki, probably as a protective spirit form. Symbolic of spiritual mana or prestige	Dominant form in all carving, as figurative support element to tiki
			Frequent in cave painting. The pītau a manaia in figurative kōwhaiwhai
Manu	Birds or avian figures	Soul or spirit vehicle of the dead. Guardians, givers of omens — precursor to manaia figure	Often associated with avian-style manaia
			Commonly appeared in rock art, later in figurative painting
Mokomoko Ngārara	Lizards (gecko and skink) presented in a range of forms, with four legs	Serve as vehicles of harmful spirits for Whiro, atua of death and destruction. Emissaries of deity, marking sacred places, guardians, deterrents	Restrained use in carving, figuratively presented
			Appeared in rock painting and symbolised in tā moko
Marakihau	Taniwha or creatures of the sea, depicted as mermen. Sinuous with terminal curled tail, horns, spinal spikes	Spirit of ancestors who had taken up residence in the ocean. Guardian figures	Appears in greenstone carving and in some carved houses
			Popular in figurative painting traditions
Pakakē	Whale that might be represented as a taniwha with attendant manaia. Ancestor of the people	A special form of taniwha and a guardian figure over fisheries, representing abundance. Powerful spirit ancestor	Prominent on pataka and appeared for the first time on whare whakairo in 1944
			Appearance of whales in rock art

	Motif description	Symbolic meaning	Application to art form
Kurī 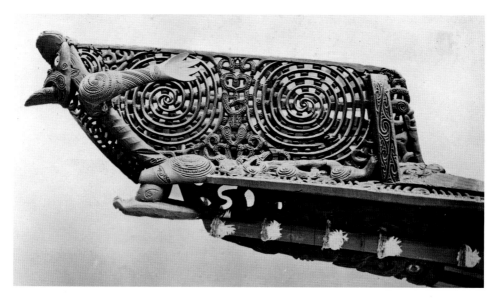	Dog presented in recognisable manner. Also dog-shaped carved bowls and dogskin cloaks	Representing sacredness of food sources, kuri were prized for their skin and represented chiefly power. *Moko kurī* — type of facial moko *Tuara kurī* — dog's backbone	Early appearance of dog in whakairo, and a carved notch called *tuara kurī*
			Appeared in rock art, less frequently in figurative painting

The attractiveness of a Māori art object as a mark of singular artistic achievement is underpinned by a sophisticated conceptual and symbolic system related to its mediatory spiritual function.[8] The information contained in these tables enables the reading and understanding of artistic and design conventions that Māori applied over a wide range of artistic pursuits.

Tangaroa, with tongue protruding and arms outstretched, is portrayed on the prow figurehead of the waka taua in this photograph, c1910. The carvings on the waka taua reflect its significance and function to a tribal group.
[Alexander Turnbull Library]

CHAPTER 2
Fibre and Woven Arts

Ngā weu: the significance of fibre work

Māori share many handweaving techniques with indigenous cultures around the world, and these ways of using fibre were integrated into so many aspects of life that they acquired special significance in terms of the mana, or prestige, of both the individual and the tribe. Woven from products of Papa-tū-ā-nuku, the earth mother, fibre items assumed strong symbolic associations with both whenua and wairua. Certain rituals were observed in connection with koha or gifting, especially of an original item. Thus the connections between the land, the maker of the object and the living people were acknowledged.

Māori made the majority of their fibre objects from harakeke, the native New Zealand flax. The Māori word hara is derived from Polynesian names for pandanus (ara in Cook Island Māori); and keke meaning strong or stubborn. Māori tended prized pā harakeke, or plantations, supporting up to 60 flax varieties, the identities of which were often guarded family secrets. Plants were selected and grown for their utilitarian qualities — not all harakeke varieties were suited to the extraction of the muka fibre used in miro, whiri, tauhere and tāniko techniques. Others were better known for their durability and used for kete, whāriki, nets, traps and piupiu. The roots of the harakeke were also cooked and applied medicinally.[1]

The pīngao, or golden sand sedge, had more specific pattern uses, for example in raranga and tukutuku. In its unprocessed form, pīngao was prized for the golden colour that made a vibrant contrast to the natural or dyed hue of harakeke and kiekie. But because of its shallow root growth on sand dunes, pīngao is vulnerable to introduced domestic livestock, other sand plants and motor vehicles, and many artists have sought to protect it for future generations. A variety of other materials were used for raranga, including lacebark; and for whatu tāniko, kiekie leaves, neinei leaves and tī koūka, or cabbage tree, were popular. None, however, was the equal of the harakeke, which continues to be widely used today, a testament to both its resilience as a plant, and its durability as a fibre.

While 'raranga' and 'weaving' are often used as a general term to refer to Māori fibre arts, these can be separated into two basic techniques: raranga — or plaiting — itself, and whatu — or weaving. Both techniques utilised the exchange of coloured threads to produce tauira, or patterns, of technical virtuosity and aesthetic complexity. Although men sometimes entered the whare pora and underwent the same rituals as women, raranga and whatu were predominantly women's work. Women took pride in the specialist nature of weaving. They protected the knowledge of the designs and initiated children into the whare pora if they showed early promise. The ceremony of dedication of the tauira (which also means 'student') to weaving was carried out by a tohunga who recited karakia, after which the tauira wove a sacred first weft known as the aho tapu.[2] The aho tapu is the weft to which the subsequent whenu are attached.

Particular importance was placed upon the kākahu, or cloak, produced by a highly evolved method of whatu tāniko, which resulted (without the use of a loom) in a distinctive range of both practical and ceremonial garments. These were also sometimes finished with pattern borders. Because of their close association with the human body, kākahu were imbued with the personal mana and tapu of the wearer, and also provided invaluable protection against a harsh, cold climate.

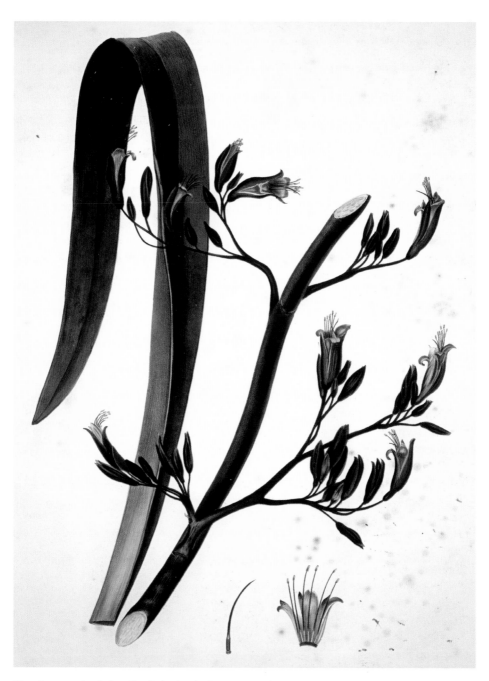

Phormium tenax, harakeke or New Zealand native flax possesses leaves that grow to heights of one to four metres. Harakeke was the most versatile of the fibrous plants, as raw material or processed for fibre and medicine.

[Alexander Turnbull Library]

Flax preparation and muka extraction

All preparation began with the appropriate selection and cutting of harakeke leaf blades. Toetoe is the name given to the stripping process where the back rib and sides are removed before the blades are split into even strips of material ready for the rui, or sorting, process. The butt ends are held in one hand, the other hand grasping the flax at the top while the bundle of strips is tapped on a flat surface. The grip is relaxed to allow the shorter strips to fall away. This traditional practice continues today pretty much as in the past.

These strips, or whenu, are prepared for raranga either by washing before beating with a patu muka, or boiling, bleaching and scraping. The whenu may also be dyed before being dried and plaited to make bags, canoe sails, footwear, belts, hats, buckets, back straps, cooking utensils and spectacular mats. More details of this process are covered in the raranga — plaiting section.

Preparing flax fibre for whatu kākahu, or for use as cordage for binding and plaiting, is a more involved process and one also still followed today. If the fibre is destined for cloak-making, the shorter strips that fall away in the rui process are put aside for the aho and hukahuka, and the longer strips are reserved for the whenu. The next stage is the whakapā, or preparation for separating muka. A skilled weaver holds up to 20 long strips (dull side up) in one hand while making a gentle sideways cut on each strip. A great deal of practice is required to ensure the correct depth of cut is achieved; too deep and the strip is cut in half, too shallow and the fibre will not separate. Once the cut has been made, the strips are turned shiny side up, ready for the hāro process.

This involves the separation of the cellulous outer layer of the flax strip from the internal fibre. The sharp straight edge of a mussel shell is used to extract muka threads. Holding the mussel shell firmly in your left hand, you quickly pull the strand in your right hand at an angle across your body, separating the underside as fine thread. The butt or hard end is worked first, then the strand is reversed and the process repeated. The skilful application of this technique produces several hair-like muka threads, although some residual para, or waxy film, may need to be removed by gentle scraping with the shell.

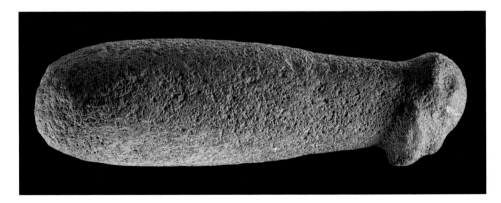

Stone implements such as patu muka date from as early as 1500. This one shows evidence of a sculpted head on the handle. Patu muka were used to soften the stripped flax fibres by pounding.
[Museum of New Zealand Te Papa Tongarewa]

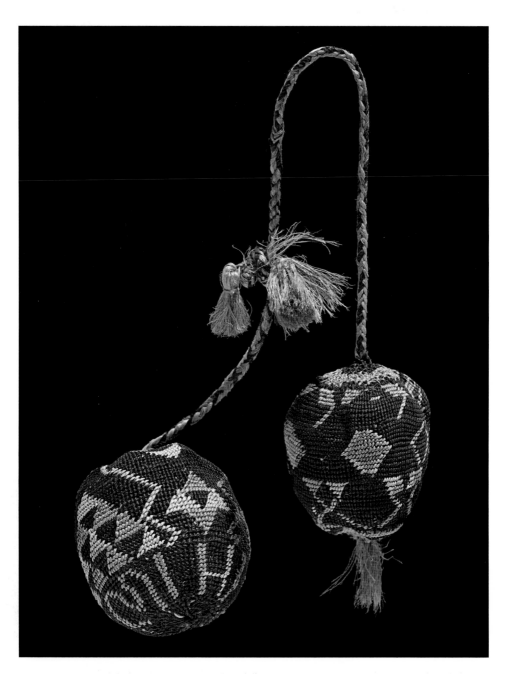

Poi were swung to increase flexibility in the wrist for hand-to-hand combat. Here muka processed and dyed constitutes tricolour taniko twining. The patter includes the word 'mihi', dating the poi to the early European contact period.

[Museum of New Zealand Te Papa Tongarewa]

Miro: thread preparation and plying

Miro refers to the technique of twisting muka into twine, string or cord, according to how many individual fibres are rolled together. Once the number of fibres has been determined (usually from one whenu), they are split in half and held between two sets of fingers, while the other end is held a hand-span above the knee of the seated weaver. By applying pressure to the skin of the leg and rolling carefully toward the knee keeping the fibres taut, the two halves roll together halfway between the wrist and the elbow along the length, and with the return movement the two halves fuse together completely, forming a fine two-ply thread. The thread is reversed and the same process applied to the other half. This completes the first whenu. As fibres taper out, it is also important to 'top-and-tail' them to even out the continuous thread.

The whenu are tied by the top ends into bundles of ten, and the fibre is soaked (these days in warm soapy water) overnight to remove the final green muka stain. Once the fibre has been rinsed and dried it is assembled into groups of 50 whenu, which are then twisted loosely together into a muka hank or whiri whenu. In preparation for weaving cloaks, a whenu may consist of 10 to 20 individual muka fibres, whereas the aho may range from two to ten tightly miro, or twined, fibres. To make an average-sized kākahu, 600 to 700 whenu are required and it is important to select whenu that are all of the same length.

A final process is needed to produce a softer fibre. The whiri whenu is beaten with the patu muka until the water is removed. With some flax varieties this achieves a whiter and more highly prized finish. The whiri is made more pliable through a rubbing process called kōmuru, the hank being held in the right hand and rubbed in a clockwise direction a little at a time, resulting in soft fibres with a gentle wave, after which the whiri is retwisted and set aside. Whītau refers to the fully prepared fibre, after the muka has been washed, beaten, rubbed and dried in hanks in preparation for weaving.[3]

Colour was traditionally added to fibres through a dyeing process, particularly to achieve the coloured tāniko for the patterned border of the kaitaka class of cloaks. Dyeing was also applied to the softened flax strips used for tukutuku and raranga techniques. A yellow dye was obtained from the karamu tree, but a richer yellow could be extracted specifically from the kanono variety. The roots were cut into small pieces and cooked in pungarehu, or ashes, to extract the juices and soften the roots. The bark of the tānekaha was also commonly used, pounded and boiled in a wooden kumete in the same manner, to give a tan colouring. Heated stones would be placed in the bowl of bark in which the prepared flax fibre was soaked, and then removed and rolled in hot clean ashes or powdered charcoal, and soaked again. Colour variants could be achieved from the burnt powdered bark of the taotao, which produced a deeper red, and a golden-brown from that of the karamū-rau-nui.[4]

Obtaining a black, colourfast dye was more complex and involved the preparation of a waitumu or mordant of makomako, hīnau or whīnau, or tutu, and by pounding the bark and mixing it with cold water. Soaking might take up to two days for makomako. After the prepared flax had been soaked it was dipped or buried in paru — a special black mud also known as maramara or uku, for up to two nights. Then the flax was removed from the mud, washed under running water and dried in the shade. If the process was followed correctly a permanent black was achieved. Unfortunately the acidic content of the paru causes fibre deterioration over time, and very old examples have not survived intact. Few weavers use the natural dyeing techniques today, most choosing to use the less complex commercial dyes.

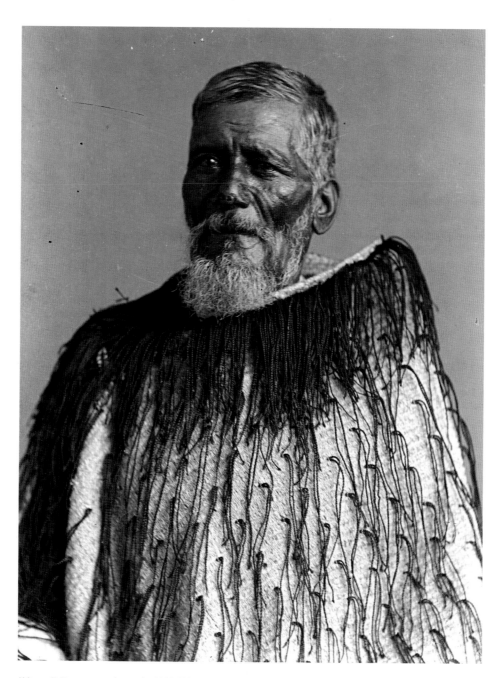

Ahipene Te Tawa wears a korowai, c1880. This style of cloak was revered for its finest twined muka body. Rolled tags, dyed black, were incorporated into the weft of the korowai body and closely spaced to create the tasselled neckline.

[Alexander Turnbull Library]

Whiri and tauhere

Māori consider the terms braiding and plaiting to be two distinct technologies. Whiri, as opposed to raranga, has more in common with a hair plait and produces a long, narrow tubular-type result used for the construction of cordage and ropes. Whiri may consist of between three and 32 threads interwoven together to produce slightly different, sometimes conical-shaped braids. The finest form of braid is created for use as cords for pendants. Three, four and eight-strand whiri are popular today and may use synthetic thread or waxed nylon to produce quality suspension cords for hei tiki and hei matau.

Whiri made from raw flax, or the finer muka, had numerous uses in hunting and fishing apparatus, the binding of structural parts in canoes and houses, and suspending garments and personal items. Whiri provided strapping for sandals, and kawe assisted the carrying of heavy loads on the back. Bases of baskets and mats, the suspension bands of cloaks and certain types of coarse kākahu were often formed from whiri. Other braided items included the tū kāretu or women's belt, which consisted of multiple long braided strands secured together to form a wider belt width;[5] the men's tātua pūpara; the maro, or short flax kilt that covered the front of the lower trunk; and the piupiu, or long flax knee-length skirt.

Tauhere/hohoua or lashing was very important to Māori and was used for both functional and patterned effect; for ceremonial items the lashing was executed to a higher level. The quality of lashed cordage also depended on the desired lifespan of the object, and muka fibres might be braided or plied together first to form a stronger or longer miro twine. Lashing techniques could form patterning as cords crossed over each other around the object(s) to give a continuous cross-stitch effect. By lashing sequentially down the shaft of an object, laying cord next to cord, a unified effect was achieved. Patterning was also accomplished by manipulating colour in ways that created overlapping areas of design. The rākau atua or god stick consisted of an extensively lashed body, and both the pūkāea and pūtōrino were similarly lashed to strengthen their longitudinal joins. The toki or adze blade, a highly prized item owing to its versatility, was attached to a carved handle using a comprehensive lashing. The execution of a lashing determined the amount of force the blade and handle were able to sustain. The chiefly toki poutangata was lashed in a more patterned manner.

Fishing hooks varied in size and shape and were made of wood, bone, stone or shell. Pā kahawai, lures used to attract kahawai, involved the lashing of the bone barb and pieces of iridescent paua shell onto a wooden shank. Nowadays, the quality lashing of hei matau, or ornamental fishhooks, produces a distinct aesthetic patterning, and these items have become increasingly popular as an iconic New Zealand symbol.[6]

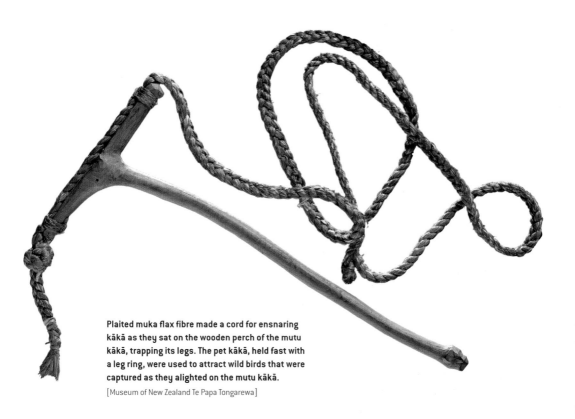

Plaited muka flax fibre made a cord for ensnaring kākā as they sat on the wooden perch of the mutu kākā, trapping its legs. The pet kākā, held fast with a leg ring, were used to attract wild birds that were captured as they alighted on the mutu kākā.

[Museum of New Zealand Te Papa Tongarewa]

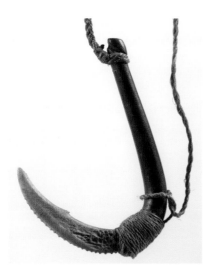

A large hook, matau toroa, consists of a bone barb shaped from the albatross, attached to a wooden shaft with muka fibre, c1800.

[Museum of New Zealand Te Papa Tongarewa]

Tukutuku or tuitui

Tukutuku or tuitui is a cross-stitching technique, similar to lashing. Tukutuku panels in meetinghouses appear to have developed from a cruder form of thatched domestic insulation. Tukutuku evolved as a way of disguising the thatching of kākaho hidden directly behind the patterned panel. The tukutuku was worked on a frame and took on greater significance in the early 1900s under the influence of Sir Apirana Ngata; it continues to be practised today. Tukutuku panels were worked on perpendicular latticework created by stitching an odd number of horizontal wooden slats to vertical backing rods. The visible lattice working area to be filled with cross-stitched patterns is referred to as moana, or the sea. The vertical stakes or rods were commonly comprised of the kākaho, the flower stalks of the toetoe, and they were placed together behind the moana to fill up the entire rear space.

> He tā kākaho e kitea, he tā ngākau e kore e kitea.
> *A defect in the arrangement of stalks is seen, but a defect of the heart is not.*[7]

This proverb is old, referring to the neat arrangement of thatch, but is popularly used today to refer to the tendency in modern tukutuku to use materials like dowelling instead of kākaho as a type of deceit not readily apparent on the surface. It also highlights the role that tukutuku plays in supporting the characteristics of the ancestors depicted in the carvings inside the meetinghouse. The horizontal aspects of the outer face of the panel are spaced closely but with sufficient space to pass thin fibrous material between them. Rimu or tōtara slats may be adzed to serve this purpose, although kākaka, or stalks, of the common fern were also split in half to form a flat strake. The rods are called kaho tara among Te Arawa people, kaha tārai on the East Coast and arapaki in Whanganui. Tukutuku has become increasingly experimental in contemporary times, utilising raffia, plastic and synthetic cordage that are more durable yet still produce a similar patterned effect. Pre-drilled pegboard allows for a similar effect but removes the need to join rods.

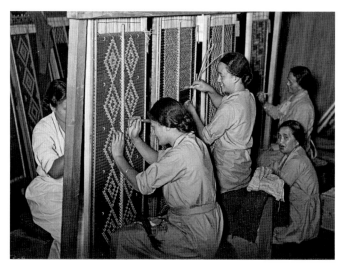

Māori women from Otakī making tukutuku ornamented panels. Working in pairs they pass the kiekie through the kaho horizontal slats to the back, to be looped and passed back again to the front, c1936.

[Alexander Turnbull Library]

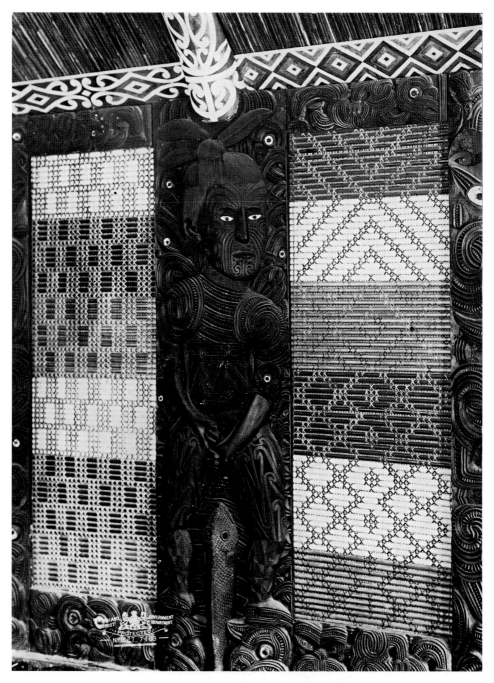

This poupou figure with face in oblique profile represents Māui fishing up the North Island. It was carved around 1900. The adjacent tukutuku lattice presents the arapaki ladder pattern (left), and the diamond-based patterns of pātikitiki and kaokao (right).

[Alexander Turnbull Library]

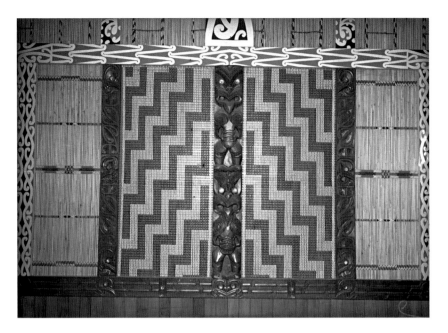

The poutama pattern signifies the growth of man, aspirations and the honouring of chiefly wisdom. The use of steps climbing upwards from both sides to reach the summit at the centre is exclusive to houses of the Ngāti Porou tribal region of the East Coast.

[Alexander Turnbull Library]

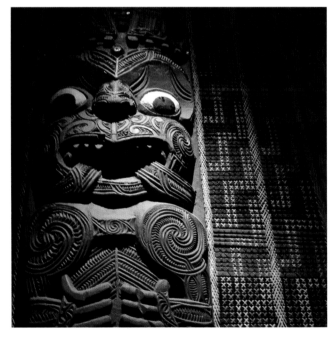

A poupou detail in Hotunui house next to which a supporting tukutuku panel clearly employs the cross-stitch technique. The overlapped wrapped stitch secures the vertical strakes to the horizontal rods. Hauraki, 1878.

[Wikimedia]

The preference, however, is for natural fibres for the stitching patterns. To attain colour pattern areas in tukutuku, harakeke was hāpine or lightly scraped with a shell to make it pliable and then soaked in hot water to achieve a pale beige colour. Kiekie, boiled and dried in the sun, also achieved a bleached white colour, lighter than flax. These materials were dyed in the same way as muka fibres, the hāpine serving to loosen the fibres to make them receptive to dyeing. The golden-yellow pīngao was used in the past when it was more plentiful.

The tukutuku process is referred to as tuitui, and a fully completed panel is called tūrapa. The stitching can be divided into three basic techniques: kōwhiti or cross-stitch, single stitch and overlapping wrapped stitch. The overlapping wrapped stitch was called the tūmatakahukī, symbolising strength or alignment, when it was executed on the outer edge and central tukutuku vertical strakes to provide stability to the panel.[8]

Patterning is achieved by laying out these three simple stitches in unique configurations. The poutama, or supportive one, is a step-like pattern of alternating colour that appears to move diagonally up and across the panel, symbolising the attainment of aspirations — for example, in education — while also honouring chiefly wisdom. A specific poutama pattern appears exclusively in houses of the Ngāti Porou tribal region of the East Coast. It mirrors itself through a central axis and mimics a stepped pyramid effect. Kaokao, which means armpits, is dedicated to Tū-mata-uenga, the god of war, and resembles a wide rib-like pattern. It is often placed next to warrior tūpuna.

Tukutuku designs have symbolic meanings. Roimata toroa/roimata turuturu (albatross or falling tears) alludes to the origins of the kūmara plant and signifies misadventure — disaster in war, or similar catastrophe. Purapura whetū symbolises 'myriads of stars', referring to population numbers, and pātikitiki is also the name of a group of stars that herald harvest time. Another pattern, niho taniwha, is the principal motif representing chiefly lineage from deity. Mumu, a chequerboard pattern distinctive to the Whanganui region, represents tribal alliances, and taki toru refers to home ties and communication. Whakarua kōpito is used to indicate marriage, and papakirango lamentation, or warding off harm.[9] Tāniko, also the name of the technique used in weaving cloaks, is a tukutuku pattern used to represent beauty. In the last 20 years, popularised by their use in Māori churches, tukutuku designs have increasingly evolved to depict religious and narrative iconography.

Manu tukutuku — kite-making

Manu tukutuku acquires its name from the tukutuku technique used to bind the raupō or bullrush strakes together to form the kite. Kite-flying, originating among the gods, is said to connect the people to sky-dwelling deities. For Māori, Rehua was the sacred bird and the main kite ancestor. Kites are also connected to the gods Rongo-mā-Tāne (peace and cultivation) and Tāne Mahuta (the flyer). They were made in the shape of manu; birds were thought to mediate between human beings and the gods, the kite becoming an extension of its owner. 'Manu' usually prefixed the names of kites, manu tukutuku referring to 'flying kite', manu pākau to 'winged bird', manu pākaukau to 'swimming bird' and manu aute to 'bark cloth bird'. Kite-flying contests attracted large gatherings, with some kites exceeding five metres in wingspan and requiring several men to launch them. As the kite ascended, a karakia or turu manu — a kite charm — was delivered, and while the kite was aloft a karere would be sent up the line to 'provide water' to the kite to show it had reached the heavens. Kite-flying was a means of divination, and also signalled enemy attacks, and the destruction of a kite was considered a bad omen.

Barkcloth was used to cover early kites, but as barkcloth became scarce it was used more sparingly and masked the face only. The 'aute' or paper mulberry (*Broussonetia papyrifera*) plant from which Maori forebears made barkcloth for clothing and as covering for items such as kites did not grow successfully in the New Zealand climate. Bound raupō was used to make finer large kites, such as the human-shaped manu tukutuku of Ngāti Porou. Raupō leaf was used on many smaller kites like the manu taratahi, the manu pātiki oval or triangular kite, and the horewai, a rectangular kite.[10] Occasionally raupō was dyed with charcoal and haematite (red) pigments, which provided striking contrasts to the cross-stitched, tukutuku-bound frames. Toetoe/upoko tangata or cutty grass was used to cover the manu kākā, a bird-shaped kite that resembled the kākā or brown parrot. Kite frames were constructed from kareao/pirita or supplejack, mānuka, kānuka and toetoe. Harakeke was used to create the tukutuku binding on the body of the kite and also made into a wide plait on the larger kites to frame the base of the body and form leg shapes.

The heads of larger kites were usually aesthetically enhanced with tā moko, either carved into a wooden head or painted onto a mask using black pigment; some masks were double-sided. Toetoe plumes served as additional aesthetic elements as well as wind-drag for the kites. Feathers of the kākā, kōtuku, toroa and kererū were used on various styles of kite as aesthetic attachments. Other additions, including pūhihi, made from clusters of feathers tied onto a light cord, and horns made from raupō or kākaho stalks secured with a feather covering, occasionally appeared on the heads of kites. Shells used in small bunches produced a rattling sound when the kite moved and karere or line messengers consisting of leaves, feathers or toetoe were mounted so as to flow down the kite lines. Cordage was often braided with the two-strand rolled cord called tamarau, popular for kites that carried a greater load.

Museums have sought to add kites to their collections in recent years and this has led to an increased interest in re-creating them today.

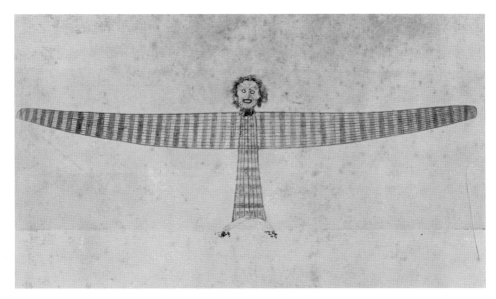

This drawing, c1850, depicts the largest, most intricate of the surviving kites, since restored many times by Auckland Museum. The framework is of grouped mānuka or kanuka sticks, alternately pigmented black and red, and the face is depicted with tā moko.

[Alexander Turnbull Library]

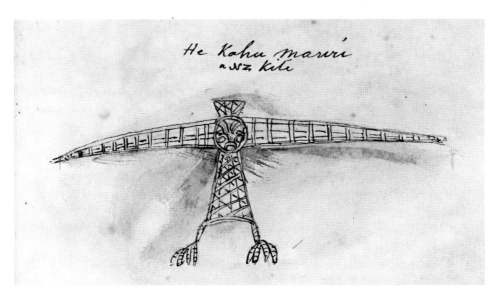

He Kahu maruru
a NZ Kite

This bird-shaped kite is named after the native harrier hawk. The sketch, made c1870, shows the basic structure of this type of kite, recorded as having a wingspan of up to 3.6 metres.

[Alexander Turnbull Library]

Tā kupenga and netting techniques

Tā kupenga or knotting is used throughout Polynesia for tying fishing nets, and for some traps. The knot is tied continuously to ngākau or base-plaited cord, with new lengths of flax being added as each strip becomes too short. Māori relied on their eye and a finger-spacing technique to keep the knotting even and at the end of a row the work was turned around to begin a new row.[11] Fishing nets over 1.6 kilometres in length, requiring 500 people to handle, were sighted by the first European settlers. Kaharua, or seine fishing nets, comprised three main sections: two outer, coarsely plaited whakaihi, and the carefully woven kōnae centre. Separate hapu and whānau were responsible for manufacturing each part of nets such as this, and the components were carefully joined, apparently under strict tapu and in the presence of a tohunga.[12]

Tapu surrounded almost all aspects of fishing, as fishing was closely linked to the atua Tangaroa and adherence to religious restrictions ensured his favour. Cooked food could pollute tapu, with disastrous consequences, and tapu endured until it was removed by a tohunga on shore. Karakia were offered to Tangaroa and other gods, inviting them to send an abundance of fish. It was also common to use a mauri or talisman to attract fish.

Kuku, kuku ika, kuku wehiwehi,
Takina ko koe nā, te iho o ika,
Te iho o Tangaroa —
Uara ki uta rā, uara ki tai rā.

Hold tight, hold the fish, hold tight with fearsome power,
You are led along, the essence of the fish,
The essence of Tangaroa —
Desired on the land, desired on the sea.[13]

It was common practice to return the first fish caught to the sea and recite a karakia of thanks. A rāhui might be placed on a fishing ground, especially if someone died at sea, or if the area was at risk of being over-fished. This practice continues today.

The netting knot was also used to construct small mesh bags that held stones to be used as sinkers for fishing lines, traps and nets. This was a quick and easy procedure, whereas the more labour-intensive bags and nets were kept dry and safely stored. The matarua was another common fishing net, circular in construction, 2.1 to 2.3 metres in diameter and 60 to 90 centimetres deep. It had hoops that allowed it to be stretched to its widest at the top and served to encourage fish to the bottom where bait was fastened. Net floats were made of very light whau wood, dried raupō leaves, or gourds. The tōrehe fish trap, constructed from pirita framing and flax netting, was spring-loaded with a weighted stone to respond to the weight of the fish by closing and trapping the fish in the bottom.

The pōhā net, constructed from raw flax, consisted of a funnel-shaped guide net contained within the main hīnaki and was used for capturing eels. A pā tuna or eel weir of fences served to guide the water through a 'V' where the net would be mounted. The rohe kākā, a small, netted bag of rolled flax fibre that held food for pet birds, allowed the bird to pull a measured amount from

between the mesh. Similar bags also held the bait in tāruke kōura.[14]

Knotless netting or 'looping' is a technique in which the entire cord is drawn through each loop, and experts applied the technique by winding the thread around their thumb and little finger. It is not unlike knitting, and needles may have been utilised to produce a mesh that would not easily unravel.[15] This technique was used prior to the nineteenth-century to good effect in the poi, in which rolled cord knotted into a bag shape was stuffed with tāhuna to form a tight ball. Pattern features were added by applying strips of kiekie leaf and dyed materials as well as small discs of paua shell. Those embellished with dog hair were called poi awe — awe being the white hair from the dog's rump area. Fish traps may have been made in this way too, and bags for carrying hand weapons.

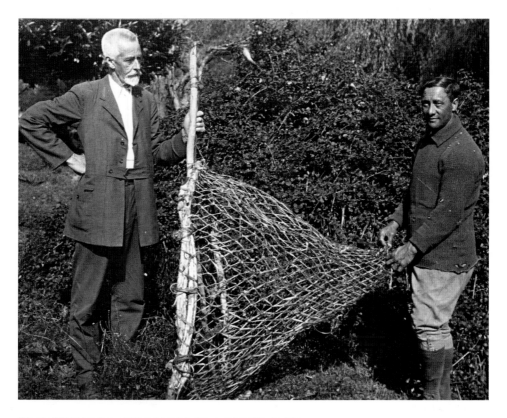

This small hoop net, termed a toemi, is made from a series of knots. A hoop just before the top has a cord attached to pull it closed prior to hauling it up by the handle. Whanganui River, 1921.

[Alexander Turnbull Library]

Kete whakairo, chequerboard plaited, over-one, under-one.
Groups of undyed and black-dyed harakeke are used as
sinistrals and dextrals to create the coloured effects.

[Alexander Turnbull Library]

Detail of a finely woven flax floor mat, 1921,
showing a band of pattern that includes
papakirango, resembling a fly swat. Dispersed
between is over-two, under-two, executed in
two colours. This plait, torua whakatutu, is
used over the entire mat.

[Alexander Turnbull Library]

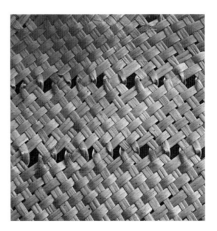

The kete whakapuareare has holes added
by folding strips of flax through 90 degrees
to expose gaps, purely for aesthetic effect.
This developed from the functional open-hole
basket that sieved water and sand out when
collecting seafood.

[Alexander Turnbull Library]

Raranga — plaiting

Plaited items were indispensable to Māori society, the many grades ranging from untreated or unprepared flax leaf items such as pāraerae to the painstakingly prepared and finely patterned kete whakairo. Raranga techniques are widespread and share similar names — ranga, langa and so on — throughout Polynesia. Māori used plaiting to create kete, rourou/kōnae, tātua and whāriki. The whāriki was a plaited floor mat that symbolised community: sharing; hospitality and warmth. Whāriki might be plainly woven for the floor of the everyday house, or more finely woven with wide bands of patterning if it was to have a ceremonial function. The takapau, a finer mat, was used especially for wedding ceremonies and burying the dead. It is likely that in early times these mats were worn or wrapped around the body, as in other parts of Polynesia today, to provide spiritual protection.

For plaiting, the whenu — torn strips of flax — were washed, beaten or boiled, bleached and scraped, and then sometimes dyed. The same dye colours and techniques used for muka and miro were applied to the raranga strips. Raranga involved the arrangement of the flat strips into diagonally composed dextral and sinistral bands that kōwhiti, or cross over, to create the plait.[16] Plaiting usually commenced with a braid and then the strips were arranged according to colour to achieve the desired pattern, with half pointing away from the weaver to the left, and half to the right. This initial arrangement was called the whakapapa, as it determined the subsequent design of the woven item. Strips could be split during the weaving process to achieve finer work and variety in patterning.[17] Exceptional plaiting was seen on kete whakairo and whāriki where sophisticated geometric designs were created by the arrangement of dyed strips. Particularly fine pieces were described as raranga puputu, as they were tightly woven with no gaps between. A unique form of the kete, the kōpare, and pōtae or hats, were made from houhere or lacebark, a strong and versatile weaving material.

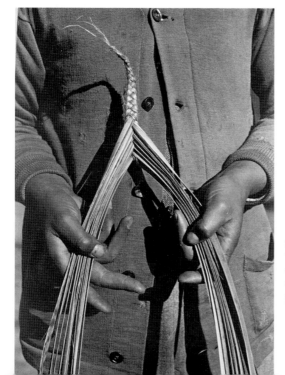

Detail of the commencing braid for raranga kete. The initial arrangement of strips, called the whakapapa, shows half pointing away from the weaver to the left, and half to the right.

[Alexander Turnbull Library]

The raranga tātahi of workbaskets produced a physically strong result despite the use of an open plaiting technique and their relatively quick preparation from green (pre-dried) flax. The kōnae or rourou was similar in construction and could be quickly and easily made to serve as a food platter. Kete kāwhiu, or diving basket, was another *open* basket, designed to hold seafood and act as a sieve by allowing water and sand to pass through the holes. The kāwhiu involved a unique method of openwork plaiting, achieved by folding strips of flax through 90 degrees, or twisting fibres to expose gaps, and evolved into a fine aesthetic technique as in the kete whakapuareare (holey basket).[18] A further unique example of plaiting can be seen on a mamaru/rā, or sail, of the Māori canoe housed in the British Museum. Despite lack of documentation, it is assumed to have been collected on Captain Cook's expeditions. The mamaru was considered technically exceptional due to the weave moving in a 'third direction' to produce 'holes'; however, close examination reveals that the sail has been created by a lacing process called nati, in a similar manner to the kete whakapuareare. This sail contains 13 papa or segments created as separate pieces running horizontally, which are joined with hiki seams of new wefts that appear continuous, with feathers and streamers added.

The most basic raranga design, takitahi, describes the technology of making the design *over-one, under-one* to form a distinct chequerboard pattern when coloured strips are laid out one way and plain strips the other. A tartan-type pattern is achieved if this basic premise is followed with groups of interdispersed, alternating colours. Twilled work consists of a change in the number of *under–over* passes. Twilled twos, sometimes called tōrua whakatakoto, are *over-two, under-two*, and twilled threes, *over-three, under-three*. Many complex patterns relied on bands of change in patterning, or the addition of blocks of differing patterns, which gave the appearance of directional change (where in fact the actual strands continue in the same direction). Complex māhitihiti or kōwhitiwhiti design changes from vertical twill to a horizontal one — sometimes described as *one-two, two-one,* to give the appearance of a rippling or dancing effect. In certain arrangements this might also be described as the poutama pattern, which also appears in tukutuku. The combinations were almost limitless, with chequered patterns and twill alone providing for many options.

Pattern names usually reference a dominant pattern feature. For example, the papakirango or fly swat referred to a particular diamond-shaped pattern that resembled the woven fly swat. Kōeaea, or the young whitebait, is created with two twilled combinations of alternating black and white sinistral and dextral to form a zigzag patterning. The pāpaka or paddle crab was created from triangular-type shapes, karu hāpuku or fish eyes from a square with encircling bands, pātikitiki or flounder consisted of large diamond shapes, and the pātangaroa or starfish made up of squares split into four triangles, although many variations existed on each of these designs. Other designs included hai taimana, ruaruawhetū and whakanihoniho, as well as square and spiral-type formations for which specific names are not recorded.

> Nāu te rourou, nāku te rourou, ka ora ai te iwi.
> *With your food basket and my food basket everybody will be fed.*[19]

It is no surprise that many pattern names bore similarities to those in tukutuku, particularly with reference to marine life and star constellations. The importance of fishing and food provision was

acknowledged with respect to patterning on baskets, food being a measure of wealth and status and continued wellbeing. Plaiting has enjoyed continuous practice, largely due to the plentiful supply of material and the fact that the practice did not offend European sensibilities or contravene Christian sentiments. While plaiting practices have undergone little historical change, modern patterns since the 1920s have seen the introduction of figurative imagery such as rau putiputi, the flower or rose, rau ponga, the fern leaf, and the use of text, both English and Māori. Weavers have adapted their practices to incorporate new materials and commercial dyes, and there are many artists who reference weaving practices and the iconographical significance of weaving patterns in other, more experimental sculptural and painted media practices.

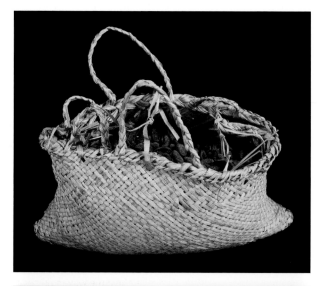

The common form of kete raranga is tightly plaited from undyed harakeke, mainly using the takitahi (over-one, under-one) technique. This example has multiple flax handles to enable goods to be carried more securely.
[Museum of New Zealand Te Papa Tongarewa]

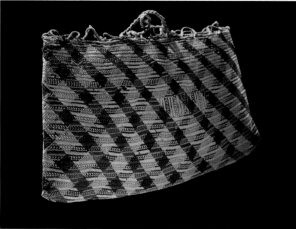

A finely executed kete whakairo from the early 1800s, made of very fine plain, as well as brown and black dyed, strips of harakeke. Complex plaited arrangements include an off-centre rectangular block of pattern.
[Museum of New Zealand Te Papa Tongarewa]

Whatu — twined basketry

Twining is a common technique practised in most parts of the world. Whatu aho pātahi, or open single-pair twining, is used by Polynesians to make fish and eel traps. The work is woven from the base upwards as the warps (verticals) are rigid and stand up, each new row being worked above the previous one. For Māori, the technology of twining baskets is the same as that for cloaks. However, due to the stiff nature of the basket-making materials, a particular type of manipulation is needed to achieve the same effect. When the warps are vertical, and the wefts are twisted across in a perpendicular fashion, this is termed torotika (straight, vertical). Hīnaki eel traps have the warps arranged at an angle described as whakawiri. A lattice pattern is formed when the warps rīpeka or cross one another to form a lattice and are held in place by the twined wefts. This method is common in Whanganui in the making of hīnaki and korotete, a type of holding pot used to store live eels. These items were made from the aerial roots of kiekie, which grow on the banks of North Island rivers, or akatea, the climbing vine of the rātā.[20] In Whanganui, the mangemange, a strong vine, was utilised as well as the kareao or supplejack.

Two thick mānuka posts were planted into the ground for stability, around which the supplejack, which kept its shape, was moulded to create a strong oval base. The tāruke worker sat on the ground and used the supplejack to construct circular horizontal rings onto which the young mānuka stems were twined using the flax and vine in the rīpeka, or cross-warp, twining method. Once this was completed to a certain depth it was turned inwards and the warps bent outwards so the trap could be continued down the outside where it was expanded into a fuller form. Hīnaki could be made very tall, the full height of a person, and presented a formidable sculptural form in itself. The ribs of the hīnaki were described as potaka, and when continuing in a spiral were known as whenu. The hīnaki was used alone as a baited trap, or with the addition of a poha net funnel attached to the pā tuna and fed into the hīnaki. The eel, once inside, could not escape through the narrow funnel. The tuna were transferred from the hīnaki to the korotete, until it was time to despatch them with the patu tuna. Both hīnaki and korotete had a woven taupoki, and popoia or mānuka handles. Tuna were a very important food source for Māori, with over 100 distinct names being recorded for eels and lampreys, the latter being caught in the same manner.

Tāruke or kōura pots were made from young mānuka stems bent around a frame of supplejack vine and mānuka, and then tied with flax and vines. A woven net was constructed around a supplejack loop and hung inside the opening of the tāruke, tapering off away from the opening. This trapped the kōura inside the pot, making escape through the entrance almost impossible.

A uniquely twined trap called kupenga kōaro for catching small whitebait was in use around the Rotorua and Taupo regions. The wefts were quite widely spaced and the warps diverted across one warp stitch to the side and back again in a zigzag manner so they sat tightly together. This gave the appearance of a tall bag, with a circular base and a top that came together as two sides.[21] For the most part, Māori fishing methods have been replaced by Western technologies; however, natural fibres are considered superior because the vibration of metal tends to give away the presence of traps underwater. Contemporary artists have increasingly become interested in the hīnaki and tāruke technologies as sculptural forms.

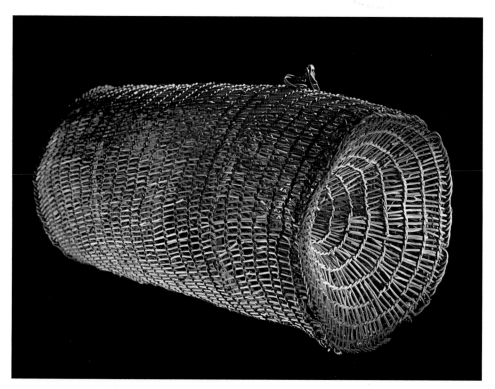

Hīnaki were open-work traps made from stiff vines such
as supplejack, shaped in the form of a cylindrical body
and inverted funnel, used to catch freshwater eels. Hīnaki
like this one, attributed to Te Ati Haunui-a-Paparangi, were
still being made in the 1900s.

[Museum of New Zealand Te Papa Tongarewa]

Whatu tāniko — hand-twined clothing

The two basic garments worn by Māori prior to European contact were the rāpaki — a waist mat — and the kākahu or cloak. Finer garments were made for ceremonial occasions, but everyday dress was of a practical nature. The basic process of cloak weaving was laborious, but produced a garment of particular strength and beauty. Once prepared by stripping and soaking, the whenu of muka flax took well to dyeing, but the main body of the cloak utilised the whitest undyed muka achievable. The first row of a cloak is usually placed about 15 cm below the top of each whenu and is called aho tapu, aho tāhuhu, tāwhiu or whakamata. The 15 cm gap is left to enable the tāniko border to be completed after the main body has been manufactured. The process is always worked from left to right. In pre-contact days, at the completion of the aho tapu row, the kākahu was usually suspended between two turuturu to enable the kaupapa to be laid out easily and manipulated. Today a specially designed adjustable frame is used.[22] Kākahu are woven upside down, as they are begun from the bottom edge of the garment. Shaping was evident through the introduction of short wefts and darts that ensured the cloak fitted snugly around the shoulders and hips. The main body, then the poka, were worked and the tāniko border was the last phase to be completed. When the length of the whenu warp began to reach its end, another was simply attached using the whatu process, and this continued until the appropriate cloak length was achieved. When the kaupapa or main body was completed, the cloak was removed from the turuturu and turned so the border could be worked on in a horizontal, left-to-right fashion.

The basic whatu techniques have been identified as whatu aho pātahi, pukupuku and whatu aho rua.[23] Construction of cloaks may utilise only whatu aho pātahi or whatu aho rua; however, both techniques may be combined in a single garment. Whatu aho pātahi, the simplest form, involves using a long single aho weft folded in half to create a pair. The first whenu warp is placed at the looped junction. One of the aho wefts is passed in front of the whenu warp and the other to the rear, enclosing the whenu warp between them. Both aho wefts are twisted around each other in a clockwise direction so that the lower aho is taken up over the upper aho in an s-twist. The next whenu warp is added and the whatu aho pātahi process is repeated around the whenu warp. This technique is continued until the row is completed. Subsequent rows are built up beneath and worked at equal, spaced intervals. Pauku or pukupuku differs from whatu aho pātahi in that aho rows are woven closely together, resulting in a very dense, stiff, strong cloth. Whatu aho rua, where rua indicates *two*, is often termed whatu kākahu and involves the looping of two aho through each other at the centre point, so that there is a pair of aho on the left and right respectively.

In the pre-contact period the most prestigious cloaks were made of dog skin. These were the exclusive property of high-ranking chiefs; native dogs or kurī generally belonged to chiefs. There were three distinct dog skin cloak styles: the māwhiti or kahu waero, kahu kurī and a third, made of entire dog skins trimmed and sewn together. The kahu waero was tasselled with the tail tufts of the dog bound at one end by flax fibre looped around in close half-hitches, in the same way tufts embellishing the neck of the taiaha spear were fixed. The kahu kurī were assembled using a single whatu twist, applying the pauku or pukupuku method. The attachment of dog skin was completed after the full kaupapa was finished. The skin strips (1.2 cm in width) were positioned in a warp arrangement and sewn with a needle and thread passed horizontally over the strips through the

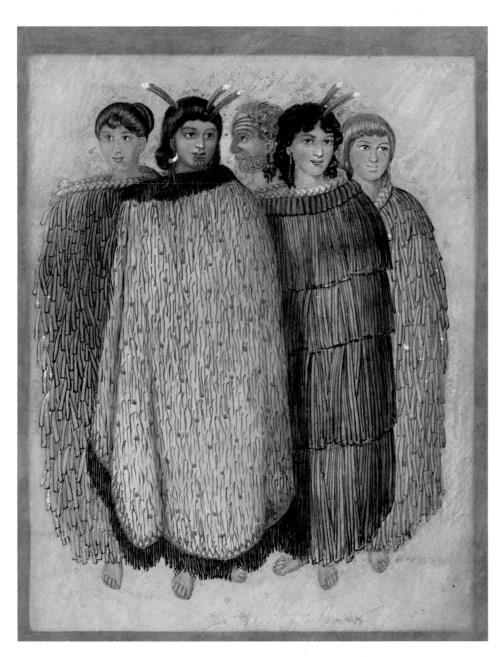

Kākahu were widely used at the time of European contact. This drawing shows the two main classes of cloak. The pihipihe was practical, with rolled flax tags, while the ngore was a finer style korowai, or tag cloak, with red pompoms.

[Alexander Turnbull Library]

gaps behind the whenu warp and out again. The placement of the gaps ensured that the skin hung in a graceful manner and the thin skin strips were not easily displaced.[24]

While the kahu kurī might have a narrow patterned border worked on each side to provide stability to the garment, the fully developed tāniko pattern borders became more a feature of another prestigious cloak used for ceremonial occasions, the kaitaka. The perfection of the fine weaving, and an almost white bleached colour, signified that the aronui (the finest version of the kaitaka) was a highly prized garment and worn only by leading chiefs. The tāniko patterning was achieved by twisting dyed plied threads in such a way that the aho horizontal elements, twisted around the whenu vertical, brought the required colour to the front of the piece. This was completed in the same manner as the fish traps, but the soft nature of the muka material made it easy to achieve as it enabled a half twist to exchange colour. Tāniko is the name often applied to the whatu finger-weaving twining technique, but also refers to the patterns created by controlling the amount of twist that brings a colour to the fore.

The kaitaka were known as pātea, paepaeroa and huaki, depending on the arrangement of the tāniko patterned areas. Narrow tāniko borders around the sides of these cloaks combine the functional necessity of maintaining structure at row endings with the aesthetic capacity of the tāniko technique.

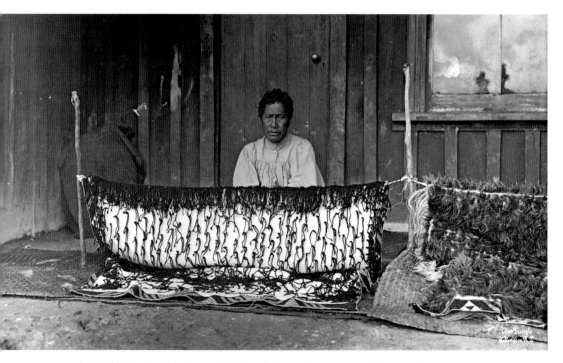

In this 1905 photograph, a woman sits in front of a korowai strung suspended between two supports called turuturu. A tāniko-ornamented border of the tukemata, a triangular-composed pattern, is visible as a wide band on the bottom and as a narrower one on two sides.

[Alexander Turnbull Library]

A few surviving cloaks collected before 1780 are decorated with a very wide tāniko border worked in complex compositions of tightly woven spiral-style and lozenge designs in single lines of white fibre, but with the black or dark brown background predominant. Other linear design elements were used, including oblique lines, chevrons, and vertical and horizontal parallel lines. The kaitaka of the mid-1800s generated a range of more colourful tāniko patterning. More emphasis was given to geometric shapes as masses with linear design becoming peripheral, but still with the emphasis on black backgrounds. Scrolls were no longer used and colours included red, black, white and yellow. In the 1900s four distinctive patterns can be observed: aho rua or two mouths, based on diamonds; aramoana or pathway to the sea; aonui with zigzag patterning; and tukemata composed of triangles. The Christian cross, and letters of the alphabet also appear. Tāniko patterning was seen less frequently on tagged and feather cloaks, but appeared on new forms of tātua, tīpare, pari, purses, bandoliers and small baskets. Later, New Zealand symbols such as the fern leaf and kiwi, together with the letters NZ, became common on tourist items. More recently woollen tapestry has been used to replace tāniko items, but tāniko (although utilising wool) is still preferred on cloak borders.

There were many other types of cloaks, and they can be grouped into two main classes. The mai or pākē may be considered the rougher, stronger, more serviceable garments. The fibres were often thicker and technically speaking more coarsely woven. However, their primary function was to provide warmth, deflect rain from the body and, in times of war, protect the body in hand-to-hand combat. This cloak was achieved by leaving the para on, applying light scraping, and when the tag was attached it was laid flat against the aho ara, split into several smaller sections and then each part was individually woven across each warp, ensuring that the tag overlaid the previous row to create a thatched appearance when the cloak was turned up the right way.

The other class of cloaks was constructed using finer fibres and with the addition of tag embellishments. These types of cloaks included kaitaka, kahu kurī, korowai, kahu huruhuru, and kahu kiwi. There were also the hīeke, maro, tātua and piupiu. Ornamentation of cloaks has changed significantly since the minimal kaitaka cloak that was prized at the time of contact. The korowai cloak, stained red with kōkōwai and featuring hukahuka attachments, was in fashion at the time of European contact. The method of attaching cords by catching them in the weft was the same technique used in other apparel such as the hīeke and piupiu. The kārure, with an unravelled rolled tag, and ngore, with red wool pompoms, were two derivatives of the korowai that appeared in the early nineteenth century. While wool became a pattern feature at this time, it was later abandoned due to its vulnerability to moths.

There were very basic techniques for attaching soft materials like cords, tags, feathers and tufts of dog skin for the purpose of patterning tagged cloaks. Each soft fibre was prepared to enable attachment without adding bulk to the overall design or shape of the cloak. Feather cloaks required between four and twelve birds: four if the patterning was applied in bands, and 12 for fully covered kahu huruhuru feathered cloaks. After sorting, sizing and grouping, the feathers were bound together in groups of two or three using gum from the base of flax blades, or ordinary bar soap. Each feather placed over a whenu warp ensured that the base of the feather group lined up with the ara, or aho weft line. The whatu twist was executed to enclose the feather and warp together.

On the next whenu the quill was twisted up in the same direction as the feather and another whatu was completed, enclosing both quill and whenu. In this manner the feather was firmly attached to the garment and could be attached in both vertical warp and horizontal weft positions utilising the whatu technique.

The tagged garments, hīeke, whakatipu, pākē or mai, were usually made from prepared and stripped kiekie or flax leaf that was beaten, scraped and soaked in water to make the tags softer and lighter, and prepared in specific ways prior to attachment. One involved removing the green para, or epidermis, from one end of the flax tag (utilising the hāro technique) to expose the fibrous muka that was then lightly miro, or rolled, this end being attached using the same whatu method for attaching feathers. Full body garments made with rolled tags were classified as pihepihe. Rāpaki waist mats, maro and piupiu tags were all constructed the same way, using more or less aho to achieve the desired pattern effect and function.

Prior to European contact, Māori had already developed a pompom that was initially made from a strand of dyed flax fibre. One end of the strand was placed on the whenu warp and two aho whatu were completed before the first loop was made in an upward direction. The fibre was then placed on the third warp and the next whatu was completed to fix the fibre in place. This process was continued until six loops were firmly fixed to a total of nine whenu warps. This resulted in a protrusion, cylindrical and not circular in appearance.

While fibre arts have undergone many transitions and developments, kākahu are still treated with the utmost respect and reserved for special occasions and celebrations. They are considered heirlooms and handed down through generations of family members.

The piupiu is made from harakeke, which forms rolled tags as it dries, providing a distinctive sound as the tags move against each other. Harakeke bands have been stripped to the muka so they absorb the black-stain mordant.

[Museum of New Zealand Te Papa Tongarewa]

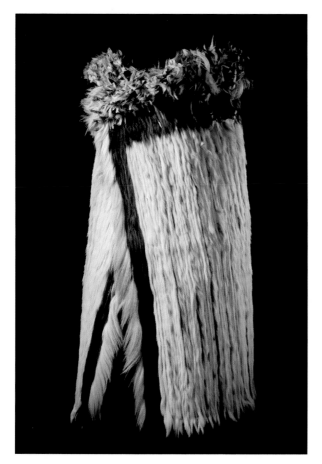

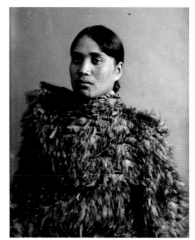

Atiria Te Hauwaho of Ngāi Tūhoe wears a kahu huruhuru, a prized cloak c1880, with bird feathers woven to cover the muka cloak body. Kiwi, kererū, kākā kūkupo and tūī feathers were the feathers most often used.

[Alexander Turnbull Library]

Popular around the 1800s, kahu kurī are made by stitching and twining muka, using the pukupuku technique, around strips of white native dog skin. Tufts from underside the tail fashion tassels and threaded strips of dog skin form the collar.

[Museum of New Zealand Te Papa Tongarewa]

This kaitaka huaki features the double taniko border and finely woven flax body with introduced wool accents. The taniko patterning featured, includes aramoana (top row), aonui — triangles and pātikitiki — diamonds (bottom row).

[Museum of New Zealand Te Papa Tongarewa]

CHAPTER 3

Painted and Pigmented Arts

Ngā Tuhituhi: drawing and painting

The stories that deal with the origins of both carving and tattooing suggest that painting was seen as less desirable than the more permanent chisel.[1] However, given the widespread use of paint and the significant ways it was used, painting seems to have had greater relevance in the context of ritual. Its relative obscurity in post-European Māori society may be attributed in part to the widespread Polynesian practice of painting as the communal activity of women. In the 1800s the shift in focus to the carved meetinghouse, which remained tapu to women during construction, led to painting activities being combined with male-led carving projects. The most significant contribution was the decline in Māori ritual and religious practices due to the widespread introduction of Christianity and British cultural norms.

Archaeological evidence of kōkōwai, or red ochre, on objects like pounding tools indicates the use of red pigments as paint. Traces of red ochre have also been found on many old carvings and cloaks. The practice of daubing red onto early Māori garments may have its origin in the widespread Polynesian practice of barkcloth painting. The intricate painted patterning on barkcloth was less viable on the rougher weave of Māori hand-twined cloaks, and that weave gave rise to its own distinctive twined patterning, called tāniko. Tāniko patterns were readily transferred to other painted contexts including the prows of early canoes and on the heke, or rafters, of meetinghouses.

Painted hoe or canoe paddles collected by the earliest European settlers provide evidence of the antiquity and evolution of the distinctive painted patterning called kōwhaiwhai, which also appeared on canoe hulls and architectural structures. In the 1840s, George French Angas recorded in his sketchbooks painted designs on large architectural objects such as tombs and memorials, further indication that painting had a spiritual function. Kōwhaiwhai had its own design conventions that could best be described as abstract or non-figurative, despite naming which sometimes made reference to natural forms. Though Māori were not greatly concerned with naturalistic images, there were allusions to naturalistic forms among the human, animal and curvilinear forms found in rock imagery and on rudimentary carved amulets.

The pigments used in painting kōwhaiwhai were mainly soot and kōkōwai — red ochre. The white was the natural unpainted surface of the timber. The red ochre was termed karamea before it was burnt and crushed into a powder with a paoi or kōhatu to create kōkōwai or hōrū. This was mixed with shark oil to make a bright red paint that was both resilient and long lasting.[2] In the Waiapu district of the East Coast a blue-grey was retrieved from slimy clay known as tutaewhetu, and in Taranaki it is said that blue clay was collected from a special area on Mount Taranaki. The deepest black, charcoal, was used for tā moko, permanent incised designs into skin, although it looked more like a darkish green once healed within the skin.

Māori did not commonly draw an outline before they proceeded to paint or carve designs, but such outlines, made on wood with charcoal, later pencil, were known as tuhi, tuhituhi and huahua. Sometimes these lines were lightly incised or grooved with a chisel as a way of sketching out designs before carving commenced, although this was minimally applied. For incised tā moko designs on the body, the intended pattern might also be lightly traced with charcoal or other material before the chiselling process commenced.

Kōwhaiwhai painted designs within the meetinghouse underwent a period of revitalisation in the 1940s under the influence of Apirana Ngata, who popularised particular notions of design and colour. Kōwhaiwhai also underwent notable changes in the 1900s, owing to the influence of the prophetic leader Te Kooti Arikirangi Te Turuki; painting became more of a community pursuit, and there was a proliferation of new figurative vocabulary. Tā moko has undergone a similar transition, becoming totally obscured by Western tattoo practices by the 1950s, but enjoying increased popularity in the last 20 years.

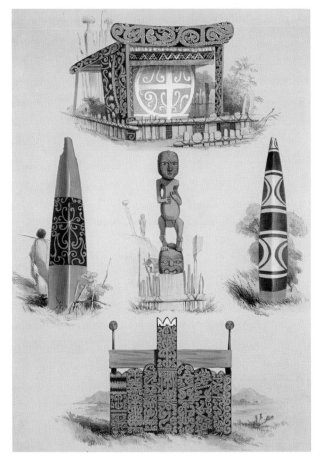

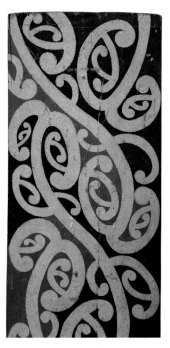

Kōwhaiwhai evolved as distinctive patterning using a range of painted scroll designs on objects, both large and small, but most commonly on meetinghouses from the mid-nineteenth century. Red and black represent prosperity and adversity respectively.

[Museum of New Zealand Te Papa Tongarewa]

TOP: The Angas drawing shows the papa tūpāpaku erected for Te Rauparaha's mother with extensive carving, painting and feather ornamentation. LEFT, RIGHT AND CENTRE: Two waka whakamaumaharatanga, portions of canoes that serve as memorials, as does the carved pou. The bottom image is a monument to three children.

[Alexander Turnbull Library]

Te ana tuhituhi — rock drawing and painting

Most of the known rock art is found in the South Island, Te Waipounamu, with the highest concentration of sites occurring around the limestone valleys of North Otago and South Canterbury. Five hundred and fifty sites have been recorded in the areas surveyed to date, with 107 rock art sites scattered around Te Ika a Māui, the North Island. Most of the archaeological evidence indicates that drawings in caves were executed over 500 years ago, during the earliest period of occupation. The early drawings are said to record Waitaha tribal history. It is likely that rock drawing was a continuous practice pursued alongside, and influenced by, developments in other Māori artistic pursuits.

The majority of Māori rock drawings were created using dried pigments, which on a rough rock surface gave a textured result. Black (charcoal) and red kōkōwai (haematite) were most frequently used, as well as yellow and white ochre. The earlier use of black, with white pigment for emphasis, is connected to Waitaha tribal traditions. Additional drawings using red are attributed to the Kāti Māmoe tribe, who later used the same rock shelters as sleeping places when travelling between the coast and their inland villages. By adding their own names, and drawing freely over the existing black drawings, they secured their own spiritual protection, the red marks signalling their respect for the deceased.[3]

Up until about 1350 the moa were abundant and constituted an important food source — so much so that this period has often been described as the moa hunter period. Moa hunting artefacts found in rock shelters, the discovery of important carved objects in moa bone sites, and drawings on the walls that depict moa, all provided important evidence regarding the art of this period.[4] Extinction of the moa around 1500 forced Māori to leave the inland areas and return to a fishing economy, resulting in a decline in rock art.[5] It is more common in the North Island to find incised lines or engravings cut into the soft rock; this is described as rock carving.

Drawings were often executed with the huata, or a mānuka pole with feather or flax extensions used to apply paint to areas where drawings appeared high on cliffs. The kōkōwai was found in the streams, and was the same red ochre used for preserving the dead, and painting on the body and significant objects. The red ochre is not found in the area where rock painting and drawing occur, indicating that paint materials were transported, most likely for body adornment and creating wall drawings. Black pigment, made from the charcoal of fires, was mixed with oil compounded with maukoroa, weka oil and shrub resin. In some instances animal or bird fat was used as a binder, and combined with vegetable gum and the colorant to create a smoother, more paintlike, finish.

Rock drawing iconography includes a range of figurative images. Human figures, moa and manu or bird-like figures, the fish, lizards, kurī, taniwha, the huge extinct pouakai, canoes and mythological figures are readily identifiable. Some rock drawings, however, have more ambiguous animal-like forms. What may be identified as a dolphin or porpoise could as easily be fish, whereas the kurī is most clearly distinguishable. Some rock drawings occur as outlines, but most are blocked in and usually have a clear strip running down the centre. Figures drawn in profile usually have the head facing right, and the drawings are representational — but stylised, rarely realistic. Some figures have clearly defined fingers and toes, and others are painted upside down. Figures are either drawn frontally or in profile, with arms and legs slightly bent and squat-like. The bird-like

human form that appears in rock drawing closely resembles the manaia, a spiritual mediator or alter-human form that appears in carvings juxtaposed with tiki figures.

The left and right side of both human and animal-like bodies are arranged symmetrically, just as body composition is mirrored along a horizontal axis; both suggest a strong design relationship with the carved and painted arts. Carved pendants and small personal items use similar figures: there are fish, lizard forms and headless running figures in symmetrical arrangements, and many of these have come from sites where moa hunting occurred. Pendants of stylised birds and bent-knee figures that appear in the same style as rock drawings have also been found, and suggest the wider influence of rock drawing. The sequential arrangement of figures is described as indicating whakapapa, or generational succession.[6]

Geometric designs are also present and although there are some regional differences they often exist as part of a human or non-human form. A simple spiral is also seen, with a koru-like (bulbous) development, which may have evolved later into the arts of kōwhaiwhai, tā moko and whakairo. In the early nineteenth century, after a period of European contact, horses, sailing ships, trains, houses and Māori names in Roman lettering were introduced.

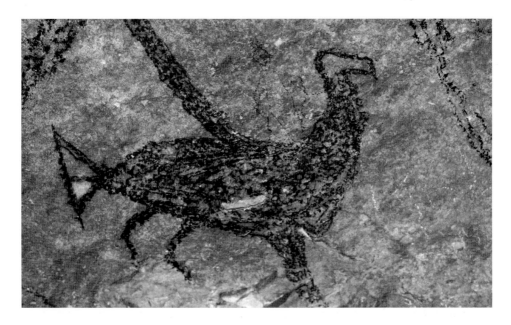

Birds were an important theme in rock drawing, the bird here being drawn in profile with black charcoal and thought to depict an albatross or extinct eagle. This one, from Craigmore, South Canterbury, is at least 500 years old.

[Alexander Turnbull Library]

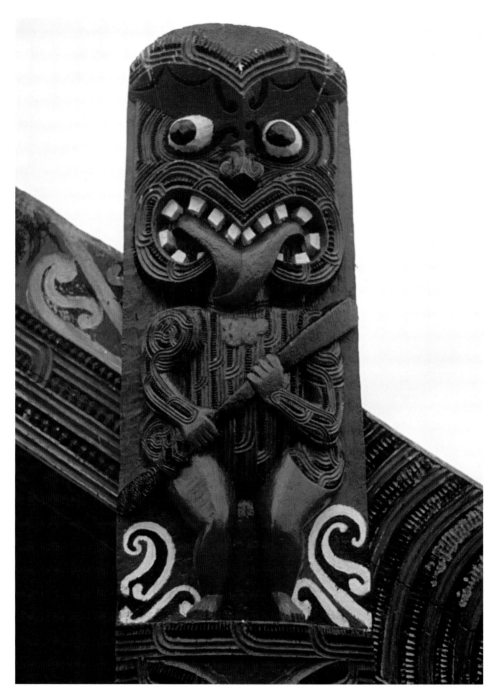

The carvings on this Mokai meetinghouse have been enhanced with black and white features in addition to the usual application of red paint over entire surfaces to present a preservative barrier.

[Museum of New Zealand Te Papa Tongarewa]

Waituhi — painting wooden objects

It is likely that kōkōwai, mixed with shark-liver oil and painted on numerous wooden items, served particular spiritual and ceremonial purposes. In particular, the colour red was a highly sacred colour. Kura meant not only 'red' but also 'divine law', 'valued possession' and 'education', and the term 'tētē kura' denoted chief. Red was used on wooden tombs, memorials and burial chests and, as already mentioned, in the embalming process. Most carvings were painted with kōkōwai mixture to signify both their ritual functions and their tapu status, and the unique mixture also served as a preservative.

Particular attention was paid to the painting of the waka taua for the above reasons, and also because of the significant community investment that went into the making of a waka taua, and the high status it carried. A canoe shed was built to house the waka taua and painting maintenance would be carried out with the craft disassembled. The painting of the canoe was part of its physical and spiritual transformation for use, along with the tied addition of feathers of the kererū, kōkō and toroa. Sizing of the canoe with sap from the poroporo was followed by application of the ochre or charcoal pigment and oil mixture. Paintbrushes were fashioned from clusters of flax muka attached to a stick, but finer detail was achieved with feather tufts. The hull and carved attachments were usually painted red but in the northern districts the prow and stern were sometimes blackened. Paddles were often plain (or sometimes carved) and coated with red ochre paint. Some paddles provide the earliest evidence of designs applied with paint, called kōwhaiwhai. The bottom of the hull of the waka taua was painted with a particular kōwhaiwhai design called the pūhoro and executed in black and white — the white being made from taioma or pipeclay.[7]

It was common in the Bay of Plenty region to emphasise the facial tā moko in carvings with white or black paint. In the East Coast some treasure boxes with carved designs had accents added to the carving with black and red paint.

Architectural carvings may have also been subjected to a swamp blackening process by first soaking the carving in a dark dye from the hīnau tree and then placing it in paru, a special swamp mud used for its preservative qualities, after which an oil preparation was applied. In Taranaki carvings have been recovered from swamps where they were hidden during the musket wars and, as well as having a uniform black colour, they were well preserved. In the 1870s and 1880s, particularly among the Mataatua tribes of Ngāti Awa, Ngāi Te Rangi, Tūhoe and Whakatōhea, the practice of polychromatic painting (using European paints) on carvings grew under the influence of Te Kooti Arikirangi Te Turuki and his Ringatū religious movement. Gaining popularity in other tribal areas such as Te Arawa, specific colour schemes came to be seen as characteristic of certain tribal areas. But often the original colour schemes were painted over with red, due to a view that red was more authentic.[8]

Kōwaiwai — body painting

During Cook's time in New Zealand he noted that women applied paint liberally over their faces, mouths and other body parts, and that many young men and women 'daubed' themselves with paint. Body painting was apparently a widespread practice, with colour combinations of blue and white, yellow and black, and white and red. Facial arrangements in red included stripes of blocked areas that moved horizontally across the face, to daubs, circles, crosses, spots and block areas of colour. Tuhi kōrae or tuhi marae kura (specifically in red) referred to lateral bands of pigment painted across the forehead. Bands or stripes of the same colour, crossing the face diagonally from the corner of the forehead down over the eye to the cheek, were termed tuhi kōhuru.[9]

The origin of the red earth is said to be the blood of the Sky Parent, Rangi-nui, and Earth Mother, Papa-tū-ā-nuku. During the course of their separation it was necessary to sever the limbs of Rangi-nui and Papa-tū-ā-nuku so that the blood soaked into the body of the Earth Mother. In these places the tohunga found the red clay from which to make hōrū or maukoroa, in order to produce the red colour esteemed by chiefs. The red clay was mixed with hinu mako, hinu weka, or oil obtained from the berries of the tītoki, giving it a paint-like consistency. This oil was carefully rubbed into the face and body with appropriate karakia, the process being repeated several times at varying intervals, before venturing outside. The addition of the strong-smelling oil taken from shark livers provided dual protection against mosquitoes and cold temperatures. The sacredness of red was reinforced by the use of red kōkōwai to mark the skulls and heavier bones of chiefs when the bones were disinterred and deposited in a burial cave or tree.[10]

Parakawahia was the term given to broad ultramarine circles around the eyes with a band across the nose on either a white or red ground. This colour was obtained with difficulty as it was found adhering to the roots of cyperaceous plants. Cook observed that blue marks were applied to the face and body in a vertical, horizontal or diagonal manner, or as alternating bands of lines and dashes. Blue pigment was obtained from pukepoto, iron phosphate or vivianite found as a natural deposit, thought to be derived from decomposed moa bones. The slimy blue-grey clay that Ngāti Porou called tūtaewhetū was used as body paint as well as for making designs on wood. The practice of marking patterns in blue is likely to have preceded tā moko, and appears to have been used mainly on ceremonial and religious occasions. The Mataora origins speak of kōwaiwai, the predecessor of kōwhaiwhai or hōpara-makaurangi, as being the only form of body marking available until Mataora returned with the knowledge of the more permanent form of tā moko from the underworld.

White was derived from taioma or white clay, and black from charcoal and certain plant and flower juices. The yellow pigment was derived from the pollen of the kōtukutuku and was often smeared on the cheeks of women and young men. One early European observer noticed Māori whose noses and chins were stained bright yellow while the remainder of their faces were fiery red.[11]

Kōwhaiwhai — painted scroll designs

Kōwhaiwhai is the name given to the range of painted scroll designs that commonly appeared on monuments, cenotaphs, mausoleums, calabash water vessels, paddles, the underside of canoe prows, storehouse porches and both inside and outside meetinghouses. It was uncommon for an artist to copy designs, but they carried motifs in their heads, which allowed them to combine and translate patterns in various ways in order to create new designs with subtle or dramatic differences.

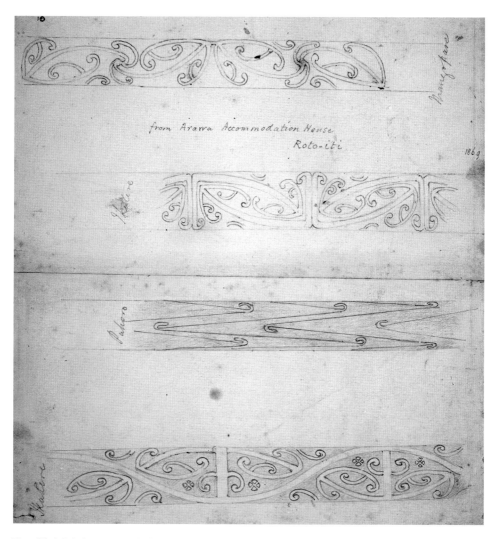

These kōwhaiwhai patterns are individually labelled: mangopare, ikatere, pūhoro, and ikatere.
Arawa accommodation house, Rotoiti, 1868.

[Alexander Turnbull Library]

An oral account from Ngāti Kahungunu tribe traces the common origin of both wood-carving and kōwhaiwhai. [12]

When Whiro, Haepuru and Haematua climbed up to the second heaven to obtain carvings for their house, they were told by one of the gods that the art of decorating houses with woodcarvings had already been taken away by their younger brothers. Whiro and his two friends complained to the god that they could not go begging to their younger brothers for the art, so the god showed them how to embellish a house with painted designs, 'painted it is said with red ochre, blue pigment, white clay and charcoal'. Whiro and the others then descended and adorned their own houses with painted designs.

Red, black and white came into common use in kōwhaiwhai painting after the mid-nineteenth century where white was achieved by leaving the unpainted wood surface exposed. Red and black used together was more a feature of kōwhaiwhai in meetinghouses, and was said to represent prosperity and adversity respectively. [13] The Western genre of drawing and painting teaches the drawing of a positive with attention to its placement in the surrounding negative space. This concept and its inverse are true for kōwhaiwhai design where the main patterned elements may conversely be exposed through the painting of the background area, producing a unique interaction of both positive and negative elements. The application of finely painted embattled lines, a series of regularly spaced and patterned lines radiating from the bulbs of the closest koru and accentuating the curves of the kōwhaiwhai, may have been reserved for superior houses. [14]

Before painting commenced, the surface of the wood was sized with sap extracted from the poroporo. [15] Red ochres from karamea and tākou, kōkōwai and hōrū were used, as well as the black of charcoal, and prepared in the usual way by mixing with the preservative shark oil. Any departure from this limited colour range was the exception rather than the rule. In more recent times with the introduction of modern paints, it has become common to apply white to the previously unpainted pītau, kape and rauru kōwhaiwhai elements to add a more varied palette.

He kāwai hue, he kāwai tangata —
Human pedigrees are like the runners of a gourd plant. [16]

Kōwhaiwhai symbolism is thought to be based on the kāwai, the lateral tendrils of the gourd plant, a visual metaphor for whakapapa or generational descent. This was also signified by the incising of kōwhaiwhai patterns on hue, or water vessels, belonging to the highborn, while those belonging to commoners were left plain. Other gourds enhanced aesthetically with kōwhaiwhai were cut lengthwise to form an open oval bowl called an ipu whenua and used to hold the afterbirth of a highborn baby. Kōwhaiwhai elements were also found incised on a limited number of older wooden objects such as wakahuia or papahou — treasure boxes — as well as constituting the vocabulary for tā moko. [17]

Kōwhaiwhai is normally applied to the tāhuhu or meetinghouse ridgepole and on the heke, or rafters. However, kōwhaiwhai can also be discovered on kaho, maihi and poupou after the

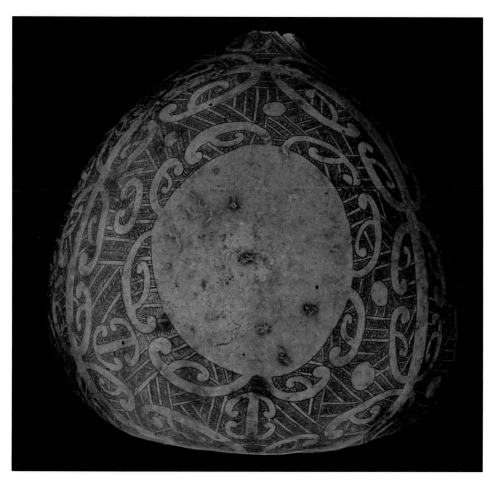

This tahā, or calabash, has been incised with a series of pītau — curved scrolls with
bulb ends — kōwhaiwhai patterning. Gourds prepared in this manner were used
around 1800 as water containers for individuals of high birth.

[Museum of New Zealand Te Papa Tongarewa]

mid-nineteenth century. The ridgepole runs the full length of the ceiling, from the front apex of
the bargeboards of the porch through to the rear wall of the house. The rafters ascend from the
carved poupou sidewall posts at regular intervals up to the centre ridgepole. Kōwhaiwhai designs
can also be applied to other facing boards in the house and on the frames of tukutuku panels and
windows. The tāhuhu represents the manawa or heart line of the tribal whakapapa beginning with
the founding ancestor and flowing continuously to the back wall. The total kōwhaiwhai design
transitions included on the tāhuhu might represent the number of generations depicted in relation
to the eponymous ancestor of that particular house. In addition, each heke represents a rib of the
ancestor, and depicts the genealogical connections of the ancestors on the poupou to the main

ancestor. Pātaka and other types of storehouses of this period also carried kōwhaiwhai similar to that of the meetinghouse, often with increased elaboration.

The language of kōwhaiwhai has evolved as a complex abstract non-figurative system of its own, where pattern names have developed out of apparent visual empathy with forms of the natural world — animals, fish and plants. The relationship between design and meaning may be overstated in the sense that actual physical references to natural form are less significant than understanding the layered cultural connotations. The main motifs of kōwhaiwhai design might be described as the pītau or koru — a curved scroll with a curved end; the kape or ngutukākā — an indented crescent shape; and the rauru or spiral. These three elements might be used in isolation or together.[18] The koru bulb is inspired by the pītau or shoot of the fern frond unfurling as it grows to produce diminishing fronds reflected in the koiri design composition of kōwhaiwhai. Most substructures of kōwhaiwhai developed from the main structure in a cyclical fashion, but exceptions occurred where the terminal bulb included an anti-cyclic bulb at the end. Other anti-cyclical elements, although rare, may be self-contained units, or double-ended as in Te Hau ki Turanga house. The main cyclical design element was the rauru spiral, distinctive in its double s-shaped centre, that partially emerges in the pūhoro design. The spiral probably developed as a natural consequence of the splitting of koru bulbs.

Common compositional devices employed in kōwhaiwhai included the addition of secondary or smaller koru forms stemming from the larger koru-defined areas. The application of spatial suggestion to imply the presence of a secondary koru element might also be used instead of

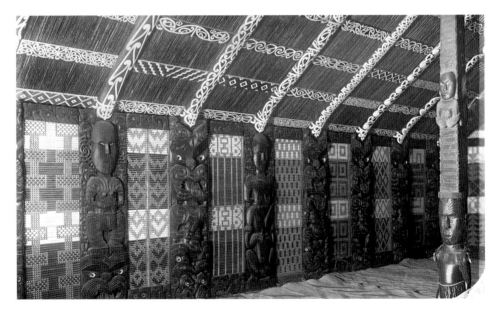

A range of kōwhaiwhai can be seen on the heke of Te Rauru meetinghouse, Whakarewarewa. The kaho have also been extensively painted and feature geometric patterns that mirror those of the tukutuku, c1910.
[Alexander Turnbull Library]

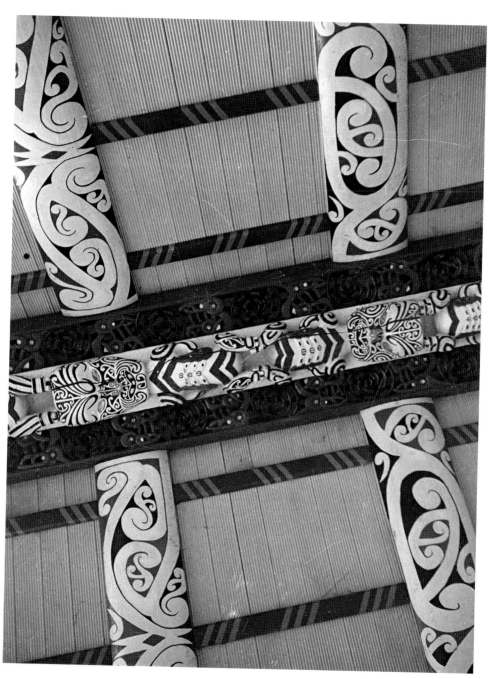

The meetinghouse Tamatekapua at Ohinemutu provides an example of the nature of kōwhaiwhai patterning, arranged to best fit the lengthened format of the house rafter supports.

[Alexander Turnbull Library]

the design element itself. The transposition of kōwhaiwhai onto the elongated rafters of the meetinghouse saw the development of symmetrical systems such as bilateral symmetry, slide reflection and bi-fold rotation that allowed for the reproduction of designs longitudinally. Straight lines and curves were further introduced to enable repeated patterning, with the geometric designs influenced by tāniko weaving also serving as visual disruptions. Interesting variations in the application of the three colours, and subtle changes applied to the repetition of minor patterning elements, were also employed.

The mangopare design and its variations — mangotipi, mangoroa or mangoururoa, composed entirely of the koru or pītau form — reflect the qualities of the mangopare or hammerhead shark. These are strength and persistence, the fighting qualities also required of the warrior. Another popular design, the kōwhai ngutukākā, alluded to the scarlet Clianthus, also known as the red kōwhai, parrot's bill or kākā beak, a drooping shrub with brilliant curved red flowers. Designs in which the kape predominate include kōwhaiwhai kape rua, comprised of kape positive elements

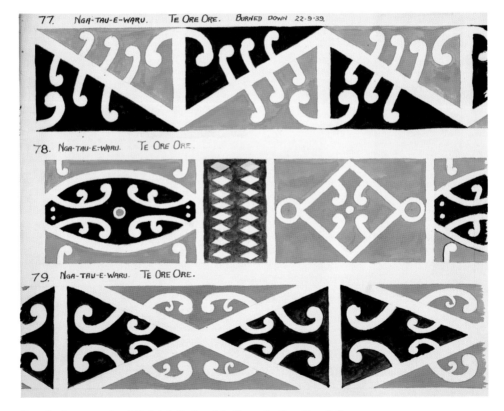

These drawings are copies of kōwhaiwhai in the original house Nga Tau e Waru, Te Ore Ore, Masterton, which burned down in 1939. Painting innovations include single pītau units placed at right angles and kōwhaiwhai compositions that become individual bounded shapes.

[Alexander Turnbull Library]

and negative spaces in equal proportions, and a kape/koru combination form called kape rua.

The pūhoro is a distinctive kōwhaiwhai design especially characteristic of the Te Arawa tribal region and used on the front hull of waka. Its symbolic reference to speed and dexterity, desirable attributes in the warrior, also makes it a popular design for the peha or permanent male thigh patterning. The pūhoro consists of a series of V-angled bulb stems split by a penetrating hairline instigating a spiral pattern. The designs continue to fit according to translational symmetry or slide translation within each subsequent pūhoro, allowing the design to be repeated as a continuous pattern. In one version, aramoana begins the rotation process of the rauru spiral and commonly alternates with a bilateral pītau inflection. Other designs referenced the pātiki, the flatfish or flounder, and the design field was divided into bilateral lozenge-shapes composed of pītau. The rautawa design was based on the tawa leaf.

The spiral designs had strong spiritual references, rauru relating to woodcarving and māui relating to the carved form. The design matau-a-Māui, the hook of Māui, combines the kape and rauru designs. The pītau-a-manaia is a distinctive design that relates to the manaia figure in carving. Pītau-a-manaia first appeared in Poverty Bay kōwhaiwhai in 1842 in Te Hau ki Turanga, and is said to have developed to disguise the manaia figure within the kōwhaiwhai elements. As missionaries put more pressure on Māori to forgo their spiritual practices, ancestral carvings became unpopular and this type of kōwhaiwhai hid the figurative intent.

Figurative painting developments

Contact with Europeans meant exposure to the influence of European artistic conventions. As well, European paint products and new building technologies provided opportunities for spectacular developments in the painting of churches and wharenui.

The innovative figurative kōwhaiwhai-derived pattern of pītau-a-manaia initially appeared in 1842 in Te Hau ki Turanga at Manutuke near Gisborne, carved by Raharuhi Rukupo. It later appeared in 1863 at Kaiti, Gisborne, Poverty Bay in the house Te Poho o Rāwiri and on a church at Manutuke — both attributed to Natanahira Te Keteiwi. This figurative form of kōwhaiwhai employed a set of stylistic conventions in which the manaia figure was created with positive and negative interactions of pītau, kape and rauru to create fingers, toes, mouth, shoulder, arms, body, hip and leg.[19] In a later Manutuke house, Te Poho o Rukupo, the translation of the pītau-a-manaia from the heke to poupou saw the development of fully painted kape and pītau patterns, rendered as tiki, ancestral figures, in the manner of carved tiki forms with spirals indicating shoulders and hip areas. Individual koru elements were also introduced to emphasise areas that in normal carving practice would have been filled with different types of pākati notch pattern between carved grooves. Long sinuous figures with angled heads featured on the back wall, rendered with red and black lines interspersed with white spaces, replicating carved haehae grooves. Complete naturalistic human figures mimicked various haka stances. Although they were painted using European portraiture conventions, the typical Māori stance showed the feet in profile. Portraiture first seen on the door of Te Tokaanganui a Noho were originally very simplistic paintings of Māori warriors. These were later repainted as Māori male and female forms in European dress.

The most prolific period of building painted houses and figurative innovations occurred after the New Zealand Wars of the 1860s. This was largely owing to the actions of the Māori Land Court, which imposed the individualisation of land titles. Large houses were built as a reaction to reconfirm, both to European authorities and Māori communities, Māori status as tangata whenua — first people of the land. On and within the new ancestor buildings, Māori drew and painted, imported and created, new imagery to reflect their politicisation and changing worldview.

Most large meetinghouse building occurred between 1860 and 1910. This is largely attributed to the influence of the prophet Te Kooti Arikirangi Te Turuki and his religious movement known as Ringatū — the Upraised Hand. Te Kooti developed a syncretic religion combining Māori belief systems and Christianity with his study of the Old Testament. His influence ranged from Tairawhiti through Mataatua and across the northern central plateau to the Waikato.

Under the direction of Te Kooti, the house Te Tokaanganui a Noho was erected in the Waikato in 1873. This house demonstrated a major departure in ancestor figures, which were carved using an imported Mataatua style and painted in bright polychrome colours emphasising the relief work of the carved forms. This was the first house to include ancestors from other tribes as part of the genealogical scheme. Three new modes of visual literacy were employed to aid in the recognition of the ancestor figures. Names were painted on the chests of ancestral figures, naturalistic scenes depicted between the legs described particular ancestral events, and mnemonic devices were placed in their hands that established their importance as rangatira.

In the porch area of Te Tokaanganui-a-Noho were finely painted naturalistic plants instead of

conventional kōwhaiwhai. However, their composition followed customary kōwhaiwhai practice, the flowers and leaves being aligned along a central manawa line in a symmetrical format, in the same manner as kōwhaiwhai. In Rongopai at Waituhi on the East Coast, the ancestor figures on poupou were replaced by naturalistic images of plants as a more figurative reference to ancestral connections with the land and the environment. In this case, the land and ancestors are depicted as one and the same, the plants emerging from the land and in some cases growing from a European vase or jug to reference tribal land and resources becoming constrained within the Pākehā system of land ownership.

Other motifs included small figures in European dress playing cricket and soccer, a variety of small active human figures (in tribal houses on the East Coast Bay of Plenty and Tūhoe tribes), and figures on horseback, performing bird-hunting and wood-chopping activities. Some of this imagery transferred to flags adopted to establish Māori sovereignty over the land.

Small painted waka taua, and in later houses images of modernity in the form of steam trains and motor cars were included on kaho paetara. Lettering commonly occurred in conjunction with a number of figurative painting conventions.[20]

There was a proliferation of newly built houses influenced by Te Kooti's painting methods; some like Rongopai favoured images of plants alongside more traditional kōwhaiwhai elements, and others expanded on the pītau-a-manaia to create entire poupou from kape, pītau and rauru. Māori have continued to respond creatively to Western modes of figurative painting, including work on canvas.

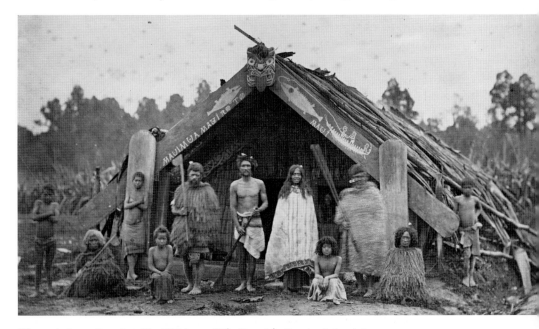

This meetinghouse, Mangakuta Pā, c1865, has maihi (gable ends) with naturalistic paintings, including the depiction of Māui and his brothers fishing up the North Island. It shows an evolution in painting towards more recognisable forms.

[Alexander Turnbull Library]

Tā moko — permanent skin marking

Cook's observations and the later writings of Horatio Robley in *Moko* (1896) are an invaluable record of the extent of historical tā moko practice. Tattooing chisels have been unearthed in moa hunter sites, although the predominance of wider chisel blades than those used after the late 1700s suggests that rectilinear designs preceded curvilinear design. Tā moko, however, involves the permanent insertion of coloured pigment into the chisel grooves. Evidence suggests there was substantial exchange in symbols and meaning between the arts of carving, painting, weaving and tā moko, and developments in the art forms were therefore likely to reflect changes in Māori society in general.[21]

The common name given to the albatross bone chisel is Uhi a Mataora, after Mataora, the originator of tā moko. It was he who brought the knowledge of tā moko back from Rarohenga, the subterranean spirit-world, to the terrestrial world where permanent body marking had not previously existed. Particular importance therefore was placed upon tā moko practices, and since they involved the shedding of blood, restrictions or tapu were imposed — all of which served to enhance the spiritual power of tā moko. The artist was referred to as the tohunga-tā-moko, and a good practitioner was widely sought after and amply rewarded. Tā moko was either performed outside or under a specially constructed temporary shelter. A social occasion often marked the completion of tā moko and neighbouring people would be invited to a ceremonial feast. It is likely that certain tā moko such as the moko kauwae, involving the chin and lips, performed on women, marked a rite of passage at puberty. Girls who had their lips marked in this manner would be presented to the people at these occasions, adorned with fine garments, pendants, kaiwharawhara (albatross feathers), and other adornments.

The most prominent and widespread moko were those on the face, and for men this could be done in stages culminating in an entire facial moko called moko kanohi. By the mid-1800s, tā moko on the face followed a particular design structure, although it appears that a range of designs may have preceded this, as discussed below. The unmarked face attracted the descriptions papatea, or plain-face, and tūtūā, or nobody. For women the designs were mostly confined to the chin, although designs on the temple and nose as well as other facial areas were observed. The other commonly seen tā moko form was the peha (a name recently reclaimed from the Samoan heritage of tatau[22]), which describes the combined covering of the lower back, waist and hips, buttocks and down around the upper legs, like a pair of breeches. Fewer observations of this form were made for women. Tā moko was found on shoulders, arms, breasts, neck and chests, backs, stomachs, thighs and lower legs, although this became less immediately obvious in the 1800s owing to the British etiquette that required clothing to cover the body. Tū tātua refers to a waist patterning, takitaki to lines between the breast and navel, and hopehope to the thigh markings — all distinctive tā moko for women. Bands of tā moko also encircled ankles and wrists, akin to the effect of woven anklets and bracelets. Men occasionally had the penis tattooed, but among women the tara whakairo or genital moko was more unusual.

Pigment was made from the awe kapara of burnt resinous wood, and sometimes from the burned resin or gum of the kauri. This kauri pigment produced a very dark colour, which was more desirable. The anuhe vegetable caterpillar might also be burned and mixed with the juice of berries

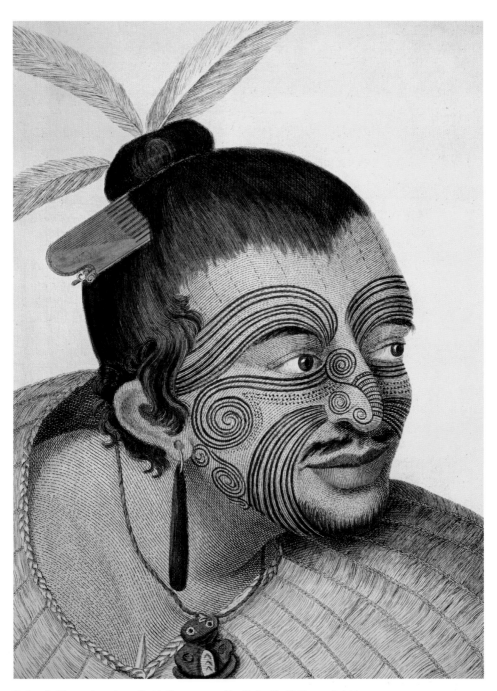

Sydney Parkinson, the artist on Cook's first voyage to New Zealand in 1769, recorded this moko kanohi, or facial tattoo, of a chief. Linear and dashed patterns are notable features of early tā moko, visible here on the forehead and underneath the eyes.

[Alexander Turnbull Library]

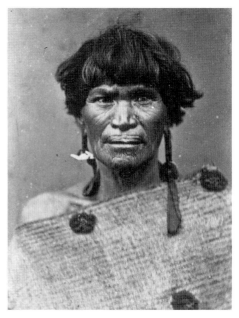

The engagement of the chiselled grooves of moko kanohi with the lines of the face can be seen in this portrait of Tukaroto Matutaera Potatau Te Wherowhero Tawhiao, the second Māori King. The upper cheek spirals have not been completed, c1884.

[Alexander Turnbull Library]

Portrait (c1860) of a woman with moko kauwae and lines chiselled around her top lip. She wears long ear ornaments, which appear to be made from teeth, suspended from her right ear, and a ngore, or pompom cloak.

[Alexander Turnbull Library]

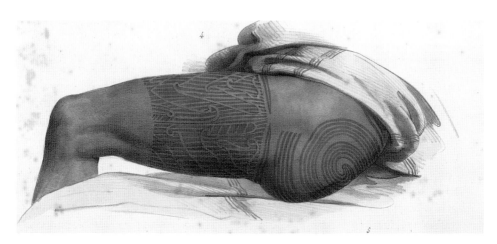

The main thigh area was usually laid out in the pūhoro design featured here, a pattern that also featured on the underneath of the prow of the waka. The rape or spiral on the buttock is also visible.

[Alexander Turnbull Library]

from the mahoe tree, and the residue used for black pigment. It was kept in lumps for years and remixed with juice when it was required for use as ink. This reconstituted black pigment was placed in an ipu wai ngārahu of pumice or wood, which was sometimes elaborately carved. Another object of significance was the carved wooden kōrere, a feeding funnel from which liquid foods were fed to the person undergoing facial tā moko. Eating was painful, and food was not permitted to touch the lips in their tapu state.[23]

The tā moko design was traced with charcoal before the artist began work, followed by the process of chiselling with the uhi. The artist dipped his uhi into the pigment and, placing it on the traced line, tapped it smartly with a tā, a light mallet or striker, so that it entered the skin leaving a narrow groove; a soft flax towel was used to wipe away blood. The process was painful enough that only a little could be done at a time with resting periods between.[24]

The main uhi used, called the uhi whaka tātarāmoa meaning 'to clear the way', was commonly made from a piece of albatross bone and ground flat to a thin smooth blade about 10 mm wide. This made the grooved design. The uhi puru was serrated with a small row of teeth filed into the blade and was used to insert pigment into the grooved cut. It was dipped frequently into the wai whakatairangi, the term kamu being used to denote the relative retention of the pigment in the flesh cut. Several uhi were specifically designed for the job required. The uhi kōhiti had a plain narrower face in order to create the tighter curved scroll designs and finer work associated with the titi and kōhiti areas. The uhi matarau had a serrated edge so that cutting and inking occurred in one manoeuvre for the kaho maro lines of pākiwaha, ngutu, rape and kauwae. The uhi might be made of human bone in the case of tattooing a warrior, so that he might boast he had been tattooed with the uhi of an enemy.[25] After European contact metal chisels were added to the artists' kit and in some cases replaced bone. The practice of using the uhi matarau also became more common; the procedure was faster although less effective than the deeper grooving methods. The last skin markings to be made with the chisel date to before 1925.[26]

For moko kanohi the basic design consisted of a pair of large cheek spirals on either side with smaller spiral pairs executed on either side of the nose itself. The large spirals had a series of lines, usually three, laid closely together and balanced by an equal area of space left unmarked. The nose spirals are made by a tighter chisel line spiralling inwards. The basic pītau or koru element, laid out in differing arrangements, constituted the main areas of patterning on the forehead, from the cheek to the ears and jaw, on small areas between nose and mouth and on the chin. As with kōwhaiwhai, pattern was accentuated by the contrast generated by pigmented chiselled areas and the exposed unchiselled patterns in adjacent areas. Long sweeping sets of curved lines radiating from above the eyebrow, and from nose to chin, served to accentuate facial features and link the spiral and koru pattern areas. Designs on either side of the face were predominantly symmetrical, but secondary areas of design might have individual marks that broke with the obvious symmetry. Names for chiselled areas of the face differ, but common ones include: Titi — central forehead patterns; Tīwhana — long lines on the forehead over the eyebrows; Pukaru — fine lines on the temple, on the outer ends of the eyebrows; Rewha — lines below the eyebrows on the eyelids; Kumikumi — curved lines on the cheek under the eye; Paepae — large spirals on the cheek; Korowaha or koroaha patterns — on the cheeks between the cheekbone and the ear; Rerepehi or kawe — lines

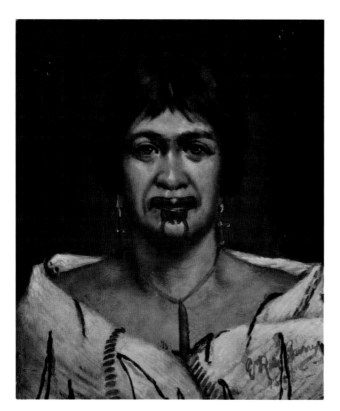

This painted portrait of Te Wai-Ringiringi shows her chiselled moko kauwae. Lines are visible on her lips as well as a parallel set of lines above her top lip.

[Alexander Turnbull Library]

Uhi matarau of this type were made around 1750 from bone, with fine teeth filed into them – in this case, triple-teeth. The blade was bound to a wooden handle that was tapped with the tā to incise and ink the skin.

[Museum of New Zealand Te Papa Tongarewa]

from the nose round the mouth to the chin; Wero — hatched curves on the cheek (between the previous two); Hūpē — a scroll pattern just under the nose ; Ngū — a pattern on the body of the nose; Pūtaringa — patterns under the ear ; Pīhere — patterns at the corner of the lips; Kauwae or pūkauwae — a scroll pattern on the chin; Ngutu-purua — patterns on the lips; Pōngiangia — lines near the nostrils.[27]

The distinctive moko kauwae, or chin design, worn by women was composed of partial spiral and koru arrangements that descended in curved groupings down the chin, sometimes as low as the neck area. Again the lines were set in threes, closely clustered with due consideration given to balance between pigmented lines and non-patterned areas. The marking of the lips was called ngutu-purua, for both lips, and occurred in both men and women. The uhi matarau was used so that cutting and pigmenting were executed simultaneously. Ngutu poroporo referred to the encircling of the lips with two or three parallel lines set close together to outline both upper and lower lips, or the upper lip only. Additional facial areas apparent on women, like those of the male moko kanohi, included the hōtiki or forehead, the area above the upper lip, areas at the corner of the mouth, spirals on the nose and areas around the eyes.

The peha on the lower back and hip region and around the thigh down to the knee was widely applied at the time of initial European contact. This appeared to have distinguishable design fields with elements individualised to the wearer. The buttock area consisted of the spiral design executed in a number of spiral variants including the s-styled interlocking double spiral, or a single spiral form, one on each buttock. These were often referred to as the rape o Mataora, or the great spirals on the buttocks.[28] The main thigh area was commonly laid out in the pūhoro design, which was also painted on the base of waka taua. This design was also recorded by Cook as moko kiore, or rat, an overall design on the lower section of the male face. Another unique facial design consisting of notched vertical and horizontal groups of lines was termed the moko kurī.

All forms of moko had ceased being practised on men's faces by the 1860s and was greatly reduced on women by the 1900s. In 1907 the Tohunga Suppression Act and missionary influences saw tā moko virtually cease until the 1930s, when the kauwae moko for women was revived using steel needles. Throughout the history of tā moko, technological innovation has tended to determine stylistic development, and contemporary tools allow more for painted than carved effects of tā moko. Today some artists are choosing to return to variations on the serrated chisel or uhi matarau of old.

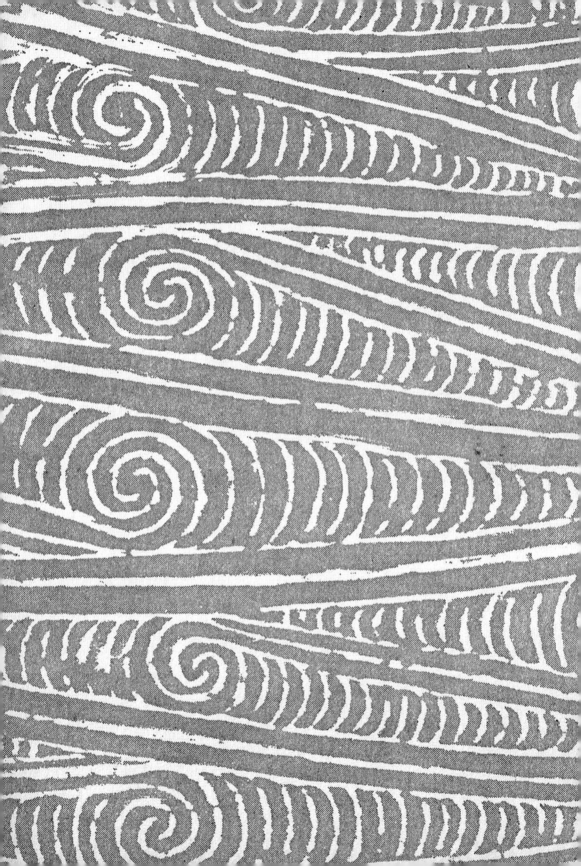

CHAPTER 4

Architectural and Structural Arts

The kāinga and settlements

The kāinga describes a single residence, but a number of huts might be called kāinga collectively. If the settlement was fortified it would be referred to as a pā. The largest kāinga seen on Cook's first voyage was estimated to have 500 houses, while the smallest had only three houses. For everyday life the hāpu, or sub-tribe, was probably the most effective unit. Individual communities may have had both allies and enemies in close proximity.

Fortified pā, kāinga and the structures contained within both were constructed without nails in pre-European times. The main technique consisted of lashing large wooden components by passing cord through holes cut by chisels, and driving wooden pegs into holes to make the lashings firm. The binding of plant materials was also a prime technique in the construction of dwellings and storage facilities. Archaeological evidence suggests that early houses were similar in design to those found in eastern Polynesia. Māori adapted local native materials, including raupō reeds, toetoe, aka vine and nikau palm leaves, and the timber of the tōtara, mānuka and pukatea trees.

Seasonal subsistence activities determined the social groupings and duration of dwellings in a particular area. During the moa hunter period, pre-1350, these were simple but semi-permanent dwellings. Different houses or shelters were lived in at different seasons, the most common being the whare raupō, of reed construction. In the South Island houses were deeply excavated, allowing them to be used again during seasonal migrations.

The wharepuni or sleeping house was the major dwelling, and that name was also applied to assembly houses. In the winter the whare puni was used frequently, but tribes using both inland and coastal areas constructed less permanent houses as well. In superior houses, hewn wooden slabs were used for the walls as well as horizontally placed logs, but tree fern trunks were considered the most durable material. Small doorways, low roof height, inclusion of a fire and lack of furnishings were consistent features of early houses. They might be partially excavated to contend with cold weather and were kept almost uncomfortably hot for the same reason.[1]

Eighteenth-century houses ranged from flimsy temporary shelters to more substantial rectangular buildings. The term wharau refers to temporary shelters or sheds made of tree branches, some being of the lean-to type that provided temporary shelter, although shelters have left little evidence of their existence.[2] Whare pōrukuruku was also applied to the inverted, curved, sloping roofs of this style of shelter or house. In summer, in warmer parts of the country, coastal visitors wouldn't bother with shelters at all. Temporary kitchen or cooking sheds built of less-flammable tree-fern trunk were also called pōrukuruku due to their rounded roofs. They were considered necessary as shelter, but also to separate food from sleeping areas. Pā korokoro or fences became increasingly common after the moa hunter period, and were a significant feature of many eighteenth-century settlements. While probably influenced by settler behaviour, they were used to protect house walls, separate domestic units from the kitchens and later to protect against pigs.

Waka (canoes) were, at least until the middle of the nineteenth century, the most valued of tribal possessions — particularly the waka taua. The manufacture of a canoe up to 30 metres in length was an undertaking that required community dedication over a number of years. Wharau was also the term applied to the better constructed canoe sheds, a name shared with Polynesian

canoe sheds.[3] These were built at ground level within the defences of fortified villages and could be 17 metres in length and from six to ten metres wide. Wharau waka had a steep pitched roof thatched with two layers of raupō reeds, secured with mangemange vines. A second floor might be added to the wharau that housed fishing canoes and be occupied by those responsible for the canoes and replacing the raupō roof, and for storing fishing nets.[4] However, changes to the resource base of tribes, and more secure settlement patterns over time, moved the focus of tribal mana to community chattels that featured in their kāinga as permanent structures.

Houses and other major structures were a community task. Before building commenced, a small sacrificial offering was often made, such as a ngārara lizard. This was thought to ensure security for the occupants of the new house against the malignant powers of lizards, considered earlier dwellers on the land. A site was cleared and the supporting post or posts erected with a mauri stone placed under the first post. Launching a waka, or the opening of a house, required more significant rituals — sometimes including the sacrifice of slaves.

Late nineteenth-century villages were organised around a marae, an open space dominated by a large whare whakairo, or carved house. The focal point of the village, the whare whakairo evolved from the smaller communal building, the chief's dwelling. Earlier impermanence had not warranted investment in a fully carved house but the nineteenth century brought a more settled way of life.

This drawing of Glenburn Station shows two whare and a pātaka, or storehouse, in a typical kāinga setting, with a European-styled house some distance away. A shelter and fence are also evident. Waikekeno, Wairarapa East Coast, c1865.

[Alexander Turnbull Library]

The introduction of metal tools also made larger houses a practical proposition, particularly as structural elements presented opportunities for sculptural enhancement. The concept of the marae as a ceremonial space, in which only communal buildings and a single carved post stood, was reinforced during this period.

Elaborately carved storehouses and one or more superior (i.e. chiefly) dwellings were present, as well as cooking sheds and food stores on the periphery.[5] Storehouses ranged from simple earth pits covered with fern and soil, to elaborately carved pātaka or raised storehouses. Others included kauta, whatārangi and tāpaturangi. Stored food items included kūmara, taro, uwhikāho, aruhe, dried fish, cooked shellfish, kiore, and various birds.

While the development of the pā with fortifications was a dramatic change that seemed not to be present during the early period of settlement, other changes were less obvious but equally important. Notably, the significant fundamental changes to Maori belief systems, brought about by the New Zealand Wars and that affected the construction, symbolism and function of architectural structures, including the whare whakairo and temples.

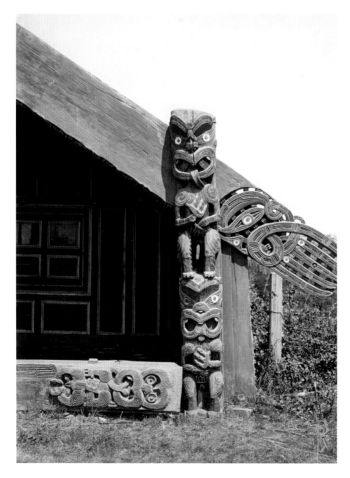

On an upright carved tiki feature on the amo, five fingers terminate on the raparapa, and a figure reclines on the paepae of Heretaunga meetinghouse, c1890. Note the European influence seen in the scotia used to create framed panels on the back wall of the porch.

[Alexander Turnbull Library]

Pā — fortified villages

The kāinga was the unfortified village of an extended family grouping of either a hapū or iwi. The defensive or fortified village was distinguished from kāinga by the name pā (although the use of 'pā' is more widespread in modern times than 'kāinga').

From the 1500s warfare had increasingly become a common part of tribal life as disputes arose over land and scores were settled over tribal boundaries. Warfare was a major feature of Māori society by the late eighteenth century and the building of fortifications became a major preoccupation. Typically the pā was sited on a hill, ridge or headland, protected by the setting as well as steep ramparts and terraces. Some pā were defended by scarp, terrace and palisades, while others were protected by a ditch and rampart with a stage. The majority of pā had mixed functions, although some were primarily refuges while others had more token defences. Still others changed their function over time; defences may have been built to protect stored food rather than for actual settlement, or habitation may have been seasonal. The pā was occupied between major defensive phases, with each phase representing progressive strengthening of the defences.

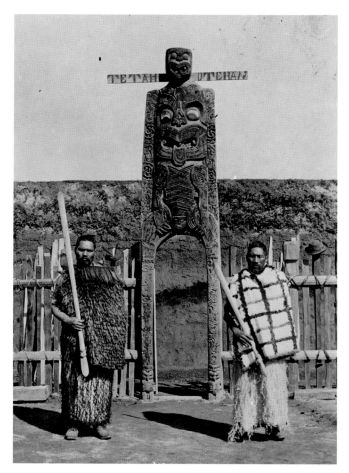

Palisades and a gateway protected pā sites, providing regulation of entry. The use of literal language to carve out the name of the Ngāti Awa ancestor 'Te Tahi-o-te-rangi' indicates a date c1905 for this waharoa.

[Alexander Turnbull Library]

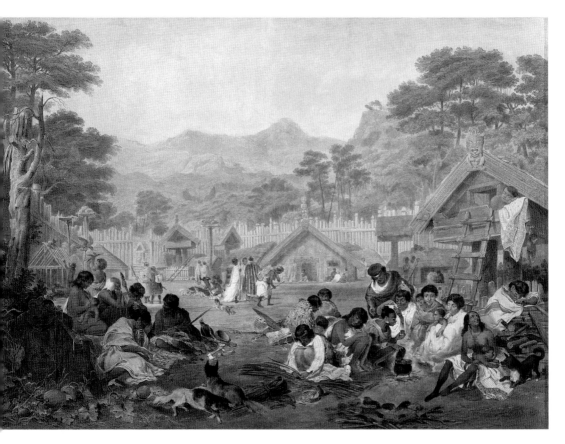

This depiction of the interior of a pā provides considerable detail of the structures and their function, as well as the relationship of buildings to each other. A range of storage, sleeping and communal structures are discernable.

[Museum of New Zealand Te Papa Tongarewa]

Tūwatawata, pūwhara and taumaihi all added protective strength to the pā. Laid out in connecting lines with poles varying in scale and dimensions, the tūwatawata strategically hid defensive positions, while the addition of carved figures served as a warning to enemies. The pekerangi was the outer palisade of light construction, but the last defensive position was the main palisade built of pointed hardwood stakes lashed to rails and carved ancestral posts. The waharoa or gateway to the pā was considered to be an important defence mechanism and might be cleverly designed — its solid single tōtara slab construction set firmly in the ground — to admit only one person at a time. The approaches to the kūwaha, enclosed with palisades or ramparts, meant defenders could throw long spears to repel attackers.

Behind the defensive tūwatawata stood the pūwhara, from which stones and spears were thrown. There were notched poles for climbing while sliding hatchways provided access to the platform. The taumaihi, built of adzed and smoothed kauri and hardwoods, rose above the fortifications to a height of ten metres or more. These were constructed as two platforms with

Mānuka and kōrari palisades combined with posts and rails from a settler's stockyard, are a feature of Gate Pa, Tauranga — seen here after British forces had taken it over following the siege in April 1864. Trenches and underground pits, and covered ways connecting inner and outer rifle-pits, completed the defences that had been made against musket attack.

[Museum of New Zealand Te Papa Tongarewa]

walls, lashed together with vines and fixed to four or more heavy posts with a stronger lash. The watchtower was also used as a vantage point from which to hurl rocks and darts.[6]

Māori acquisition of European weapons in the 1830s brought dramatic changes, as pā became sited to defend against musket attack rather than traditional weapons, and fighting stages were abandoned in favour of firing trenches. The northern tribes, armed with muskets, conducted successful campaigns throughout the North Island until other tribes gained the weapons needed to restore the balance of power. Fortifications were often tactical, designed to invite attack and by strategic advantage defeat the attackers before fighting actually took place within the pā. Whare punanga were a unique style of hut built among the branches of trees as refuges for non-combatants.[7]

As Māori attention became increasingly focused on a Pākehā enemy, the engineering of fortifications was further developed to withstand artillery bombardment. Trenches were zigzagged or traversed to prevent exposure to enemy fire, and level or near ground-level pā, called musket pā, replaced the traditional hilltop style. A standard rifle pit was a simple hole dug about 1.2 metres deep with a roof consisting of timber covered with earth. With the introduction of heavier artillery Māori dug deeper wood-covered bunkers and manned firing trenches beyond massive stockades so the initial attack could be made as enemies approached, countering an attack before it reached the pā itself. Flax screens were mounted in front to absorb fire and conceal visible signs of damage to the main timber defences. Māori continued to modify pā design to encourage attackers while the fighting advantage remained with the defenders. In many cases this tactic was highly successful as long as the behaviour of the attackers remained predictable.[8]

Whare raupō — reed constructed houses

Early houses typically had raupō walls, thatch and roofs, and established the template for later developments. Many were constructed in rectangular, round, and oval or canoe-shaped form, and were designed to sleep a single family group as well as for specific storage purposes. The early roundhouses featured a beaten earth floor, mānuka or other timber lashed frame, central roof post and raupō reed thatch roof. They averaged 3.5 metres in diameter and were up to four metres high. The mānuka was lashed with aka and securely fastened to make a strong and flexible frame, to which layers of nīkau fronds and raupō were added, and finished with toetoe thatching. The oval house was made in a similar way and had the appearance of an inverted waka hull, supported by a support post at each end, averaging three by five metres. Other materials included aka tokai and mangemange, a tough flexible climbing plant used to bind the house frame, and harakeke, toetoe, rautahi or rīrīwaka for lining the interior. Dirt floors were covered with flax mats, and some houses had sunken floors and additional small covered rua, nearby or connected, for storing root crops and preserved meat.[9]

The amount of raupō thatching applied to the house determined the warmth that could be contained within its fire-heated confines. Kaho battens were laid horizontally along a vertical framework to support layers of raupo. Kākaho, stalks of both toetoe and raupō, were used for thatching, and by laying them out parallel and tying them into oblong mats they could be neatly applied as house lining. The packed bundles of kākaho were fixed to the framework securely

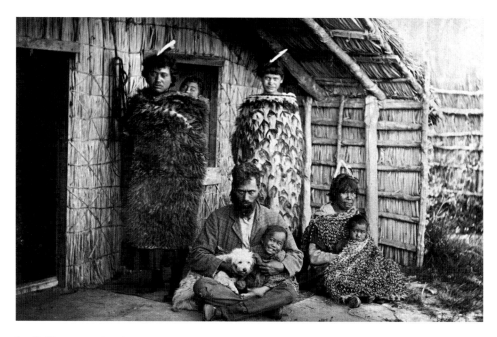

Detail of the construction of an unidentified whare raupō, c1910. The raupō is bound onto the horizontal support poles. The porch wall thatching has been secured with a crossed-over binding, and the door and windows have been edged with timber.

[Alexander Turnbull Library]

with kareao, which was bound around and between the stalks and kaho. Supplementary battens, called karapi, were added to the outer covering of raupō bunches so further layers could be added overlapping each other, butt ends uppermost and worked horizontally along the karapi, to be tied beneath. The bark of tōtara or mānuka was sometimes used as additional thatch material, particularly as an outer roof layer.

Roundhouses that served as storehouses were called pata pūrangi. These were roughly built of split mānuka stakes bent over from the sides of the roof post where they were fastened with mangemange vines. They could be from three to six metres in circumference and either thatched with raupō or covered with aka-bound strips of tōtara bark attached to the roof frame. They also had compressed clay floors. The whare patutītī was a seasonal dwelling house built by tītī hunters on the Kawhia coast. This simpler form of circular house averaged about four metres in diameter and consisted of a mānuka frame, raupō reed covering with no wall and a floor below ground level.

Back view of a whare raupō, Karaka Bay, Wellington, c1890. The neatly packed raupō thatching for walls and roof are evident but European materials began to appear with wooden extensions and windows as well as corrugated iron flashing.

[Alexander Turnbull Library]

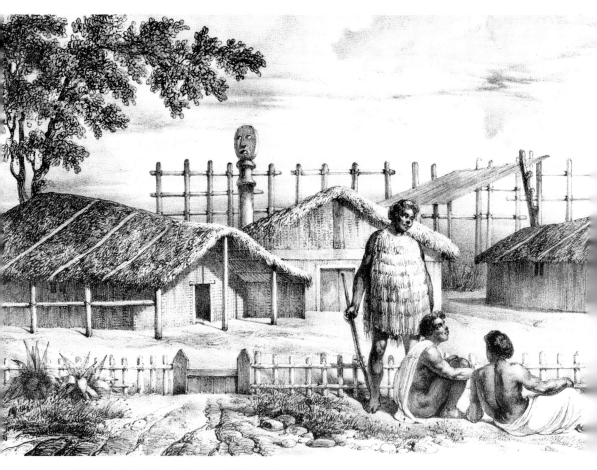

In this drawing, the low roof structure of the raupo house and wharua or lean-to, are in evidence. Palisades are visible at the rear, and, in the foreground, a Western-style fence and gate. 1841

[Alexander Turnbull Library]

Wharepuni — sleeping house

The pūrori or huki was a type of roundhouse in use after 1830, mainly in the South Island. This house differed in that it had a separate wall, layered rather than continuous raupō thatch, a conical roof that shed rain, and a greater central height of 2.5 metres. A sliding door provided ventilation and the house, called a wharepuni, was used for sleeping only. Up to nine metres in circumference, the pūrori had a mānuka sapling framework secured with aka tokai vines, and some had a sunken floor to the depth of one metre. This house also had double walls, the inside being made of mānuka stakes faced with toetoe and the outside with raupō or tōtara bark. Tōtara bark was used where available instead of thatching, and frequently as a roof covering.

With the extinction of moa, more permanent structural materials evolved as agricultural practices proliferated. The separation of walls and roof was common and houses possessed a tāhuhu or ridgepole structure with two or more support posts. A framework of mānuka saplings would be prepared with mangemange or aka vine. A lining of nīkau leaves was overlayed with raupō thatching.

Rectangular wharepuni were typical of this period, consolidating the features in the separation of walls and roof structure, an apex or triangular roof, and increasing the use of wood as a structural material. Two support posts to support the tāhuhu projected further out than the front wall to provide a porch area. Frame and thatch were applied in the same way, but extra horizontal wooden akatea, or poles, were laid horizontally along the structure to secure the thatch in a more stable manner. The main entrance consisted of a tatau, a sliding door only about half a metre square and a single small pihanga, or window. A central passageway divided the house and there would be a small sunken fire pit. The whare āpiti, or steep-pitched roof house, had no walls at all, whereas the pōrukuruku type of sleeping house was semi-cylindrical — similar to the waka-shaped house of the moa hunter period but with a less steeply pitched roof.

A better class of sleeping house would have the walls lined with dyed kākaho or toetoe with the porch wall formed of neatly presented rows of raupō thatching. A chequerboard effect was achieved on the porch and sides of a chiefly house by interlacing yellow pīngao with the grey-green kiekie and green harakeke.[10] Whāriki covered the floor, and bedding of dried fern was laid on boards two metres long by half a metre wide. Carved additions on chiefly houses were simple to start with, the maihi or bargeboards being minimally carved. On the apex a tekoteko, or stylised carved human figure, might be attached.

European visitors were not particularly impressed with even the more superior eighteenth-century Māori wharepuni — they were sparse, with a single low door, small single window and relatively low roof. When the fire was lit in winter, whare puni became hot and stuffy.

The main European influences on the whare puni occurred during the 1880s, particularly in the partitioning of houses to incorporate functions other than sleeping, despite raupō and tōtara bark houses still being the norm. Houses grew in size to around five by three metres and were divided inside by a mānuka frame partition covered with plaited flax matting. Small features like metal hinges for doors and, occasionally, glazed windows were added. The tapu regarding food eaten inside sleeping houses was relaxed somewhat and this saw the introduction of furniture like tables and chairs. At the turn of the century, floorboards began to replace earth floors.[11]

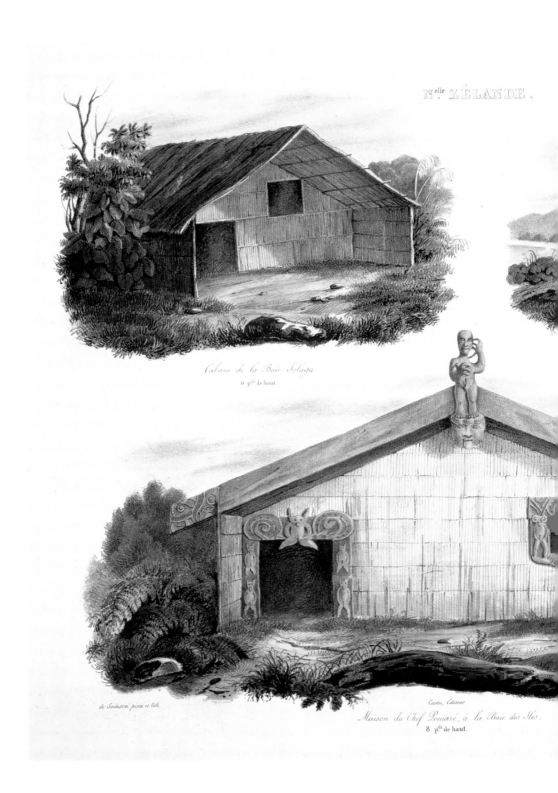

Cabane de la Baie Tolaga

6 p.ds de haut

de Sainson pinx. et lith.

Castu, Editeur

Maison du Chef Pomaré, à la Baie des Îles.

8 p.ds de haut.

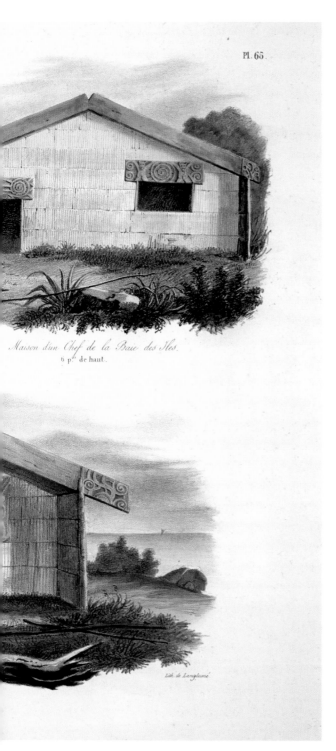

Pl. 65.

Maison d'un Chef de la Baie des Îles.
6 p^ds de haut.

Lith. de Langlumé

This drawing from 1827 shows how
the carving of dwellings became
increasingly elaborate according to
their use and status. Wall and roof
thatching, as well as standard door
and window layout within a porch,
are features of all three.

[Alexander Turnbull Library]

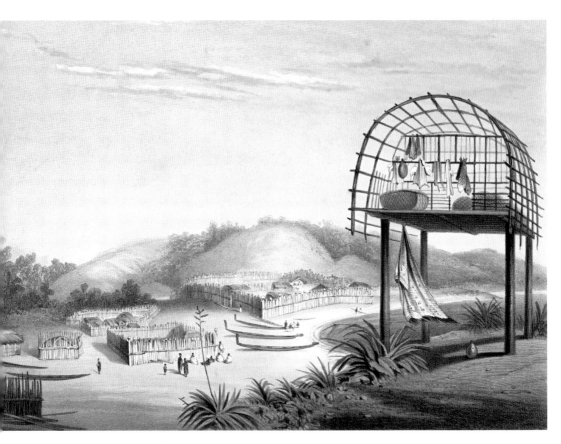

This Angas drawing looks down on Taupō pā in 1847 (present-day Plimmerton), where the main village is secured within palisades. The whata or storage platform in the foreground holds household utensils, skins, calabashes and dried fish that may have been placed there under tapu restriction.

[Alexander Turnbull Library]

Whata and rua kai — food storage structures

Food storage methods followed four main developments: the whare raupō hut form; semi-subterranean pits and caves; elevated stages and racks; and raised storehouses supported by a platform and one to four posts.[12]

Storage pits and caves were associated particularly with the kūmara and, although called rua kūmara, may have had other names according to the form they took. The kūmara in particular was a venerated food source and a number of ritual processes accompanied phases of cultivation. At the end of the season, tubers were offered to Rongo-mā-Tāne and Haumia-tiketike, gods of agriculture, before the harvest was stored.

The storage of kūmara in such pits required raupō wall linings to protect the tubers from contact with the soil. Slabs cut from the trunks of the tree fern, whekī ponga, were also popular lining materials as they resisted rat attack, while fronds of the rarauhe provided a cushion. The bark of kahikatea and mānuka made good covering material for entrances to storage pits. Drains might be specially laid to ensure water was excluded from the pit. Other important stored food items included taro, uwhikāho, aruhe, dried fish and cooked shellfish threaded on flax lines. Kiore and various birds were stored, preserved in their own fat, in incised patterned gourds. A common roundhouse storage pit, more deeply excavated for kūmara and called a whare mānuka (with a mānuka roof), was noted for the fact that two women reportedly lived in one of these pits in the Wairarapa in 1849.[13]

An elevated platform for suspending or storing food was called a whata. The simplest form was a type of rack used for drying fish and shellfish, and also at times for spreading fishing nets to dry. The whata was erected near cultivated areas for the temporary storage of harvested crops where the food was placed, covered with thatch, until it could be carried to the village storehouse. Platforms were also used for drying fern roots and storing weapons.[14]

Whata kōpiha kai on the other hand represented another form of food storage, a multi-floored stage for the purposes of a hākari, or feast. The pyramidal or conical type was constructed around a tree trunk centre post with lashings securing the horizontal framework. The tree was debarked and set up with surrounding support poles that provided structure to the horizontal framework. One account from 1835 suggests the existence of a stage of 15 platforms with clearance between for men to walk upright, which would make it at least 30 metres high and up to 10 metres in diameter at the base, tapering upwards. Flags were described as decorative features and baskets of food were hoisted between the levels of the stage. Portions of food were allocated to the guests, after which the stage was either burnt or left to decay rather than being used again.

The second type of hākari stage described was a longer, wall-like structure with parallel rows of poles inclined inward and meeting at the top. Structural stability was maintained by vertical centre poles erected along the length. One such stage for a great feast in the Bay of Islands in 1849 is described as being some 45 metres long and catering for 6000 guests. Preparations for large feasts were made a year before the food items were planted. In Taranaki and on the East Coast, a different way of presenting food was practised — that of tahua, where the prepared food was piled on the ground in long heaps.[15]

The storehouse on a high elevated platform was called whatarangi and was used to store prized agricultural or fishing implements, canoe equipment, important tools, weapons and cloaks. The

whare mata was an extremely tapu kind of storehouse for manufactured bird snares and spears. The whatarangi was also considered highly tapu, particularly when used solely for storing the most sacred of food.

The whatarangi had a strong hardwood frame covered with raupō. The flooring was usually made in one piece, from an adzed log, or even the mid-section of a small river canoe. This was lashed to the top section and overlapped slightly to form a verandah, which also protected the base of the reed wall. The rear wall was made of stronger material, usually strips of tōtara bark fastened

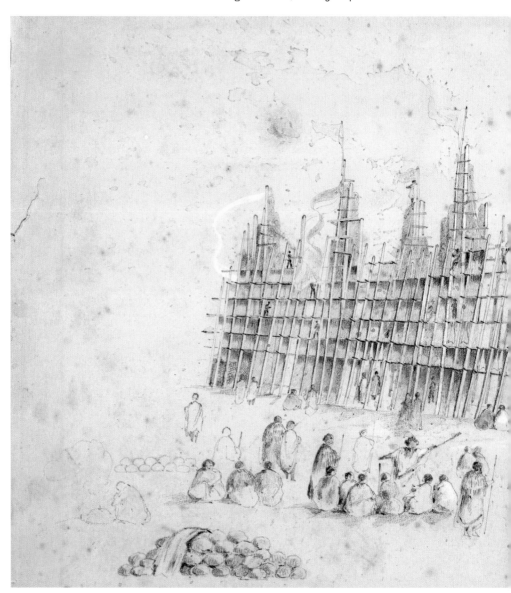

with aka to wooden battens. A kaupeka (climbing cord) or arawhata (notched post) provided access to the whatarangi and was removed after use to prevent rats from accessing the store. A pata pūrangi is described as a more elaborate version of the elevated storehouse, with a matai frame lashed with aka tokai, the porch panelled with toetoe reeds and the roof made of tōtara bark. This storehouse had carved elements and was used for storing prized preserved birds, kao, huahua and other tapu food of chiefs. By the nineteenth century, fencing was increasingly used to protect the valued contents.

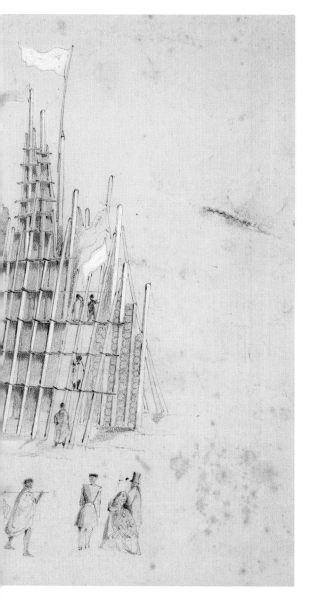

Feasting stage with flags flying, built to hold food for a feast held by chiefs to honour Sir George Grey, Kororareka (Russell), Bay of Islands, 1849. The number of people climbing, seated and moving around clearly shows its size.

[Alexander Turnbull Library]

Pātaka whakairo — carved elevated storehouses

The pātaka whakairo or carved elevated storehouse evolved as the most impressive of all storehouses and was situated within pā fortifications to protect the most valued possessions, including greenstone weapons, cloaks, fine woven mats, and birds and kao kūmara in gourds incised with patterns. Tohunga whaiwhare, expert builders, were called upon to construct these pātaka with as much care as for carved houses. Toki tārei, or stone adzes, were used to split and shape tōtara logs into wall slabs. A coarse face was achieved with the ngao pae, while a more even finish could be achieved with the ngao tū. The smoothing of edges followed using tahi, or quartz river stones.

Four or six carved posts were embedded in the ground, with a 1.2 metre elevation, and positioned before huapae were laid with kaupapa lashed to them. A longitudinal rod or batten was laid on the floorboards on either side and lashed to the beams between the floorboards. The huapae, also called kaho paetara, extended the length of the side walls to form a plate where the walls met the roof, to which tōtara wall slabs were secured with aka kai vines. The side supports of the house projected a short distance at each end to form papa kiore, and sometimes notches were cut in the piles to further obstruct the rats. The arawhata for access to the storehouse was removed after use as a further deterrent.

A tāhuhu provided support for heke, which were made fast to the roof framing. Roof thatching of toetoe was laid on battens — kaho paetara — and covered with tōtara bark secured with vines. A mahau or verandah and porch was created by setting the front wall back from the edge of the roof, both the front and back walls of the pātaka being cut in an oblique manner at the upper edge to accommodate the shape of the gable roof. Tōtara roof bark and toetoe reeds were collected for embellishing the side walls of the mahau.

The enclosed mahau was fronted with amo, which supported the frontal maihi or bargeboards. Around the verandah were the wall slabs or poupou, the tekoteko and whakawae. The outer threshold, called the pae kai āwhā, together with the external pātaka elements, were even more elaborately carved than the meetinghouse. The pātaka was painted with kōkōwai mixed with shark oil and the pakakē, a whale, was often found carved on the maihi, along with tiki and manaia forms filling the frontal surfaces. Battens between the front panelling were often embellished with feathers inserted under the plank lashing.[16] Other aesthetic enhancement included painted kōwhaiwhai, albatross feathers, tukutuku panels, and whāriki or floor mats. Pātaka averaged nine metres long by three metres wide and were often named after important tribal ancestors. At their ceremonial opening a human sacrifice was offered to ensure the goodwill of certain gods, including Rongo-marae-roa, the god of agriculture.[17]

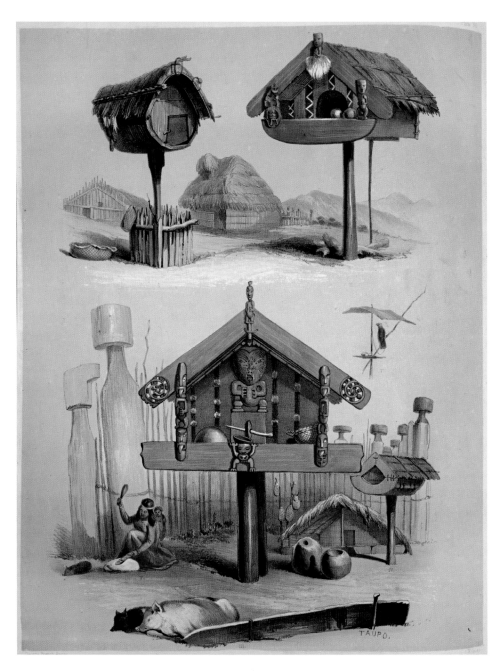

Three elevated storehouses are shown in this Angas drawing: the first is a plain whatarangi made from a canoe hull for holding seeds, with a rua kai in the background. The bottom pātaka whakairo is elaborately carved, and would have stored the most valued possessions.

[Alexander Turnbull Library]

Waka kōiwi, whata kōiwi — burial structures and bone containers

After the death of an important ariki, or chief, the tūpāpaku was bound in a sitting position and placed in the porch of the meetinghouse, where his passing was mourned in a tangi ceremony lasting many days. Weeping and lamentation continued while women showed their grief through the practice of haehae, lacerating their bodies with shards of obsidian. After the nehu, or burial ceremony, the body was often interred for a number of years. Sometimes the bones of an important chief were laid in a papa tūpāpaku, an ornate tomb built within the defences of larger pā. Other bodies, trussed in the sitting position with knees against their chest, were interred in caves. Some tribes mounted the corpse on an atamira, a burial stage, erected so that birds would remove the flesh from the bones.

The hahunga tūpāpaku ceremony involved exhuming the body and scraping, oiling and painting the kōiwi with kōkōwai. The bones would then be wrapped in takapou, fine mat coverings, and cloaks that had been in contact with the body, and laid on the marae where speeches were made in their honour. A technique called pakipaki existed for the preserving of heads, particularly for important chiefs who had died during a campaign so that it was only possible to bring the head home. A detested enemy chief might have his head brought back to be reviled in death. As these were chiefs, the heads were usually tattooed. The preserving technique included removing the eyes and tongue, extracting the brain and stretching and stitching the skin of the neck to a small aka hoop. The head was wrapped in leaves and placed in an earth oven where it was dried by the smoke.

After the hahunga ceremony, the bones might be placed in a special tomb, ana, swamp, hollow tree, whata kōiwi, or waka kōiwi — also called papahou in the north. When bones were buried in a cave, they were termed toma and rua kōiwi. Swamp burial required the wrapping of the body in mats and pushing it into the mud. Sand burials were favoured by coastal tribes, but this carried the risk that the bodies might later be exposed by strong winds. In the Urewera, burial in hollow trees, such as pukatea, was common, as also was the use of platforms in trees.

The whata kōiwi was a waka-shaped structure made to store the bones of the deceased. Whata kōiwi were constructed like other whata but sat closer to the ground. They were embellished with care, the wood being carved and kōwhaiwhai painting added. Sections of canoe hulls containing bones have been found in caves, as well as a range of specially made waka kōiwi, or burial chests. These are shaped and carved to represent figures, with a large hollow body and small head and limbs. A lid at the back of the body sealed the bones inside. Some very old waka kōiwi are of a simpler carved form with a peg to secure them to the earth. Later examples of waka kōiwi show a distinctive carving style associated with the North.

Kāore te aroha ngau kino i roto rā, *Alas, the bitter pain that gnaws within,*
Ki te waka i pakaru, *For the canoe that was wrecked,*
Ki te hoa ka riro. *For the friend who has gone.*[18]

Papa tūpāpaku or tombs were erected for the burial of important chiefs, serving first to inter the body and, later, their bones. Some were built simply to commemorate an important person; Te Wherowhero, paramount chief of Waikato, had a tomb built in the 1850s to commemorate a beloved

daughter. This memorial had a thatch-covered sloping roof that sheltered a number of carvings and sides faced with well-presented toetoe reed panelling.[19] A pou rāhui or marker post that defined wāhi tapu would also be erected to commemorate the place where an important person died, as well as on the boundary of the burial site or tapu land in general. These were usually carved from a large slab of tōtara with one or two tiki figures and covered with kōkōwai paint. A number of these monuments to important chiefs that were recorded in the early 1800s had been made from the bow portion of a waka hull with the addition of painted kōwhaiwhai patterns.[20]

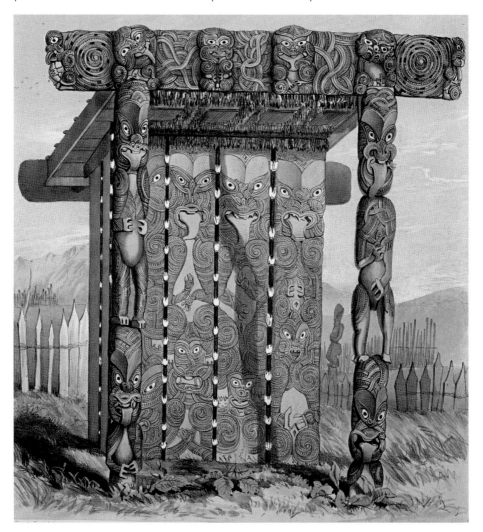

Papa tūpāpaku, tomb and memorial, which Waikato chief Te Wherowhero had built for his daughter at Raroera Pā, c1847. The thatched roof sheltered detailed carvings and side walls that were faced with toetoe reed panels.

[Alexander Turnbull Library]

Waka — canoes

Māori sailed vast distances to come to Aotearoa, New Zealand. However, once they were settled here the evolution of their canoes favoured coastal travel rather than ocean navigation and power by paddles rather than sails, although sails might be used if the wind was favourable. All canoes had similar basic components including a dugout hull, side-boards or wash strakes, carved bow and stern fixtures, and cross thwarts to keep the sides at the correct distance apart.

Waka unua or hūhunu were double canoes, with two distinct hulls lashed a distance apart by kīato, or cross-booms, and a deck laid on top. These were better suited to long-distance travel and, although observed by Tasman and Cook, by the end of the eighteenth century they had become redundant. Māori canoe builders were instead using huge tree trunks to make broader monohull vessels that might or might not have an ama, or outrigger, lashed to the port side with two curved kīato. Three types of single hull canoes can be identified: Waka tīwai —simple, dug-out hulls, used in lakes; Waka tētē — seagoing all-purpose canoes up to 15 metres in length; Waka taua — war canoes of 23 metres or more, with elaborate carving.

Waka tīwai were small dugout canoes used on rivers, lakes and in sheltered coastal waters. They had no rauawa or side-boards, and were usually made in one piece. Waka tīwai were still common in the 1930s, especially in regions like Whanganui where they were used for river and lake fishing, food gathering, transportation and races. They averaged nine metres in length, could carry up to six people comfortably and were usually without patterning. Some, however, had simple kōwhaiwhai patterning and others were stained red with kōkōwai. They were shallow canoes shaped upward at the prow and stern, but relatively prone to tipping.

The all-purpose canoes, waka tētē, were used mostly for fishing and general conveyance. They were made to cope with rough water by the addition of the rauawa lashed to the upper edge to give them greater freeboard. The seam joint was covered with an inner and outer batten, lashed to the conjoint structures. One or two haumi were added, depending on the size of the available tree. A tauihu or bow piece might be simply carved as a face, and a transverse washboard was added to turn back the bow wave. A taurapa stern piece, usually uncarved, was fitted to the rear section of the waka tētē. The plain face form on the haumi was known as tete, pakoko or pākurukuru, with the name waka pakoko often used as an alternative to waka tētē.

The third type, the waka taua, could exceed 30 metres in length and would take a number of years to construct. Made from the trunk of the tōtara, or kauri in the north, they consisted principally of a long middle hull section. A tree with minimal imperfections was selected, to avoid structural issues later on. To hollow a log for the waka taua, small fires were kindled along the trunk as far as the riu, or hold, was to extend. After a period of burning these fires were extinguished and the charred wood was chipped away with stone adzes. A surface to be adzed was scored across the grain and the timber hewn off in line with the grain — a splitting process. A toki tīwara was the heavy adze for this purpose. The inside of the waka was adzed smooth and finished with sandstone or sharkskin that acted like sandpaper. Flooring methods and materials varied, but consisted of rods laid longitudinally, supported by pae or cross pieces. Women and children were not allowed to approach a canoe under construction; the presence of a woman was considered to break the protection of the atua.

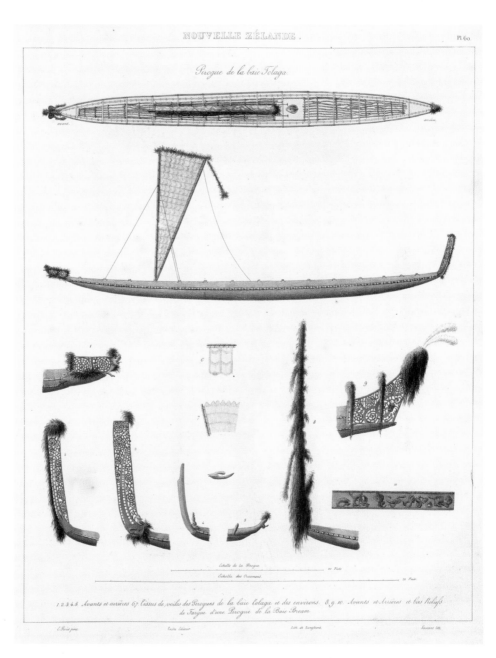

Pirogue de la baie Tolaga

1.2.3.4.5. Avants et arrières 6.7. Tissus de voiles des Pirogues de la baie Tolaga et des environs. 8.9.10. Avants et Arrières et bas Reliefs de Targue d'une Pirogue de la Baie Bream.

Detail views of sail rigged (and sail furled) waka taua with tauihu and taurapa details.
The waka pakoko with simple mask head is also detailed, as well as the placement of
streamers and feather ornaments for both types of waka.

[Alexander Turnbull Library]

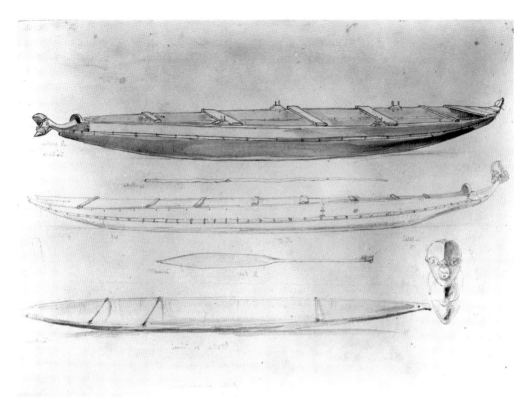

Two waka tētē are distinguishable by the parata carved figurehead on the haumi and the addition of the rauawa lashed to the upper edge. The waka tīwai (below) is a dugout canoe made from one piece, suited to lake and river usage, 1844.

[Alexander Turnbull Library]

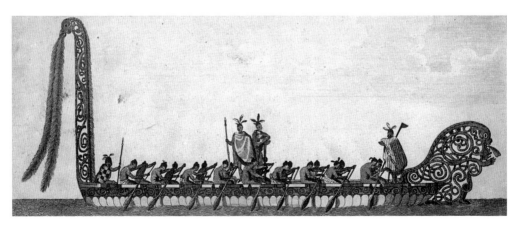

This carved war canoe shows the power of synchronised paddling. Elaborate carved canoe prow and stern carvings are a notable feature as are feather streamers affixed to the stern.

[Alexander Turnbull Library]

The outside of waka taua had wide grooves made with the toki umarua, the double-shouldered adze, so it would slip smoothly through the water. Two haumi sections were attached, the tauihu for the bow and taurapa the stern. Mortice and tenon joints called haumi kokomo fixed the pieces together, the mortice being on the hull section. The join was covered with raupō pads. The tauihu was large enough to carry full figure forms that followed particular design conventions. The taurapa was of an extended height, and also carried carved forms.

The hulls of waka taua were painted red, except for the kōwhaiwhai designs applied to the underside of the bow section of the hull. This was commonly the pūhoro pattern, signifying speedy passage. Carving was applied to the length of the rauawa and sometimes on the taumanu (thwarts) where high-ranking chiefs were positioned.[21] These carvings were among the very best executed, as befitted the prestige of the waka taua.

Kōwhaiwhai designs were painted on the bow section of the hull, and the waka taua was further visually enhanced with streamers of feathers floating from the stern, and ihiihi or hihi, antenna-like projections of mānuka with long circular feathered ends called karu atua — the eyes of the gods. Other equipment associated with the waka included hoe, hoe urungi or steering paddle, tatā or bailers and punga, anchors.

Waka taua might be equipped with plaited mamaru or rā — sails — that were controlled by line shrouds. The rigging of sails was completed in two ways, either vertically (spritsail), or slanting (lateen sail). For a spritsail rig, the sail was attached permanently to a mast and sprit, the mast being stepped in a rope ring grommet seized with a small cord and lashed to the side of a thwart. The mast was steadied by shrouds on each side, with the forestay and backstay also attached to thwarts. Movement of the sprit was achieved via a loose rope ring attaching it to the mast. The sail was manoeuvred by a rope, or sheet, tied to the sprit and in lowering the sail it would be furled with the sprit attached to the mast. The entire mast with sails could be laid along the middle. The mast would be stepped in different ways according to whether one, two or three sails were used.

The slanting rig, or lateen sail, was called rā kaupapara. It was attached to an upper spar or yard, and to a lower boom. A short mast was stepped at the bottom of the hold, supporting the sail with the apex at the bow to form a low angle with the waka hull.[22]

Mending split canoes was done with raupō down, and by boring holes in either side of a split so a batten could be lashed to cover the fissure. Lashings were countersunk on the outside — a process that was used to lash haumi, the bow and stern additions, onto multiple-piece waka. A hole would be repaired by inserting a piece of wood to act as a plug, a process called rau tawake.[23]

The waka taua as a symbol of tribal mana or prestige and unity was re-established by Waikato tribes for the Treaty of Waitangi centennial celebrations. A kaupapa Māori project for the 1990 sesquicentennial Treaty of Waitangi celebrations saw waka taua created using a full range of old and new materials.[24]

Whare whakairo and whare tupuna — the ancestral meetinghouse

The marae we know today as a reasonably large permanent house is a relatively new development. The accommodation of guests in the chief's house (which was on a smaller scale and had simpler carved and painted accents), or in temporary structures, used to be more common practice. By the nineteenth century however, Māori had established a lifestyle around permanent kāinga or pā settlements, and within these the whare whakairo, along with the marae ātea, an open space in front of it, became the single most important element.

The entire community was involved in the building of a whare whakairo, even if it was simply to supply food for the workers. The ground was levelled in preparation for the house and carefully measured off. Twenty metres or more in length, with a far more solid framework than the whare puni before it, the whare whakairo needed expert builders to construct it. Pou tuarongo and pou tāhū (back and front support posts) were formed from halved tree trunks and carved with human figures. They supported a massive timber tāhuhu, a ridgepole piece that spanned the entire length of the roof and was raised to the tops of the support posts with the aid of an inclined scaffold and supporting struts. The tāhuhu projected beyond the front support post to become the roof of a porch. One or two poutokomanawa supported this heavy main roof structure and were carved as a human figure at the base. Sidewalls called pakitara were supported by carved ancestral poupou, thick slab wall posts up to a metre wide. They were embedded at the base into the ground and leaned inward to counter the thrust of the rafters. Whare whakairo were fairly low structures, no more than two metres from the floor at their highest point. All wooden structures were carved except the narrower areas that were reserved for kōwhaiwhai painting. Thatching of kākaho and aka was positioned between the carved poupou, and evolved to include the tukutuku decorative pattern features. These features supported the narratives on the ancestral poupou. The structure and symbolism were similar to the non-elevated pātaka, but more expansive and on a larger scale. This extent of artistic evolution in the meetinghouse can be understood in terms of the extent of whakapapa representation, and the relationship of the whare tupuna to the mana of the chief and the tribe.

The construction of the whare tupuna was mainly of wood — earlier tupuna houses were probably minimally carved and built of undressed wood. The house itself may be seen as the symbolic embodiment of an important ancestor, his head presented on the koruru at the apex of the bargeboards where another important ancestor stands as a full tekoteko figure. The maihi or bargeboards at the front of the house are his arms, which end in raparapa, or fingers. The porch area is known as the roro or brain, and the inside is the poho or belly — as indicated in many houses by the term 'Te Poho o (Tiakiwai)'. But other tribes, Whanganui for example, see their houses as upturned waka, and the house names refer to an incident rather than an ancestor.[25]

The main construction of the whare tupuna began with the pou tuarongo and pou tāhū, or rear and front supports, created from halved tree trunks and supporting the major structural item, the massive timber tāhuhu. Both these supports had important atua associations, with Tāne Mahuta in front and, at the back, Hine-nui-te-pō, recipient of the souls of the dead. The tāhuhu ridgepole, spanning the entire length of the roof, was raised into position with the aid

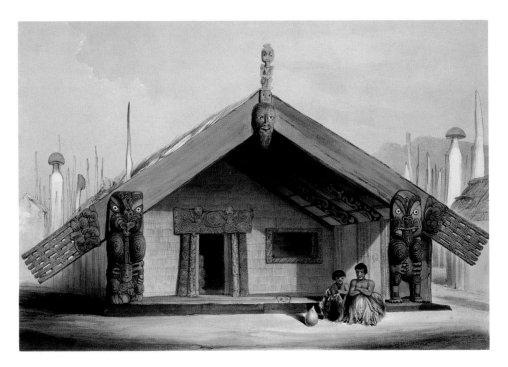

This whare whakairo, carved meetinghouse, has carved lintel, support posts and gable figures. The carved gable mask is said to represent Te Rangihaeata who is thought to have carved the house.

[Alexander Turnbull Library]

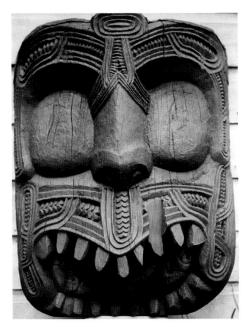

The koruru, the 'eyes' of the meetinghouse, represents the main ancestor of the house and is presented on the apex of the maihi, the arms of the ancestor. Kotahitanga meetinghouse, Levin, c1863.

[Alexander Turnbull Library]

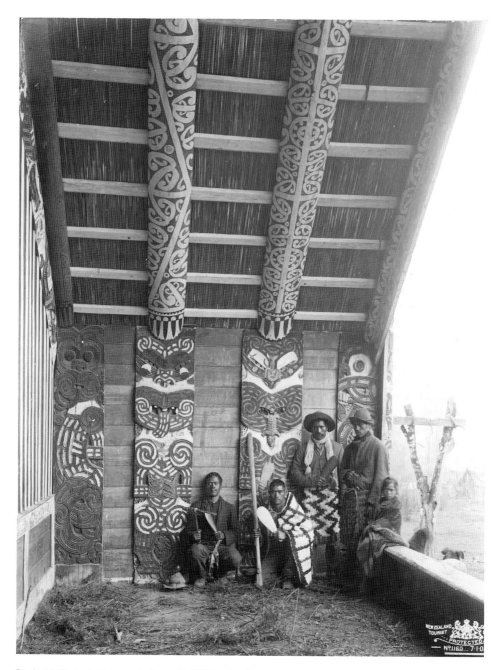

Porch of Te Whai-a-te-Motu meetinghouse, Ngāi Tūhoe, Ruatāhuna, built in 1888 to commemorate Te Kooti Arikirangi.
The painted accents of the carvings are a new feature and the kōwhaiwhai designs hide figurative references within the
pattern arrangements. Photograph taken c1903.

[Alexander Turnbull Library]

of an inclined scaffold and supporting struts. The tāhuhu links the important genealogical relationships through to the heke or ribs of the ancestor — all linked by the kōwhaiwhai design elements. The tāhuhu projected beyond the front support post, where it was often carved with figurative forms representing Rangi and Papa, elements which functioned as the main support for the roof of a porch. Heke tipi, the facing boards linking the porch end posts with the tāhuhu, were also covered with kōwhaiwhai elements.

One or two poutokomanawa with carved figures at their base were spaced along the tāhuhu to add support to this heavy roof structure. Sidewalls called pakitara were supported by carved ancestral poupou, thick slab wall posts of up to a metre wide. They were embedded into the ground at the base and leaned inward to counter the thrust of the rafters. The poupou had a central slot at their top end to take the teremu, or tongue, of the heke, forming a mortice and tenon joint.[26] Cables called tauwhenua ran up each poupou, along the top of the rafters and down to opposite poupou to provide structural support to the framework.

A distinguishing feature was the trouble taken to hide lashings, as opposed to the Polynesian tendency to display lashing as an aesthetic feature. Mortice and tenon joints, and face and edge eyelets, were preferred to direct holes so that the internal structures remained clean, while facing boards disguised any evidence of building techniques. It is likely that these evolved from canoe technology — slotting parts together to a watertight fit, and ensuring no lashings were exposed to abrasion — as appropriate to the solid building systems required in a colder climate. The tendency to hide the structural method in houses made the transition to Western building techniques an easy one since the new materials and construction methods didn't interfere with the aesthetics of the house.[27] The outside thatching was constructed on a line of light posts outside — the horizontal support battens called kaho paetara and the vertical tūmatahuki for the lattice panels. It is important to remember that not all houses were fully carved, and that a large number of predominantly painted houses were erected in the late nineteenth and early twentieth centuries.

The whare tupuna Te Tokanganui a Noho was built under Te Kooti's instruction during the 1870s in the King Country from native materials and according to Māori building conventions. It was a large house, at 25 by 11 metres, but its unique innovation was the use of painted and naturalistic features throughout the house. Structural changes to the house have occurred, however, as a consequence of numerous moves and restorative procedures. Typical of this period, European reconstruction has occurred in the form of a corrugated iron roof, weatherboard walls, concrete verandah floor and other minor features.

Introduced European technologies increasingly became a feature of meetinghouse construction from the 1880s.[28] Timber used in building meetinghouses was now pit sawn and shaped with European tools. Copper nails replaced flax cording and lashing and European joinery techniques were introduced. Larger houses were built to accommodate more people and wall heights were based on Western norms. Rituals related to tree felling and adzing became less relevant and payments that had previously been made in food, and goods like feather cloaks and greenstone pendants, were now made in Pākehā trade goods and money. The biggest architectural change has been the separation of artistic elements from their original structural function. This is the result of Western building systems and materials.

Temples and church buildings

The first Anglican mission, established by Samuel Marsden in 1814 in the Bay of Islands, used adaptations of Māori whare puni. Later, the missionaries made their own timber-framed European-style buildings but used local materials: raupō roofs, tōtara-adzed beams and basalt walls. Schoolhouses and mission station cottages were erected in a similar manner with ledged and framed windows and doors that slid open. When meetinghouses were destroyed during tribal wars, their replacements showed a marked Pākehā influence, especially those rebuilt by Christian converts. More than one window was included, and light-beaded timber planking began to replace reed walls.

Rangiriri church is a good example of the influence of religious buildings on Māori architecture. It was the last of its type to be built entirely of native materials in the late 1850s under the directive of Anglican missionaries from Taupiri. It was timber-framed, 17 metres long by 8.5 metres wide with a relatively low-pitched roof of raupō and vines in the old tradition. The style, however, was modelled on the Taupiri mission church. The classic meetinghouse porch was absent, and the door was added to the longer side of the church. Glazed gothic windows set into the walls and secured by mānuka and vines were a unique feature. The outside was relatively plain apart from white painted window frames and black dyed panels of raupō around the windows. Kōwhaiwhai painted panels were the only artistic feature inside. The church was abandoned, however, when the Waikato wars broke out and Māori converts rejected missionary teachings.

The Pai Mārire temple was a significant religious building erected by Māori and based on syncretic Māori and Christian doctrines. Demoralised survivors of the New Zealand Wars formed a religious movement called Pai Mārire — Good and Peaceful — founded by Te Ua Haumene. In 1887 they built Miringa te Kakara, a temple at Te Tiroa in the King Country. The temple was built without nails or iron products and was distinctive for its cruciform floor plan. Two tōtara ridgepoles were crossed at right angles in the centre with collar and tie roofing, each section six metres deep with a door facing each cardinal compass point. It followed the design conventions of Māori porches, each verandah being five metres wide by two deep, with a small door and window. The house effectively combined four house fronts, each with a total north to south length of 17 metres. A strong tōtara frame was overlaid with tōtara bark, and hardwood battens called kuku were overlaid to form a crosshatch patterning. Pai Mārire followers dictated that the temple be built without exterior carvings or paintings. A unique European feature was guttering made from adzed timber, set between the sidewalls and exterior rafter supports. Members of Ngāti Maniapoto, familiar with both Māori building techniques and European carpentry conventions, built the house under the direction of Pai Mārire leaders.

Another significant temple was constructed by followers of Rua Kenana in 1908 in the small settlement of Maungapōhatu in the Urewera. Rua's Temple, Hīona, was constructed from milled timber in a unique two-storeyed circular design. It was over ten metres high with a diameter of 15 metres and an outside platform pulpit. The roof was tōtara shingles, and there were two rows of unglazed windows along the front of the building. The exterior walls were white with coloured paintings of kōwhaiwhai and playing-card symbols. Inside were rafters with kōwhaiwhai and tāniko modified painted designs.

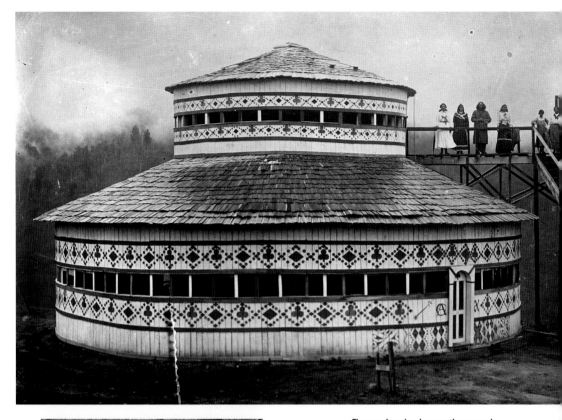

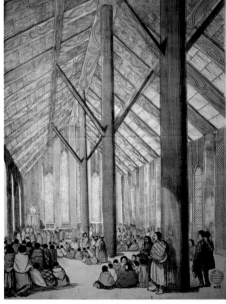

The wooden circular courthouse and meetinghouse, Hīona (or Zion) at Maungapōhatu, c1908. Blue clubs and yellow diamonds on the outer walls were inspired by playing cards and were used as mnemonics for the scriptures.

[Alexander Turnbull Library]

Rangiatea church was first built at Ōtaki Pā in 1844 but was not completed until 1851. Based on European architecture it also featured kōwhaiwhai painted rafters, large tukutuku panels and carved features, including a carved pulpit.

[Alexander Turnbull Library]

CHAPTER 5

Sculpted and Carved Arts

Hanga whakairo — carving and sculpted forms

'Whakairo' as a noun means 'a design', and as a verb 'to ornament with a pattern', and it can be used in the contexts of carving, tā moko, raranga and painting arts. Whakairo rākau more precisely describes woodcarving, but the term whakairo tends to be used to signify carving in general, although wood was not the only medium sculpted. The development of larger settled communities as well as the availability of superior materials for tool-making, and an ample supply of straight-grained timber, facilitated sophisticated developments in carving.

The Rua-te-pupuke legend from Ngāti Porou tells of the knowledge of whakairo being attained from Tangaroa, god of the sea. Rua-te-pupuke's son Manuruhi was kidnapped by Tangaroa as he fished with a magic hook made for him by his father. Tangaroa took Manuruhi, firstly because he failed to seek the god's permission by reciting karakia, or sacred incantations, secondly, he fashioned Tangaroa's sacred stone into a fishhook, and thirdly, because he failed to make an offering of his first catch to Tangaroa. Rua-te-pupuke, devastated at the loss of his son, sought and found Manuruhi as a tekoteko on top of Tangaroa's wharenui. The poupou carvings located inside Tangaroa's house could speak, while the poupou on the porch outside could not. Furious with Tangaroa, Rua-te-pupuke sought advice from a kuia, an elderly woman, on how to avenge his son's death. Blocking the window and door in Tangaroa's wharenui so that daylight did not shine through, Rua-te-pupuke waited for Tangaroa to return home at night with his fish children. Rua-te-pupuke uncovered the doorway in daylight and vanquished Tangaroa's children. He then destroyed Tangaroa's wharenui, taking with him the mute carved poupou from the porch and the tekoteko in the image of his son, which became templates for whakairo.[1]

Carving therefore was governed by tapu, ritual restrictions that served to protect the artists, the intended users, and the community from harmful forces. Karakia were recited to Tane Mahuta, atua of the forest, for permission to fell the tree to be carved. Food was forbidden where carving was in progress, but a huge feast normally took place when a large carving project was completed. Chips and shavings were to be brushed, not blown, away from work, and those chips were not to be used to fuel a cooking fire. European influence made some of these prohibitions obsolete, but others continued, while the adoption of tobacco smoking necessitated a new restriction.

Woodcarving is probably the most spectacular of the arts, and the best known due to the huge range of carved objects, the representation of ancestral figures and the associated symbolic weight carried by those objects. Carving, through items such as waka and pātaka, maintains a strong design relationship with the other art forms. Although the medium — stone, bone or wood — may have determined the specific scale and elaboration of carving design, the basic conventions remained the same for all carved sculptural forms.

Stylistic distinctions peculiar to particular tribal areas evolved, leading to recent attempts to classify unique tribal areas.

> Kāore a te rākau whakaaro, kei te tohunga te whakaaro
> *The design is not in the wood, but in the mind of the artist.*[2]

Early Māori carving was conceived, first and foremost, sculpturally. The raw material was used in

its entirety. The discarded blades of toki and whao — adze and chisel — were reworked into hei tiki and rei, or non-specific pendants. The natural form of the wooden post or slab also determined sculptural structure, and a certain depth of wood was looked for to achieve particular relief effects. The skill in executing sculptural content was particularly evident in the notional ambiguity of body forms and the layering of figures achieved by depth of adzing. In the Taranaki style of carving, this depth allowed sinuous figures with hands passing through mouths from the rear, and several layers of figures ambiguously defined and overlapping the main figures. Rauru, or spirals, seem to burst from the surface, and in larger objects such as the tauihu or prow, the takarangi — literally, giddy — spiral is pierced creating a contrast between mass and void.

The importance of sculptural integrity is particularly evident in items such as mau rākau. The taiaha, or double-ended weapon, for example, must be sculpted for careful balance, have an efficient mata, or point, and rau, or blade, in which are ingeniously incorporated a carved upoko or head with arero, or tongue, visible.

The system of apprenticing carvers within families began to change in the twentieth century, particularly in 1928 with the establishment of the government-funded School of Māori Art at Whakarewarewa, Rotorua. Since then broader carving education choices have modified practices, yet the major change is in the diminishing ability of Māori communities to sustain traditional carvers while at the same time market demand has seen commercial carving practices flourish. However, whakairo retains a relatively high status among Māori compared to other art forms because of its enduring ability to communicate important historical knowledge and philosophical values.

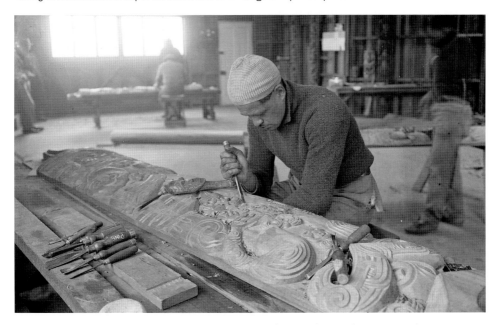

Pine Taiapa, with steel chisel in hand, works on a large carved wall slab for the Kahungunu meetinghouse, Nuhaka, c1940.
[Alexander Turnbull Library]

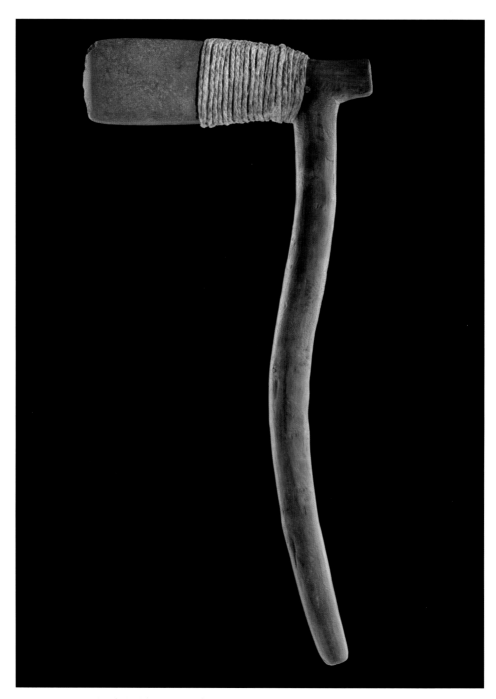

A pre-European stone adze, or toki, used for chipping and flaking
stone. The blade is hafted to a wooden handle by binding plaited muka.

[Museum of New Zealand Te Papa Tongarewa]

Taputapu kōhatu — the stone tool kit

The most important early carving practice was the making of stone tools, the essential toolkit of the carver. The shaping of blades from stone — toki and whao, the main tools of carving and building — was an involved process. The discovery of pounamu, or nephrite jade, in the South Island was important to tool-making, and the result was an accuracy of cut similar to that of later metal tools. Tools were made from pounamu, ōnewa (a dark grey basalt), and kiripaka or matā — quartz, or other flint-like stones. Stone was required to effectively work stone. Quartz was sought after for use as drill points as well as for chipping and pecking tools. Layers of hard slate and schist were used for sawing and grooving. A hammer was used for the bruising process, made by binding a quartz stone piece to a wooden handle. Blades were sharpened using a hōanga, a grinding stone made of sandstone, and the mata for the toki was then hafted with a wooden kakau, or handle.

The stone to be worked was first hammered with small river boulders to break pieces off, and then sawn with a thin-edged stone with the addition of sand or grit, and water. Flaking struck off long thin flakes of stone, such as matā, or obsidian, to make knife-like implements. However, not all stone flaked satisfactorily — pounamu, for example. Chipping or rehu was a common method of reducing stone to smaller pieces for grinding. Pecking, or timo, was a similar process, using a pointed instrument to produce small breaks. Another process — toto, or bruising — involved constant tapping to reduce the roughly chipped surface to a more even one. The hōanga for sharpening might be portable; otherwise, the grinding occurred on large outcrops of sandstone situated near a water source. Finally the stone was wetted for polishing with whaiapu stones or pieces of wood such as houhere (lacebark), with its netlike texture. Houhere was soaked in shark oil prior to being used to polish pounamu, a suitable technique for small-detail polishing on objects such as hei tiki.[3]

This greenstone adze blade has a hole drilled to suspend it around the neck for safe transportation. Such blades were important to woodcarving and would be hafted to a handle when required for use. This one possibly belonged to a toki poutangata — a ceremonial adze.

[Museum of New Zealand Te Papa Tongarewa]

The cord-driven drill, hōrete or tuiri, was an essential tool for creating holes in stone to thread cord through for suspension and for lashing. The hōrete had a quartz or argillite tip lashed to the lower end of a stick approximately 20 cm in length, and was placed on a larger stone plate. Near the top end were two strings, one wrapped around the shaft close to the point of attachment, and the other string fully extended. A pulling motion caused the point to revolve while at the same time winding the second string tight. This backwards and forwards twirling motion eventually created a hole. Small holes were used to string hei tiki and kuru, or ear pendants. A chisel was used to make larger, squarer holes to fit lashing for wooden implements.

Kakau fitted to adzes were of four types: kakau tahi-maro, straight-handled and used for heavy work; kakau tukerangi, straight and then curved to stabilise the grip; kakau kaukaurangi, double-reverse curved to adze a hollow; and kakau ruku, straight with a sharp curve at the end for chipping away charred wood. The tauhere technique used to fix the mata to the kakau varied according to the handle type; however, the joint was always by way of tauhere.[4]

He iti toki, e rite ana ki te tangata.
Though the adze be small, yet does it equal a man.[5]

The esteem in which stone tools were held was related to what the humble adze could achieve, such as the carving of a waka taua. Many different names have been identified for toki, the common ones being: toki ngao pae — a large adze used for heavy work; toki ngao tū — a medium-sized adze for shaping beams and canoe hulls; toki ngao matariki or toki whakarau — a much lighter stone adze used for putting a fine surface on dressed timbers; and toki tahitahi — used for polishing a worked surface.

The toki pounamu was used to carve in higher relief, the carver standing over the timber while he worked it between his legs. Finishing was completed in lower relief with the smaller short-handled adze.[6]

Smaller blades were hafted to a wood handle to create the smaller straight-handled whao, also described as ripi if a tākuru or mallet was not needed to drive them. Whao blades were straight-edged, or rounded to a gouge form. These finer chisels were made of pounamu, finer-grained stones and sometimes bone. They were driven into the wood with blows of the tākuru made from wood or whalebone. The tākuru had a short handle and a flattened rectangular head for striking the whao, and even after the advent of metal tools the mallet remained essentially the same.

The shift from stone to metal tools occurred at different times in different areas depending on the level of contact with Europeans. Metal was obtained early in coastal areas from Cook and other eighteenth-century explorers. In the early nineteenth century missionaries brought metal tools as trade goods into the inland areas. Māori appreciated the resilience and cutting properties of metal, and began fashioning tools from whatever metal they could secure. Ship's nails, both copper and iron, were beaten to make chisels and flat hoop iron from barrels was turned into adze blades. European carpentry tools were modified to create toki, axes never being considered a suitable replacement. Nails were also fitted into the old pull-cord drill to achieve faster results.[7]

A modern carver's toolkit contains a wide range of tools, including whao wha rua or round

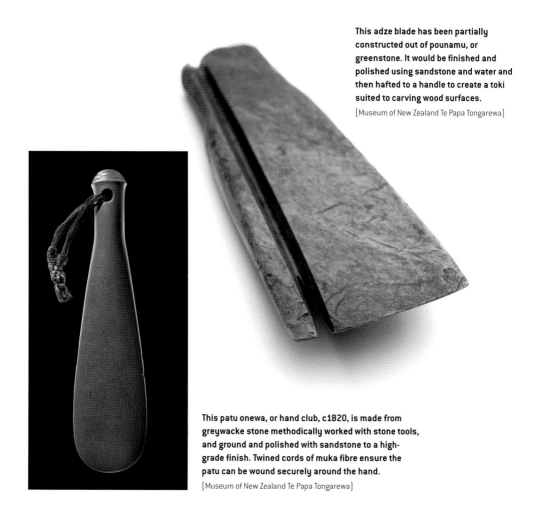

This adze blade has been partially constructed out of pounamu, or greenstone. It would be finished and polished using sandstone and water and then hafted to a handle to create a toki suited to carving wood surfaces.

[Museum of New Zealand Te Papa Tongarewa]

This patu onewa, or hand club, c1820, is made from greywacke stone methodically worked with stone tools, and ground and polished with sandstone to a high-grade finish. Twined cords of muka fibre ensure the patu can be wound securely around the hand.

[Museum of New Zealand Te Papa Tongarewa]

gouges, whao haehae or v-shaped gouges for grooves, whao papa or flat-edged chisels, and whao tīkaro, skew chisels for cleaning wood left in grooves and notches. Some carvers, however, are modelling their own metal adzes and chisels along the lines of those of old to achieve results specific to their own carving techniques. Modern tools are still considered tapu in the same way as traditional tools.

The toki poutangata was a ceremonial type of adze that signified rank. It usually had a tiki figure carved above its handle and turned outwards with a manaia present. A hole was made at the end of a long narrow pounamu blade with which to secure the lashing, after which attention was paid to a patterned lash. A small mask face was usually carved into the far end of the handle. These toki were finished to a superior level and the finely carved wooden handles were aesthetically enhanced with the hair of kurī and the red feathers of the kākā parrot. They usually had long, thin blades as opposed to the more functional type. There is a belief, however, that the toki poutangata may have been used in war to deliver the death-blow to distinguished enemies.[8]

Taonga whakarākai tawhito — early stone, bone and tooth ornaments

Stone carving has been found in a few North Island rock sites as incised lines and engravings of carved figures (both lizard and human-like) on sandstone walls, and at Kaingaroa there are a number of canoe engravings with spirals. Stone carving is directly related to bone and tooth carving, sharing the same process and tools, and therefore very similar in style. At Wairau Bar, however, an extensive find of small items presumed to be pendants and necklaces dating from the twelfth to fourteenth century has helped to identify the breadth of sculpting in hard minerals, ivory and bone. Their age is indicated by their form and patterning, and from associated archaeological evidence at this location. Some items recovered are identical to those of the same period found in East Polynesia, and others have forms and/or motifs in common. An early find from the far north, at Houhora, includes a range of ivory and bone reel forms, an ivory imitation of a whale tooth pendant, drilled teeth of seal, dog and dolphin, bird bone beads and shell pendants. The objects found at Wairau Bar were grave goods buried with human remains, a practice that appears to have been commonplace.

Examination of early materials can indicate the antiquity of an object, particular materials being favoured over others during certain periods. Wood items may have been carved at this earlier time, but — like fibre and feather items — would not have survived. Teeth were used unmodified with holes for suspension, but also alongside imitation whale tooth forms in ivory, bone and stone. These items were fashionable for several hundred years in Aotearoa, and common in finds dating up until AD 1800.

The teeth of dolphins, whales, seals, dogs, sea elephants and sharks, particularly the mako, were used as necklaces or ear pendants. Bones used included moa, whale, human, bird and dog, as well as fossil shell in pendant and necklace units. Ivory was recovered mainly from beached sperm whales. Small teeth were left in their natural shape while others were intricately carved. Seal teeth were drilled for suspension or made into beads, while sea elephant teeth were sculpted into reels or tooth pendants. Sperm whale teeth with suspension holes were used as central pendants on ivory or moa bone reel necklaces, all apparently precious enough to be buried with their owner. Human bone was used in necklaces and then later as double bracelets, suggesting that many pieces found may have been reused in different ways.[9]

The sculptural use of the mineral serpentine from the Nelson district (also found at North Cape) dates to the fourteenth and fifteenth centuries, whereas pounamu (as discussed below for hei tiki) certainly dates back to eighteenth-century use.[10] Bowenite, a particular variety of blue/green, almost transparent serpentine, called tangiwai, was popular in later personal adornment. The raw stone was found only at Anita Bay near the mouth of Milford Sound, and Poison Bay, south of Milford.[11] Pākohe, or argillite, and ōnewa were also occasionally used. Serpentine, being a soft metamorphic rock, was popular for ornaments, with soapstone from the same rock family also being used. Similar to jade in geological terms, but not hard enough for tools, serpentine colouring ranges from black through to green, with areas of blue, grey and white. Serpentine was fashioned both into whale tooth shapes and the other forms that whale teeth were used for. One particular serpentine example found at Fortrose, Southland, has been carved as a whale tooth pendant and

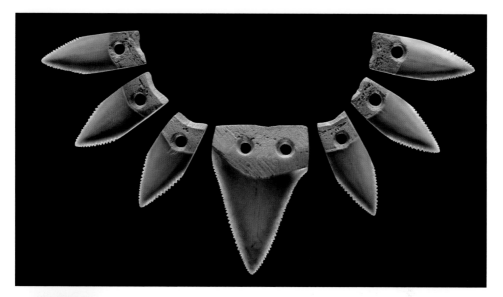

Serpentine mau kakī, a reel necklace unit, dates to the period of earliest occupation. Two ridges are visible and these are notched along their edge.

[Museum of New Zealand Te Papa Tongarewa]

These teeth are from the great white shark and the seven together comprise a single necklace unit. The six smaller pieces have been ground down and reshaped, and all pieces have had holes added for suspending. These are associated with early archaeological sites dated 1100 to 1500.

[Museum of New Zealand Te Papa Tongarewa]

weighs just under two kilograms. Another of a later period from a Waitotara burial ground has a Polynesian-style human face set forward of a tapering pendant body with chevron notches down its length, and is important in the evolution of figurative forms.[12]

Serpentine reels have mostly been found on their own, commonly shaped with three ridges along their form and a hole drilled through the centre for a cord. Others have two to five notched ridges. The majority of chest ornaments, referred to as pectoral pendants or amulets, are made from serpentine. These are carefully ridged along their circular outside edge, some with unique surface patterning and with the addition of three or four holes along the upper edge to lash to a suspension cord. The pendants range in size from 100 to 164 mm across and weigh up to 600 grams. Other exceptional serpentine objects found include partially symmetrically divided spheres, thought to relate to testicular pendants found elsewhere in the Pacific. One has evidence of a pattern of grooves in the centre where a detailed lash probably allowed a cord to be attached without the need for a hole through the main form. Reels were also made from pumice and shell, including sub-fossil dentalium, a type of tusk shell. Bird bone beads and fossil shell pendants were in continuous use until the late eighteenth century, strung in necklaces and anklets and incorporated in woven bands worn as wristlets or anklets.[13]

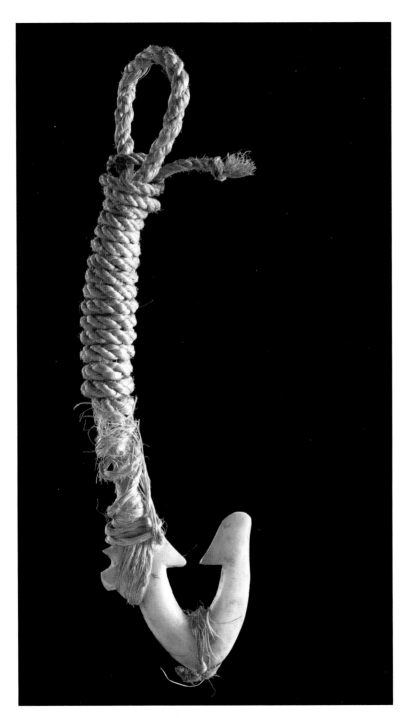

Bone fishhook with lashed muka onto a muka twined rope.

[Museum of New Zealand Te Papa Tongarewa]

Matau and hei matau — fishhooks and fishhook pendants

Fishing was an important industry, the major food economy for Māori, and a ritualised activity that involved acknowledgement of Tāngaroa for the provision of food. The fishhook was a powerful symbol in tradition — for example, the magic jawbone Māui used to fish up Te-Ika-a-Māui, the North Island of Aotearoa. Replicas of the utilitarian fishhook were used by tohunga in their ritual ceremonies at the start of fishing seasons. Matau might have a small figure added to the shaft, both to potentiate their function and to provide a line attachment. Some matau were worn around the neck in preparation for fishing, a habit which developed into the deliberate carving of matau as powerful personal talismans.

A comprehensive range of species-specific fishhooks were developed to cater for the variety of sealife in the waters around Aotearoa. Matau for fishing were technologically sophisticated and yet functionally simple, usually made of two joined pieces: a shank and a point, with a bend between them. The mata or point might be straight and inward curved or barbed depending on the mouth of the fish species. A pūreke or knob on the outer, upper end helped keep the lashed aho, the fishing cord, in place. Early composite hooks from Murihiku were made of human and moa bone and showed a range of shapes according to the angle of their bend. Shark hooks often had wooden shanks called papa kau awhi. The kahawai lure had a wooden shank with pāua inlay, attached to a bone point, and was popular in the nineteenth century. The wooden shaft provided flotation while the pāua shell flashed as the hook rotated and attracted the kahawai to the barb. Both the barracouta and kahawai lures evolved to use metal points during this period.

One-piece bait hooks, usually of moa bone but also made of other bone, ivory and shell, have also been found at early sites. Minnow shanks of stone, bone and shell were made to resemble small fish and attract surface feeders such as kahawai and barracouta. Triangular sectioned and shaped shanks with dual holes for attaching to aho were made in stone, and occasionally bone or shell. A flat type of trolling shank allowed for attachment at the rear. A third type of lure shank was grooved or notched, allowing a different lashing attachment that withstood fish teeth.

Barb detail, possibly made from whale tooth, for a fishhook, c1800.

[Museum of New Zealand Te Papa Tongarewa]

Unbarbed one-piece hooks were by far the most common items of fishing gear in the northern regions, made of shell and still in use in the eighteenth century. The blanks for matau would be rectangular and cut from stone flakes, the outer waste removed by sawing or rasping and the inner by drilling first, then rasping. Many whalebone hooks made in this manner had one or two figures that were functional, the larger figure to lash the aho and the smaller one providing a place for latching the bait. The barb at the end was left free to catch in the gill rakers at the back of the fish's throat. Other carved fishing items include early harpoon tips (probably lashed to a wooden shaft) carved from moa bone, and the auika, a needle for threading fish onto a line, carved from whalebone and featuring a finely carved manaia on the handle end.

Matau evolved as stylised forms of the practical fishhook, plaited onto a cord and attached by lashing that functioned as adornment.[14] Personal hei matau, which acquired more sophistication as talismans through generations of carving, represented the importance of food provision, provided a focus for ritual, and symbolised abundance.[15] Whale material used for making these potent objects was considered a gift from the sea.

The creation of hei matau is commonplace today as an icon of New Zealand culture and used as a tourist collectible. Contemporary carvers in bone, stone and tooth come from a variety of backgrounds, not only a conventional carving base, but with a range of new skills in jewellery, art and design. Carvers practise on the less valuable beef bone that is particularly suited to matau. Ivory has two layers, a white enamel outer surface and the honey-coloured inner dentine. Pig's tusk, antler, and other types of bone and teeth and synthetic materials are also commonly used today.

Modern tools for hand carving include a range of small-bladed metal jewellery engravers, which can be custom-ground to create edges like customary whao and hafted with custom-made wooden handles.[16] Modern equipment includes coping and fret saws, sharpening stones, drill presses or hand-held drills, metal needle files, wet and dry sandpaper and electric polishers. Most carvers have moved to an electric workshop tool or high-speed rotary (dentist's) drill with interchangeable burrs that enable intricate surface designs to be achieved, and a point carver that acts like a lathe.[17]

This matau dates to around 1800 and has been carved out of whalebone, a highly prized material used in the creation of pendant ornaments.

[Museum of New Zealand Te Papa Tongarewa]

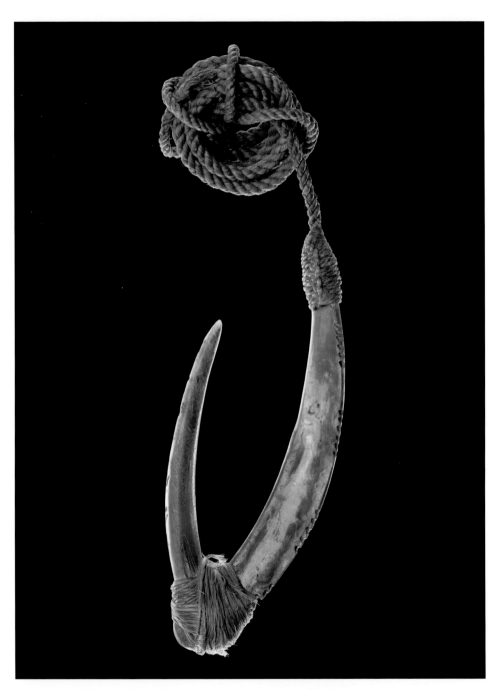

This two-piece trolling lure for kahawai is called a pā kahawai. A wooden shank is fixed
to the shaped lure made from pāua shell and attached to a bone barb. This particular
example is ornamented with a series of fine notches and bound with muka fibre.

[Museum of New Zealand Te Papa Tongarewa]

Hei tiki and figurative personal ornaments

The elaboration of symmetrical and figurative ideas suggested by early personal adornments evolved further in the chevron pendants of the fourteenth to sixteenth centuries. Made from whale teeth or bone, they developed from the earlier austere whale-tooth imitation forms. Chevron pendants suggested, in varying ways, intricate squat human figures, stylised figurative shapes, human faces, spinal cords, rib-like structures and small feet.

The figurative evolution is epitomised in the hei tiki, carved from whale tooth, whalebone or pounamu. Whale tooth and bone were particularly favoured for hei tiki, but became increasingly rare because of the reliance on stranded whales. Hei tiki became heirlooms owing to both the rarity of the material, and the laborious process of fabrication. They were considered to be powerful, protecting the mauri of both living and inanimate things. Hei tiki may have had a number of symbolic associations, among them the ancestress Hine-te-iwaiwa, who symbolised womanhood and the ability to bear children, and Tiki, the progenitor of mankind. Hei tiki were buried with their owners and after exhumation were reclaimed as tapu items because of their association with death. When a body could not be recovered, the tiki could serve as a substitute for focusing grief. Hei tiki were usually given personal names and alluded to in song and story.

Pounamu use for the production of stone tools has been dated to AD 1200, but it didn't become popular until around AD 1500 when it was increasingly seen as suitable for fine chisel blades suited to making detailed curved personal adornments. Pounamu subsequently became the material of choice for woodworking tools, weapons and personal adornment as well as being valued and traded as raw material.[18]

Māori used three main types of pounamu, named according to appearance: inanga (whitebait) — pearly white, blue-white or light green; kawakawa — the most common variety, a deep rich green colour like the kawakawa leaf, which might be flecked and speckled; and kahurangi (robe of the sky), with light streaks like clouds in an otherwise even, translucent light green. Lesser known varieties of pounamu include aūhunga, kahotea, pīpīwharauroa (breast of the shining cuckoo), raukaraka (karaka leaves) and totoweka (weka blood).

There are many narrative variations of pounamu origins, which essentially tell of a jade fish called Poutini that belonged to Ngahue, an ancestor in Hawaiki. Poutini did not want to be cut into pieces by Hine-tū-a-hōanga, the personification of sandstone, so together with Ngahue he fled across the sea to Tūhua — Mayor Island in the Bay of Plenty — where obsidian, valued for tools, was found. Hine-tū-a-hōanga pursued them around the country to important stone sites where they quarrelled with whaiapu — a stone for adzes — as well as matā and tūhua. Ngahue finally hid Poutini in the bed of the river Arahura, where he remains today. Pounamu was found in the South Island — Te Wai Pounamu — in mountainous, forested wild areas and wild isolated coastal areas.[19] The most accessible area was the coastal strip between Hokitika and Greymouth where the Taramakau and Arahura rivers carried the pounamu down from the Southern Alps. Inanga was most often found at the head of Lake Wakatipu.

The tiki figure seems to have developed to fit the constraints of the medium used, especially the whale tooth, and later the reshaped toki or whao. The hei tiki varied in style, shape, stance and form and showed regional stylistic differences. They were frequently exchanged and are

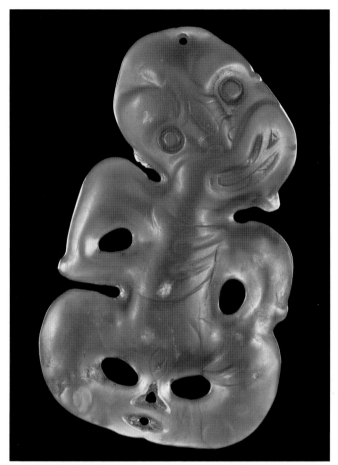

The particular form of hei tiki made from kahurangi, a pale variety of pounamu, represents the Bay of Plenty style. It is presented frontally but with a raised shoulder and hands that have three fingers and a spur thumb.

[Museum of New Zealand
Te Papa Tongarewa]

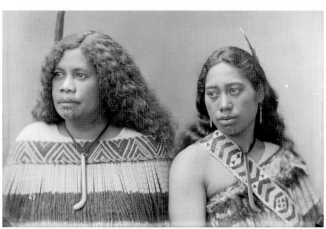

Both women wear the kapeu neck pendant, used for supporting the breast during breast-feeding, or used to cut baby's teeth. The kapeu was also prized as an ornament signifying rank, as were huia feathers worn in the hair.

[Alexander Turnbull Library]

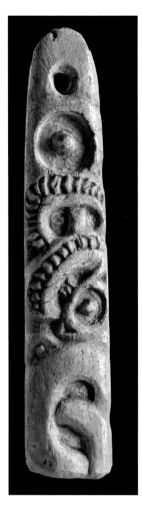

A small whalebone pendant carved with what appears to be two faces in profile, c1850.

[Museum of New Zealand Te Papa Tongarewa]

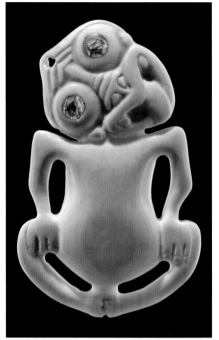

Whale tooth hei tiki pendant presented frontally, hands on hip, with the head tilted to one side and pāua inlaid into the eyes. The tiki belonged to the Reverend Richard Taylor of the Church Missionary Society — presented to him, it is believed, in 1840 at the signing of the Treaty of Waitangi.

[Museum of New Zealand Te Papa Tongarewa]

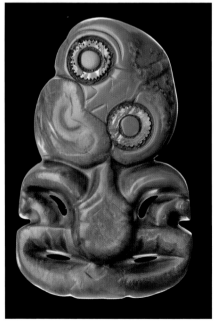

This hei tiki, symmetrical except for the head, which is inclined to one side, has large, deep eyes inlaid with pāua and set in red sealing wax. The deeply moulded limbs suggest that it was created with stone tools in the 1700s.

[Museum of New Zealand Te Papa Tongarewa]

therefore difficult to provenance with certainty. There were two main styles, the first being made from pounamu kawakawa and of full frontal form. This hei tiki was symmetrical except for the head being inclined to one side, with large deep eyes and a definite neck. The hands were placed on the legs and the limbs were deeply moulded. Taranaki hei tiki were carved in this style and may be recognised by their peaked head. The second form was preferably made from inanga or lighter pounamu. It was presented frontally but with an asymmetrical twist caused by a raised shoulder. The hands had three large fingers and a spur thumb, one hand to the chest or mouth and the other on the hip. Other details included flat back-projecting ears and a slimmer overall form of lower relief. While female organs were sometimes present, generally hei tiki were presented without genitalia.

The tiki was shaped in such a way that a minimum of material needed to be removed, head, legs and shoulders spanning the entire width of the material. The slow grinding with specially made sandstone whao or small toki aided the sculpting and shaping of the hei tiki, which was then enhanced by simple surface features to define the hands, feet and facial details. A toggle was cut from the wing bone of a bird and finished at the end of the cord where a loop from the opposite end was secured over it. Pāua shell eyes were carefully cut, often with notched edges, and inlaid into the pupil area. In post-European work, red sealing wax was used to fix the pāua into place, or used as the pupil feature on its own.

Apart from the tiki, there were other types of plainer or non-figurative pounamu carved adornment, including ear pendants. The kuru and kapeu were pendants worn in the ear and around the neck. The kuru was a straight pendant while the kapeu had a slight bottom curve and was used for supporting the breast during breast-feeding, or used to cut baby's teeth. Some straight pendants had a slight kink at their end and were called whakakaipiko, and in later years others had red sealing wax and black ribbon additions. A thin adze-like pendant might have doubled as a flax-stripping tool. The rei puta and pōria, or bird ring, were two other personal adornment forms fashioned from bone, tooth and pounamu. Occasionally hei matau with small genealogical notches were fashioned in pounamu and given terminal bird-like heads. Other figurative forms were more popular, including koropepe, a coiled spiral form with a head; the single curved manaia; the double-headed symmetrical pekapeka or bat, and a marakihau or sea creature.[20]

The supply of pounamu was unreliable owing to the inaccessibility of pounamu sites. A specialist trade industry in pounamu dates back to the 1800s and jade items have been highly sought after by tourists and collectors ever since. As metal began to replace pounamu adze blades, Māori, anxious to trade for European goods, converted many pounamu blades into hei tiki. Today pounamu is still revered and its extraction regulated due to the historical relationship Kai Tahu have with pounamu. Modern carvers of pounamu have the benefit of commercial equipment, diamond drills and wheels used with running water to carve the nephrite and polishing lathes for finishing. Contemporary designs in pounamu have taken on a variety of non-figurative and figurative forms, but maintain the integrity of the design principles so a balance is achieved between form and void. Hei tiki more closely follow customary forms, mainly because of the already established sophistication of their design. Carvers tend to respect the rarity of whale and pounamu products by ensuring they are carved to the highest standard.

Āhua whakairo rākau — surface patterning on wood

Surface design achieved its fullest expression on native timbers, the most useful for carving being tōtara, kauri and to a lesser extent kahikatea. These timbers lent themselves to sharply detailed cutting of surface pattern. Tōtara was widespread in Aotearoa, growing large, tall and straight, and reaching maturity quickly compared to some other indigenous trees. Tōtara also had the advantage of being a soft wood that cut cleanly with few knots. Other trees were slower growing and had limited availability, kauri, for example, growing only in the northern regions. Tōtara and kauri in particular were considered to possess inherently noble qualities, great chiefs being referred to as tōtara at the time of their deaths.[21]

> Ka hinga te tōtara o te wao nui a Tāne.
> *The tōtara of the great forest of Tāne is fallen.*

Surface pattern was employed to the extent required to enhance the form and figures of both small objects and architectural structures. The designs combined linear, curvilinear and spiral elements to create a vocabulary of patterns capable of being arranged in many combinations. While certain common elements can be identified, carving regions increasingly developed their own recognisably specific patterns and variations. The introduction of metal tools also had an immediate effect on surface patterning, permitting quicker fabrication and allowing for heightened proliferation and detailing of aesthetic nuances.[22]

Pākati are notches combined with sets of parallel raumoa, or ridges, and haehae. While haehae is the name given to the v-cut, it also applies to the ridge-groove combination as a visual element. The varying patterns created by combining both haehae and pākati features show subtle differences that are given particular names according to a perceived visual affinity with natural forms.

The most commonly identified pākati are niho taniwha, taratara-a-kai, tuara kurī, ritorito or pūwerewere, unaunahi and pītau. The chevron-style pākati — niho taniwha or dragon tooth — is repeated down a length to create an overlapping triangular effect. Taratara-a-kai or taratara-a-Kae has a barbed appearance achieved by distributing alternate triangular cuts to produce a zigzag effect. This design featured prominently on pātaka and has symbolic associations with the abundance of food. A special version of the taratara-a-Kae, called taowaru, is found on Te Kaha carvings where the notched ridge is elevated and rounded.[23] Triangular cuts, made directly opposite each other to create a raised diamond effect, were known as the tuara kurī notch, which references a dog's backbone. The resulting pākati takes on a square, or more elongated, appearance depending on how it has been executed.

Ritorito, or young flax shoot, consisted of a fleur-de-lis composition, the pākati being a group of three (sometimes four or five) splaying from a common point like the habit of a harakeke bush. Unaunahi was named after the fish scale, also called te-ika-a-Tangaroa or Tangaroa's fish. The crescent-shaped scales were carved in groups of three, four or five — sometimes extrapolated from spiral shapes. Groupings often exceeded five along lengths of parallel sets, or placed within haehae lines. The pītau was based on the kōwhaiwhai stem and bulb unit, also known as koru, carved in

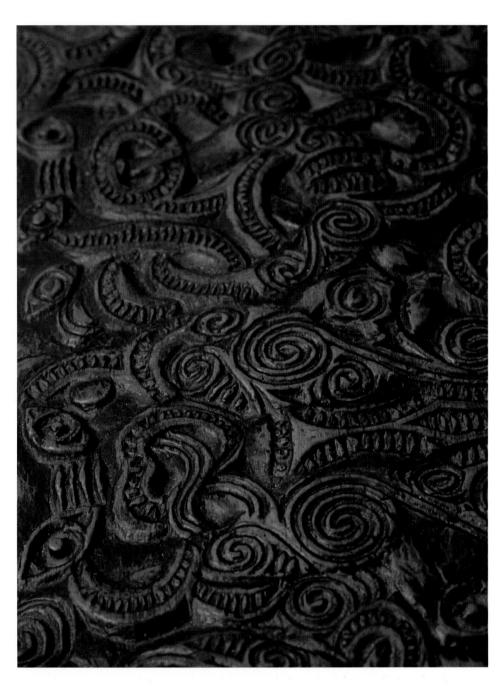

The photograph shows detail of a papa hou carved in the northern style, as distinguished by the extensive intermingling of body parts and patterning, featuring pākura or kiri kīore, and unaunahi. This papa hou was carved before 1800 using stone tools.

[Museum of New Zealand Te Papa Tongarewa]

outline with crescent shapes following the curves of the bulb, their compositional arrangements being similar to those in the meetinghouse.[24]

These basic pākati units were arranged in both rectilinear or curvilinear compositions. The common rectilinear formats included rauponga and whakarare, while pākura and pūngawerewere were more curvilinear in nature. The rauponga, named after the tree-fern leaf, was the most common pattern articulated with variants up until the mid-nineteenth century, when triple haehae groupings became standard. An adaptation of the rauponga design, called whakarare — to distort or bemuse — provides a strong visual direction by curving the haehae across the central pākati to meet the next series of haehae. The pākura pattern, which has its earliest manifestation in the North, is derived from the footprint of the pūkeko and presented as continuous rows of pūhoro-type spirals with crescents dispersed between to mirror the central compositional form of the spiral. The pūwerewere, or spider, is a distinctly Taranaki design that applies extensive and often exclusive use of spaced ritorito units, arranged in parallel sets (commonly three to five). In spiral form this design is known as pūngawerewere, or spider's web.

A pattern used extensively in pare, or door lintels, and papaepae pātaka, storehouse horizontal floor boards is the fishnet design mata kupenga, common to the Taranaki, Hauraki, Tainui and Taitokerau regions. Two planes are clearly distinguished in the mata kupenga, and the background is left plain, or cut away altogether in the case of tauihu. It consists of crescent formations in higher relief to form the net-like design covered with complementary surface patterning. Taranaki frequently used this design with pūwerewere notching on the raised relief. Partial spirals are also a common feature of the mata kupenga and serve as a visual alternative to the complete spiral called takarangi. The takarangi is similar in having two distinct planes, and also because it might be pierced between the ridges. The takarangi is a full double spiral with groups of pākati holding the spiralling ridges together. It appears extensively on the tauihu and taurapa of waka taua, and on pare above doorways. The word takarangi means to reel or stagger, symbolising the separation of Rangi and Papa, a time of chaos and confusion as Te Ao Mārama, the world of light, heralds the emergence of knowledge into the world.

The main spiral elements include Rauru, Whakaironui, Māui, Takarangi, and the Piko-o-Rauru, pūngawerewere and ponahi. Their names are of spiritual significance, referencing important ancestral origins of carving. Rauru was a famous carver known in the Bay of Plenty, Tauranga and Wairoa regions. Rauru consists of a series of haehae (up to three) grouped parallel to each other with a continuous series of pākati between, which circle from an s-centre to form a double spiral. Piko-o-Rauru is similar in design but plain and features two double spirals placed next to each other. This form may also be presented as a single ridged spiral placed on the shoulders and cheeks of older carved figures. The spiral called Māui refers to the demi-god by name and is distinctive in both kōwhaiwhai and carving design for its composition of double spiral elements that deflect outwards away from each other after their interlocking central rotation. Whakaironui spiral is composed like the rauru, but the pākati between is taratara-a-kai. Ponahi describes a spiral with ritorito and unaunahi accents, pūngawerewere being the Taranaki variant of ponahi where pūwerewere accents are used.

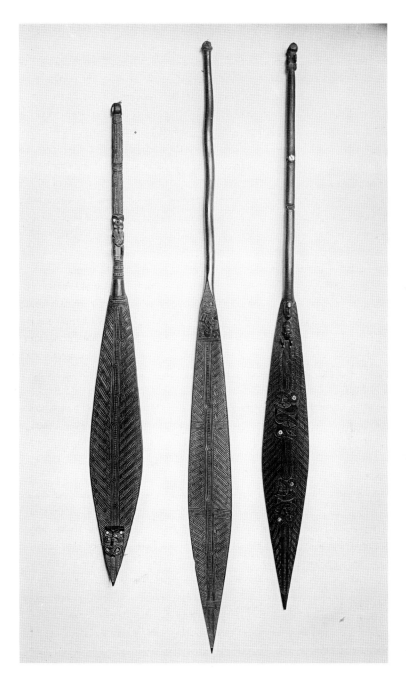

Early carved hoe from the collection of Augustus Hamilton, c1890. The carved surface patterning is arranged symmetrically for all three hoe, dominated by the whakarare form of raupunga pattern.

[Alexander Turnbull Library]

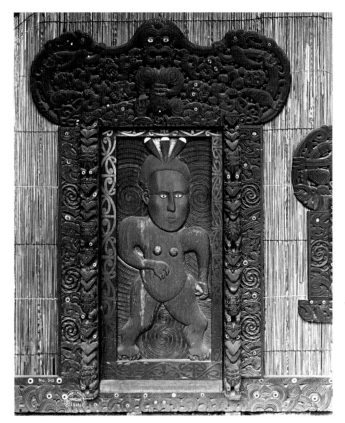

Tene Waitere experimented with European portraiture techniques in his carving of Te Rauru meetinghouse, Whakarewarewa, in 1900. The head of Kurangaituku is carved on the sliding door in low-relief three-quarter profile, and the figure appears to be running.

[Alexander Turnbull Library]

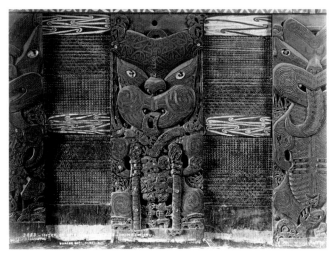

The surface patterning is profuse, and secondary figures are placed across the bodies and between the thighs of the main tiki figures of these poupou. This house, Tametekapua at Ohinemutu, was built in the 1870s but has since undergone several transformations.

[Alexander Turnbull Library]

Tiki, manaia and figurative forms in woodcarving

Māori carving reached the pinnacle of its development during the eighteenth and nineteenth centuries, form, design and style being elaborated on an extensive range of wooden objects and structures. A level of aesthetic balance between form and function, and figurative and non-figurative elements, was achieved through experimentation and refinement.[25] Forms that appear non-figurative to the untrained eye are often ambiguous figurative forms disguised as limbs, intertwined and being enveloped by background patterning. The carved pare, as the tapu threshold between the world outside and that inside, frequently exhibits this level of figurative and non-figurative complexity and ambiguity.[26]

The expression of reverence for ancestors was the paramount function of tiki representation. Ancestral gods with mystical powers were carved in a more abstract manner than ancestors of the more contemporary world.[27] Particular figures in the meetinghouse are naturalistically presented, like the poutokomanawa centrepost where the face is depicted wearing moko kanohi. Tiki figures are presented frontally to fit almost the entire width of a wooden slab. Typically, earlier tiki were presented with discrete surface design accents over the facial features, including eyebrow, nose and mouth areas. Surface pattern was similarly applied only minimally to the body on shoulders and hands, thighs and feet. Later styles applied rauru patterning to the shoulder, elbow, buttock and knee joints, and by the late 1800s patterning had increased to include the belly and entire facial region.

At first sight, tiki figure proportions appear to follow no logic. Heads are disproportionately large, both in width and height, while legs and arms might be significantly reduced in scale. Feet are sometimes shapeless with toes suggested in rudimentary fashion, while hands are commonly three-fingered or replaced with manaia heads, particularly on pare. The number of fingers, ranging from one to seven, has been much debated and is generally thought to indicate spiritual figures when numbering three. Other explanations cover the three states of creation, the descent from gods, three baskets of knowledge, or the deceased state of the ancestor depicted.[28] The number of fingers is also considered to be a reference to states of being, two fingers indicating Te Pō, the state before creation, supported by a lack of gender distinction on the central tiki. Significantly, only deceased ancestors were meant to be depicted in carving; however, Raharuhi Rukupo broke this convention by carving his own likeness on a poupou inside the doorway of Te Hau ki Tūranga house in 1842.[29]

It was rare for tiki to appear in woodcarving without flanking manaia — spirit beings that appeared in isolation on portable objects, but more often in support of tiki on larger structures. This dual presentation represents the interaction of the spiritual world with the human. Since birds are considered to be guardian spirits, there is support for the belief that manaia had an avian derivation — although mana, significantly, means authority or prestige. The paepae of a meetinghouse has tiki and manaia faces alternately paired along its length in a similar manner to the rauawa of the waka taua. Pare contain at least two manaia flanking a single tiki and a number of ancillary manaia between to emphasise a spiritual state.

Debates on the significance of manaia have focused on its possible bird or reptilian derivation and the evolution of the design to a more human form over time.[30] The idea of split

representation has been applied to both tā moko and whakairo, as an alternative way of looking at frontal tiki faces. That the manaia might have evolved from a half-face profile, two of which when matched together presented the full face of a tiki, is an idea that has also been explored in the context of Native American art.[31] Sometimes described as 'simultaneity', this allows for multiple viewpoints of a figure to be represented on a single plane without perspective distortion. A central axis is applied to the tiki face and limbs, and sometimes the body, allowing for some ambiguity in the way elements are combined. While artists were continuously inspired by both earlier and later articulation of motifs like the manaia, they most likely deliberately explored ambiguity as part of their own design repertoire.

Tiki and manaia are the most commonly used figurative forms, but others include kurī, ngārara, pakakē and marakihau. Ngārara were considered to be the vehicle for harmful spirits sent by Whiro, god of death and destruction. Yet some lizards served as guardians and were powerful deterrents, used in carving to mark sacred places such as burial sites. Kurī were revered, and the weaving of kahu kurī or dogskin coats, and their use on amulets, dated back to early settlement. Kurī appeared in limestone cave drawings and in the mid-nineteenth century on dog-shaped bowls. There are house examples of dogs carved alongside ancestors on panels.

Marakihau, with dorsal fins, horn-like protrusions and seahorse tail, is considered to be a taniwha or sea creature residing in water. The marakihau is presented with frontal face but profile body in a merman style with a tubular tongue, or ngongo, that was said to be able to suck up fish — or a whole canoe. It was believed that men could be transformed into taniwha at death. Te Tokaanganui a Noho has two porch panels of marakihau with extensive surface patterning. The pakakē was found on maihi and pātaka in the North Island, and was also believed to be a type of sea creature presented in whale form. Pakakē followed a particular convention, being carved in high relief profile with curved bodies and tails and manaia-style head. They were treated in much the same manner as the takarangi spiral pattern, often pierced, and extensively patterned with the taowaru (taratara-a-Kae variant) specific to the Te Kaha region. Towards the 1900s, figurative references in Māori meetinghouses were influenced by European portraiture as a technique of presenting historically important figures. Tene Waitere of Ngāti Tarawhai, Rotorua, was one carver who explored portraiture conventions at this time.

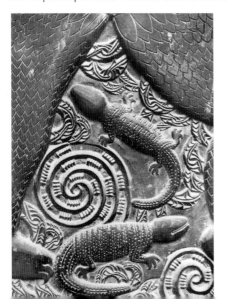

Detail of wood carving, featuring spirals and the ngārara, or lizard, Whakarewarewa c1910. Lizards can signify guardianship, particularly when appearing between the legs, and are often used to mark sacred places.

[Alexander Turnbull Library]

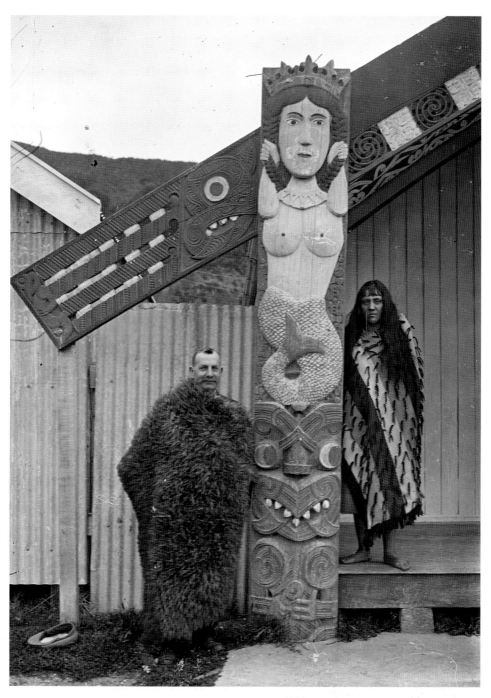

The marakihau is a semi-human carved figure, which from the waist up is a stylised human figure but below has a curled fishtail. The carved amo of Wairaka house, Whakatāne, c1920, shows the influence of the European mermaid on the marakihau form.

[Alexander Turnbull Library]

He mana whakairo — excellence in woodcarving

The earliest woodcarvings have been radiocarbon dated to AD 1500, the same early settlement period as bone and stone pieces. The evolution of simple into more complex sculpted form is explained by the growing refinement of artists' tools over a period of consistent settlement. Earliest carvings have minimal face detailing, simple relief between facial and limb features, and the body also shows minimal detailing and surface pattern accentuation. Faces are depicted in frontal view and are stylistically similar to Polynesian carving of the same period. There is evidence also of three-limb composition and the slight knee-bent stance typical of later carved tiki. Surface patterning is of a simple nature — mainly small indentations made on a regular surface with the end of a whao or small adze and notching along raised edges created by incrementally spaced adze indentations. Spirals and manaia are more recent additions.

These arts were portable and directly associated with the individual's needs. They were embellished in acknowledgement of their mauri, as with tiki wānanga or whakapakoko rākau, which were peg-shaped wooden figures used by the tohunga, thrust into the ground or held in the hand during kūmara planting, divination or other tapu activities. Tiki wānanga were carried by a war party and used to divine favourable outcomes. They were often given names and were not considered effective until they were significantly lashed, dressed with feathers, and painted with kōkōwai.

Objects associated with fishing, agriculture, foraging, leisure pursuits, eating and fighting were all carved with regard to their spiritual role. A high level of artistry was afforded to objects that belonged to ariki, who paid well for the skills of tohunga-whakairo. Heru or combs were highly regarded as a visible indication of status and authority, and highly tapu because of their association with the head. Men of high social standing allowed their hair to grow long and used heru for combing and fixing their topknot. These were made from a piece of wood or whalebone and had a spirit figure, a manaia, carved on one side.

Wakahuia — waka indicating vessel and huia meaning prized — were treasure boxes between 25 and 90 cm in length used to store the highly prized white-tipped black tail feathers of huia, along with a range of other prized objects. The lid was rebated into the base in a range of ways to appear seamless. Cords might be tied or threaded through the handle ends, passing through holes in the lid so that when the box was strung up in the rafters the lid closed. They were usually elaborately carved over their entire surface, including the base viewed from beneath when suspended. Early European visitors collected wakahuia as souvenirs as vigorously as hei tiki, and these provide insight into the regional carving diversity of the time. Typically papa hou from the Northland and Taranaki region were flat and oblong, while later East Coast—Bay of Plenty region style was more rounded or canoe-like. Some wakahuia appear as though they have predominantly non-figurative surfaces, but closer inspection reveals hidden figures within the carved patterning. Others show careful figure arrangements, the East Coast style in particular, where high-relief figures (sometimes copulating, or head-to-head) feature on the lid as handle supports and suspension attachments.

Northern wakahuia, called papa hou, possess distinctive low relief tiki with subtly defined bodies, with pākura or kiri kīore and unaunahi surface patterning applied all over in a manner that makes it difficult to distinguish body areas. Tiki with high-domed heads and sinuous bodies, limbs twisting and sometimes subsumed beneath background pattern, were usually composed

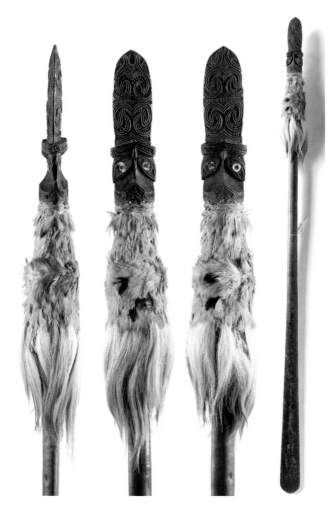

The blade of the taiaha kura
is shaped as a tongue and
patterned. A sculpted brow and
shell-inlaid eyes complete the
upoko, fringed with kākā feathers
and dog hair, while the other end
is formed into a striking blade.

[Museum of New Zealand
Te Papa Tongarewa]

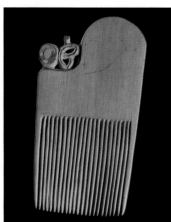

Men used the heru, a comb sculpted
in whalebone or wood, to groom their
long hair and secure it in a topknot.
This example, with carved manaia head,
inlaid pāua eye and pierced mouth, may
have been collected by Captain Cook.

[Museum of New Zealand Te Papa Tongarewa]

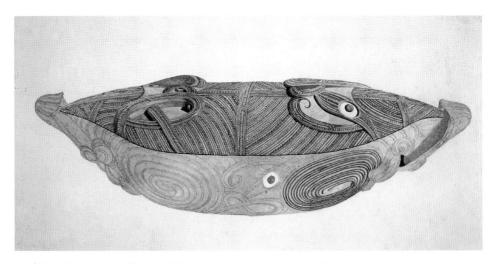

Wakahuia were intricately carved as befitted the treasured objects they were to contain. This watercolour shows a unique example, with the head of the manaia rotated on each side of the lid, and frontal tiki heads providing handles.

[Alexander Turnbull Library]

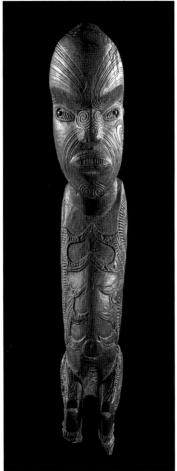

This whakapakoko rākau, c1800, has an incomplete moko kanohi, protruding stomach and shoulders carved close to an elongated body. The rape moko is carved on its buttocks. These were usually painted red and acted as temporary shrines when tohunga performed rituals.

[Museum of New Zealand Te Papa Tongarewa]

longitudinally. Manaia served a dual purpose at the ends, as they completed a balanced composition and worked as handles.[32]

Warfare was a significant part of Māori life, but one that was reserved for the summer period between November and April when conditions were favourable for supplying food to sustain lengthy campaigns. Tūmatauenga, god of war, required ritual observances to ensure toa or warriors were focused on their task. Fighting was predominantly hand-to-hand, and extensive fighting took place near and around the fortified pā. Māori weaponry was of three principal types: the long staff or club, short clubs, and spears.[33] The main long weapons were the pouwhenua with pointed end and club-like head, tewhatewha (or rākau rangatira) with blunt axe end, and the commonly used taiaha. They were all carefully executed to ensure a balanced shaft, sharp and effective point, and — in the case of the tewhatewha — a well-weighted head. The club forms, patu ōnewa, patu parāoa, mere pounamu, kotiate (meaning 'to cut liver') and wahaika ('fish mouth') were heavy and honed on the striking edges to deliver an effective blow to the victim. Other weapons included a range of wooden huata or spears, the hoeroa or whalebone striking weapon, and oka or dagger, and were all highly specialised and equally effective as weapons. These were coveted, particularly if they were won in battle, and this warranted their being handed down through generations. Today of course weapons are carved principally for their aesthetic rather than practical function, although some of the basic weapon types like the taiaha and mere are popular for the combative sport of mau rākau, and in the performance of kapa haka or dance entertainment.

Ko te kai a te rangatira, he kōrero.
Oratory is the sustenance of chiefs.[34]

Musical instruments occupied a unique place in Māori society and had roles that transcended the pleasing sounds they made. They were named after the sky father Rangi-nui, with rhythms derived from the heartbeat of Papa-tū-ā-nuku, and were meant to complement kōrero or speech.[34] The simplest stone musical instruments mimicked the sounds of birds: karanga manu or kōauau pūtangitangi and karanga weka. The pūtātara or pūmoana conch shell trumpet with carved mouthpiece, pūkāea war horn and pāhu wooden split gong were commonly used to herald war or other community gatherings. The pūtōrino served as both flute and trumpet and had a tiki figure added to the mouthpiece end and a tiki face on the central mouthpiece. Hineraukatauri, the goddess of flutes, appeared as a carved figure on the kōauau flutes made from wood (as well as human and albatross bone), and nguru flutes were played by the mouth and nose. These were carefully designed in the round in one piece to achieve the desired sounds. Today musical instruments have undergone a conscious revival with in excess of 50 different instruments being made and played.

Whakairo mana tangata — whakairo as human dignity

The carved architectural structures, particularly pātaka, waka taua and whare whakairo, because of their larger scale, presented more sophisticated design challenges. The structural presentation and symbolism of these forms meant these ancestral structures communicated specific community membership in a way smaller carved objects could not. Their genealogy began with Rangi and Papa, they were usually named after a remote famous ancestor, their structure represented an eponymous ancestor, and in the whare whakairo subsequent generations were referenced.

The whare whakairo consisted of mainly slabbed poupou, with carved figures which were made on a scale appropriate to the standing room in the house. Since the poupou were required for structural support, the entire surface was utilised to present a dominant carved figure, with interest added through planar arrangements and contrast in scale and pattern. The height of the back and front wall support posts (they supported the apex of the roof), pou tuarongo and pou tahū respectively, made them suitable for multiple figure presentations, two or more, feet on head above each other — as did the rest of the posts on these walls. Amo supports of the maihi on the front of the house followed a similar rationale. The maihi, as the initial dominant visual aspect of the building, would naturally have a significant tribal narrative represented, as with the entire porch area. The significance of tapu and noa in Māori society, enacted as a living reality through ritual observance, would naturally mark the doorway as a transitional zone and invested pare with a particular significance recognised in design.

Despite the ritual observances for entering whare whakairo, these structures were for peaceful activities — those of Rongo (god of peace) — such as meetings and debates, and therefore the carvings served as history lessons, while the outside was given to Tūmatauenga. The elaboration of whakairo on the pātaka related to the particularly tapu nature of food, and served to warn visitors rather than to invite them inside. The whakairo on the waka taua were of a similar nature, but had in addition a heightened protective aspect for the warriors they carried. The elaborate carvings, including a number of the departmental gods, and a proliferation of pierced spirals, enhanced the spiritual power required of them.

European-influenced changes since the early 1900s have seen greater emphasis on pattern elaboration, more flattened figures, less ambiguity of form in the absence of deeper relief, and the introduction of Western design conventions. Māori have a range of training options in whakairo, and are increasingly participating in contemporary indigenous art markets. These developments have presented practitioners of carving with challenges and opportunities, particularly in regard to notions of tribal style versus standardised identifiers of 'Māoriness' and the transformation of carving skills and language to new art and design media.

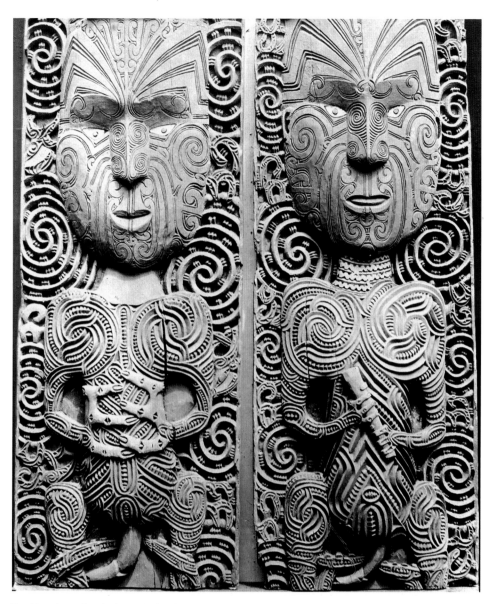

The ridgepole carvings in the porch often featured two figures joined at the feet, like these carvings originally at Rangitihi meetinghouse, Lake Rotoiti, c1890's. A proliferation of surface pattern indicates the influence of European taste and the introduction of steel chisels.

[Alexander Turnbull Library]

CHAPTER NOTES

Introduction: The Character of Māori Art

1. Mead, H. M. (1999:1): Aotearoa was named by the great explorer, Kupe's wife; Hine-i-te-aparangi: *Nga Toi Maori: Maori art in Aotearoa New Zealand,* Wellington, 1999 http://www.maoriart.org.nz/features/articles/nga_toi_maori_2, accessed 20 May 2009
2. Davidson, Janet (1987:8): Māori are closely related in language, culture and tradition to the inhabitants of the Polynesian triangle, which stretches from New Zealand to Hawaii and Easter Island. This is supported by linguistic and cultural evidence. The most direct ancestors of Māori can be traced west to the islands of Samoa, Tonga and Fiji, first settled approximately 3000 years ago.
3. Doig, Fiona (ed.) (1989:36): *Taonga Maori: A Spiritual Journey Expressed Through Maori Art*, Australian Museum, Sydney, 1989
4. http://www.festival-pacific-arts.org/ (redirects to current host site) accessed 14 April 2009
5. Mead, H. M. (1999:1): http://www.maoriart.org.nz/features/articles/nga_toi_maori_2 accessed 14 April 2009
6. Ministry of Culture and Heritage, http://www.nzhistory.net.nz/culture/Māori-language-week/history-of-the-Māori-language, updated 21—Jul—2008, accessed 20 May 2009
7. Smith, Percy (1913:150—2): *The Lore of the Whare-wananga or Teachings of the Maori College on religion, cosmogony and history*, Polynesian Society, New Plymouth, 1913
8. Doig, Fiona ibid. p40
9. Hooper, Steven (2006:38—40): *Pacific Encounters: Art & Divinity in Polynesia 1760—1860*, The British Museum Press, London, 2006
10. Forge, Anthony (1979:285): 'Problem of Meaning in Art: New Guinea', *Exploring the Visual Art of Oceania: Australia, Melanesia, Micronesia, and Polynesia,* edited by Sidney Mead, University Press of Hawaii, Honolulu, 1979. pp278—287

Chapter 1: The Nature of Māori Art and Design

1. Panoho, Rangihiroa (1996:20—5): 'A Search for Authenticity: Towards a Definition and Strategies for Cultural Survival', *He Pukenga Kōrero: A Journal of Māori Studies,* Volume 2, Number 1, Koanga (Spring), Massey University, Palmerston North, 1996
2. Green, R. C. (1963): 'A review of the Prehistoric Sequence in the Auckland Province', *New Zealand Archaeological Society*, Monograph 2, Auckland, 1963
3. Barrow, T. (1969:21—3), this is an abbreviated version of Barrow's description of the phases of Māori culture: *Maori Wood Sculpture of New Zealand,* A. H. & A. W. Reed, Wellington, 1969
4. Mead, Hirini Moko (1986:29—33) adopts an archaeological approach to the evolution of complexity in Māori carving: *Magnificent Te Maori: Te Maori Whakahirahira*, Heinemann, Auckland, 1986
5. Barrow, T. ibid. pp15—19
6. Doig, Fiona ibid. pp44—51

7. Neich, Roger (1996), 'Wood Carving', in D. C. Starzecka (ed.): *Maori Art and Culture,* David Bateman, Auckland, 1996. pp69—113
8. Mead, Hirini Moko ibid. pp29—33

Chapter 2: Fibre and Woven Arts

1. Renee Orchison Landcare research project on harakeke: http://www.landcareresearch.co.nz/research/biosystematics/plants/harakeke/ accessed 19 April 2009
2. Puketapu-Hetet, Erenora (1989:24): *Maori Weaving,* Pitman, Auckland, 1989
3. Te Kanawa, Diggeress (1992:9—17): *Weaving a Kakahu,* Bridget Williams Books Limited, Wellington, 1992
4. Mead, Hirini Moko (1973:19—21): *Te Whatu Taniko: Taniko Weaving,* Reed Methuen, Auckland, 1973
5. Best, Elsdon: *Tuhoe, the Children of the Mist,* Polynesian Society, Wellington, 1925
6. Hiroa, Te Rangi (1949:225,407): *The Coming of the Maori,* Maori Purposes Trust Board, Wellington, 1949
7. Hiroa, Te Rangi (1921:453): 'Maori decorative art, house panels', *New Zealand Institute Transactions,* Volume 53, 1921
8. ibid. pp456—8
9. Harrison, Paki (1983:57): *Te Poho o Tipene*, St Stephens College, Auckland, 1983
10. Maysmor, Bob (2001:30): *Te Manu Tukutuku: The Maori Kite,* Steele Roberts, Wellington, 2001
11. Pendergrast, Mick (2005:144—5): *Maori Fibre Techniques: A Resource Book for Maori Fibre Arts,* Reed Publishing, Auckland, 2005
12. Phillipps, W. J., revised by John Huria (2008:15): *Maori Life & Custom,* Raupo, Auckland, 2008
13. Reedy, Anaru (ed.) (1993:70,174): *Nga korero a Mohi Ruatapu: The writings of Mohi Ruatapu,* Canterbury University Press, Christchurch
14. Best, Elsdon (1977:203): *Fishing Methods and Devices of the Maori,* National Museum, Wellington, 1977
15. Pendergrast, Mick (2005:150)
16. Maysmor, Bob ibid. p45
17. Pendergrast, Mick (2005:21—2)
18. Pendergrast, Mick (1991) *Raranga Whakairo: Maori Plaiting Patterns,* Reed, Auckland, 1991
19. ibid.
20. Pendergrast, Mick ibid (2005:136—7)
21. ibid. pp140—1
22. ibid. p96
23. Mead, Hirini Moko ibid. pp23—5
24. Hiroa, Te Rangi (1925): 'The Evolution of Maori clothing', *The Journal of the Polynesian Society,* Volume 34, No. 133, pp61—92, Polynesian Society, Auckland, 1925

Chapter 3: Painted and Pigmented Arts

1. Best, Elsdon (1929:287—8) *Maori Religion and Mythology: Being an account of the cosmogony, anthropogeny, religious beliefs and rites, magic and folk lore of the Māori folk of New Zealand,* Parts 1 & 2, A. R. Shearer Government Printer, Wellington, 1929

Whiro, Haepuru and Haematua climbed up to the
second heaven to obtain carvings for the house, but
were told by one of the gods that the art of decorating
houses with woodcarving had already been taken by
their younger brothers. When they pleaded that they
couldn't go to their younger brothers for the art, he
showed them how to paint.

2. Phillips, W. J. (1939:72); Hiroa, Te Rangi (1949:319):
 'An introduction to Maori pounding implements', The
 Journal of the Polynesian Society, Volume 48, No. 190,
 pp71–91, Polynesian Society, Auckland, 1939
3. Beattie, H. (1918:137–61): 'Traditions and Legends.
 Collected from the natives of Murihiku (Southland,
 New Zealand)', The Journal of the Polynesian Society,
 Volume 27, No. 107, pp137–61, 1918
4. National Museum of New Zealand and Manawatu Art
 Gallery (1988): Ka Tuhituhi o Nehera: The Drawings of
 Ancient Times, Auckland and Palmerston North, 1988
5. Lewis, David and Forman, Werner (1982:24). While
 Maori hunting habits contributed to the demise of
 the moa, the ice age had also made the ecological
 conditions unsuitable: The Maori Heirs of Tane, Orbis
 Publishing Limited, London, 1982
6. Trotter, Michael and McCulloch, Beverley (1971:30–2):
 Prehistoric Rock Art of New Zealand, A. H. & A. W. Reed,
 Wellington, 1971
7. Neich, Roger (1993:25–8): Painted Histories: Early
 Maori Figurative Painting, Auckland University Press,
 1993
8. ibid. p28: Encouraged by a museum-based orthodoxy
 led by Augustus Hamilton, polychromatic carvings
 and entire meetinghouses in museum collections
 were repainted in an approved monochrome red. Both
 Māori and European experts believed that polychrome
 carvings were degenerative practices in Māori art.
9. Best, Elsdon (1898)
10. Beattie, H. ibid. p50
11. Tregear, Edward (1904:256–7): 'Dress Ornaments
 etc.' In The Maori race, Archibald Dudingston Willis,
 Wanganui, 1904
12. Hiroa, Te Rangi (1949:162): The Coming of the Maori,
 Maori Purposes Trust Board, Wellington, 1949
13. Simmons, D. R. (1985:21): Whakairo: Maori Tribal Art,
 Auckland, 1985
14. Hamilton, A. (1977:119): Maori Art, The Holland Press,
 London, 1977
15. Neich, Roger ibid. p26
16. Taylor, Richard (1855:155): Te Ika a Maui of New
 Zealand and its inhabitants, London, 1855
17. Hiroa, Te Rangi ibid. p317
18. Neich, Roger (1993:12–7) ibid.
19. Jahnke, Robert Hans George (2006:127): 'He
 tataitanga ahua toi: the house that Riwai built/a
 continuum of Maori art', A thesis presented in partial
 fulfilment of the requirements for the degree of Doctor
 of Philosophy in Maori Studies, Massey University,
 Palmerston North, 2006
20. Neich, Roger ibid. p10
21. Hiroa, Te Rangi ibid. pp325–9; Smith, Percy (1913:192):
 The Lore of the Whare-wananga or Teachings of the
 Maori College on religion, cosmogony and history,
 Polynesian Society, New Plymouth, 1913
22. Te Uhi o Mataora http://www.maoriart.org.nz/
 noticeboard/te_uhi/ta_moko_pub accessed 20 May 2009
23. Cowan, J. (1930:138): 'Moko: The Tattooing Art.' In The
 Maori: Yesterday and To-day, pp136–49, Whitcombe &
 Tombs Limited, Auckland, 1930
24. Best, Elsdon (1924:223): The Maori (Memoirs of
 the Polynesian Society, Vol. 5), Polynesian Society,
 Auckland, 1924
25. Graham (NS 120:241)
26. Best, Elsdon (1904:167), King, Michael (1972): Maori
 Tattooing in the 20th century, Alister Taylor, Auckland,
 1972
27. Robley, Major-General (1998:44–6): Moko or Maori
 Tattooing, Tiger Books International, Middlesex, 1998
28. Best, Elsdon (1911:168–9): 'The origin of tattooing,'
 The Journal of the Polynesian Society, Volume 20, No.
 4, pp167–9, Polynesian Society, Auckland, 1911

Chapter 4: Architectural and Structural Arts
1. Phillipps, W. J. (1952:15–17,24): Maori Houses and
 Food Stores, Government Printer, Wellington, 1952
2. Prickett, N. J. (1982:1160): 'An archaeologist's
 guide to the Maori Dwelling', New Zealand Journal of
 Archaeology, Volume 4, pp111–47, University of Otago,
 Dunedin, 1982
3. Hiroa, Te Rangi (1949:114): The Coming of the Maori,
 Maori Purposes Trust Board, Wellington, 1949
4. Taylor, Alan and Taylor, W. A. (1966:26–7): The Maori
 Builds: Life Art and Architecture from Moahunter Days,
 Whitcombe & Tombs Limited, Christchurch, 1966
5. Firth, Raymond (1929:7–9): Economics of the New
 Zealand Maori, Government Printer, Wellington, 1929
6. Taylor, Alan and Taylor, W. A. ibid. pp28–9
7. Best, Elsdon (1974:xi): Maori Storehouses and
 Kindred Structures, A. R. Shearer Government Printer,
 Wellington, 1974
8. Prickett, Nigel (2002:18–22): Landscapes of Conflict:
 A Field Guide to the New Zealand Wars, Random House,
 Auckland, 2002
9. Taylor, Alan and Taylor, W. A. ibid. pp6–8
10. Phillipps, W. J. (1952:42), the precursor to tukutuku
 patterns: Maori Houses and Food Stores, Government
 Printer, Wellington, 1952
11. Taylor, Alan and Taylor, W. A. ibid. pp46–9
12. Best, Elsdon (1974:1)
13. Best, Elsdon (Vol. 2, 1929:578): Maori Religion and
 Mythology: Being an account of the cosmogony,
 anthropogeny, religious beliefs and rites, magic and
 folk lore of the Māori folk of New Zealand, Parts 1 & 2,
 A. R. Shearer Government Printer, Wellington, 1929
14. Davidson, Janet (1987:161)
15. Best, Elsdon (1974:71–6)
16. Hiroa, Te Rangi ibid. pp130–2
17. Taylor, Alan and Taylor, W. A. ibid. pp18–22
18. Angas, George French (1979:84): Early Paintings of the
 Maori, A. H. & A. W. Reed, Wellington, 1979
19. ibid. p80
20. ibid. pp72–85
21. Evans, Jeff (2000:30–4): Waka Taua: The Maori War
 Canoe, Reed Publishing Ltd, Auckland, 2000

22. Hiroa, Te Rangi ibid. pp205—7
23. Best, Elsdon (1976:183—6)
24. Evans, Jeff ibid. pp15—6
25. Simmons, D. R. (1997:15,25—9): *Te whare rūnanga: the meetinghouse,* Reed Publishing Ltd, Auckland, 1997
26. Irwin, Geoffrey (2004:125): *Kohika: The Archaeology of a Late Māori Lake Village in the Ngāti Awa Rohe, Bay of Plenty, New Zealand,* Auckland University Press, 2004
27. Ibid. pp141—2
28. Taylor, Alan and Taylor, W. A. ibid. p46

Chapter 5: Sculpted and Carved Arts
1. Mead, Hirini Moko (1986:8—11): *Magnificent Te Maori: Te Maori Whakahirahira*, Heinemann, Auckland, 1986
2. Davidson, Janet (1987:202): *The Prehistory of New Zealand,* Longman Paul Ltd, Auckland, 1987
3. Best, Elsdon (1974:45—8): *The Stone Implements of the Maori,* A. R. Shearer Government Printer, Wellington, 1974
4. Ibid. pp115—6
5. Davidson, Janet ibid. p61
6. Best, Elsdon ibid (1974:33,23)
7. Neich, Roger (1996:76—7) 'Wood Carving', in D. C. Starzecka (ed.): *Maori Art and Culture,* David Bateman, Auckland, 1996. pp69—113
8. Barrow, T. (1969:90—3): *Maori Wood Sculpture of New Zealand,* Reed, Wellington, 1969
9. ibid. pp1—12
10. Prickett, Nigel (1999:4): *Nga Tohu Tawhito: Early Maori Ornaments,* David Bateman Ltd, Auckland, 1999
11. Neich, Roger (1997:4—6): *Pounamu: Maori Jade of New Zealand,* David Bateman Ltd, Auckland, 1997
12. ibid. pp6—8,13—6
13. Davidson, Janet ibid. pp77—81
14. Barrow, T. pp78—80
15. Myhre, Stephen (1987:7—9): *Bone carving: A Skillbase of Techniques and Concepts,* Heinemann Reed, Auckland, 1987
16. Ibid. pp53—7
17. Ibid. pp80—4
18. Neich, Roger ibid. pp4—6
19. Ibid. pp2—6
20. Ibid. pp16—21, 25—7
21. Neich, Roger (1996:72—3) 'Wood Carving', in D. C. Starzecka (ed.): *Maori Art and Culture,* David Bateman, Auckland, 1996. pp69—113
22. Davidson, Janet ibid. p11
23. Neich, Roger (1996:89); Harrison, Paki (1983:12—3): *Te Poho o Tipene*, St Stephens College, Auckland, 1983
24. Mead, Hirini Moko ibid. pp232—7
25. Neich, Roger (1996:80—1)
26. Simmons, David (2001:9): *The Carved Pare: A Maori Mirror of the Universe,* Huia Publishers, Wellington, 2001
27. Neich, Roger (1996:82—4) 'Wood Carving', in D. C. Starzecka (ed.): *Maori Art and Culture,* David Bateman, Auckland, 1996, pp69—113
28. Harrison, Paki ibid. pp10—11
29. Barrow, T. ibid. pp17, 79

30. Mead, S. M. (1975:202—6): 'The origins of Maori art: Polynesian or Chinese', *Oceania* Vol. 45, No. 3, pp173—211, University of Sydney, 1975
31. Neich, Roger (1996:86—7) 'Wood Carving', in D. C. Starzecka (ed.): *Maori Art and Culture,* David Bateman, Auckland, 1996. pp69—113
32. Barrow, T. ibid. pp40—2
33. Evans, Jeff (2002): *Maori Weapons in pre-European New Zealand,* Reed Books, Auckland, 2002
34. Flintoff, Brian (2004:14—7): *Tanga Puoro Singing Treasures: The musical instruments of the Maori,* Craig Potton Publishing, Nelson, 2004

APPENDIX: The Scope of Māori Art

Table 1 — Personal adornment

Special artistry was often associated with personal art objects — especially those belonging to the chief, as such personal items acquired powers by association with their wearer. Elaborate pattern was reserved for such items.

	Head	Accessories	Body
Fibre & woven arts	*Heru mapara* — combs of separate teeth, fibre binding creating a pattern	*Kete whakapuare* — open weave patterned basket *Kete kawhiu* — kit with holes, dive basket	*Kākahu kurī* — dogskin cloak *Māwhiti, kahu waero* — tasselled dogskin cloak
	Pōtae — plaited hat, lacebark hat *Pōtae taua* — widow's cap made from muka with seaweed tags	*Kōpare* — lacebark bag, plaited and stitched *Pāraerae* — finely patterned bag *Kete whakairo* — finely patterned kit/bag *Kete tāniko* — woven bag *Kopa* — basket with a flap like a pocket *Putea* — woven bag *Kawe* — braided straps	*Kaitaka, aronui, pātea, paepaeroa* and *huaki* tāniko — border cloak *Kārure* — unravelled tag cloak *Ngore* — pompom cloak *Kākahu huruhuru* — tāniko cloak with feather tags *Kahu kiwi* — kiwi feather cloak *Kahu kekeno, kahu toi korowai* — tag cloak
	Hutukawa, kōtaha — head-dress	*Whiri* — plaited rope used for stringing pendants and necklaces	*Tātua, tū, maro hara, tātua pūpara* — belts, double belt *Tū kāretu* — woman's belt
	Kawe, tauhere — plaited band from lace bark *Kōpare, tīpare* — headband	*Poroporo, kōmore* — bracelets *Tauri kōmere* — anklet	*Maro kopua, maro* — apron *Pākē kārure* — waist garment *Pari* — tāniko bodice *Tāpeka* — tāniko bandolier
	Piki — feather plume for the head *Kaiwharawhara* — albatross feather plumes for the hair	*Torua, korehe, kopa, pāraerae* — double-soled plaited sandal	*Hīeke, rāpaki, pākē* — tag rain cape, or waist mat *Kākahu pihepihe, piupiu* — rolled tag cloak and skirt *Mai, pākē* — coarse cloak
Sculpted & carved arts	*Heru tuki, heru iwi* — comb carved, usually with small figure	*Hei tiki* — cord suspended human figure carved pendant of bone, tooth or greenstone	*Wakahuia, papahou* — treasure box for prized personal items
	Kapeu, kuru — ear pendant *Pōria* — ear pendant Other bone, tooth ear pendants	*Hei matau, rei puta, hei kaki, koropepe, pekapeka* — types of neck pendants	*Ngutu huia* — huia brooch *Aurei* — cloak pin, breast pendant

	Head	Accessories	Body
Painted & pigmented arts	Moko kanohi, moko kurī, moko kiore — engraved full facial tattooing of males Ngutu-purua — moko on lips Ngutu poroporo — lines encircling the lips Hōtiki — forehead tattoo	Takitaki — tā moko lines between the breast and navel on women Tū tātua — waist girdle Hopehope — spirals on the thighs of women	Moko peha, moko pūhoro — waist-down tattoo of warriors Paeturi, porori — moko on upper, outside thighs Rape — buttocks, breech moko Pakipaki — moko on buttocks Pūhoro, pakituri — lower thigh
	Moko kauwae, moko kauae, pu-kauwae — female chin and lips tattoo	Tara whakairo — female genital moko	Wai whakatairangi — pigment
	Tuhi kōrae, tuhi marae kura — red lateral bands painted across the face Tuhi kōhuru — diagonal painted bands on face Parakawahia — broad face circles/bands, ultramarine	Moko taurekareka, moko ringaringa — moko encircling wrist, arms, legs Moko pokoiwi — moko on shoulders	Ipu whenua — painted gourd pot for the afterbirth

Table 2 — Personal items

The protection of the chief guaranteed the protection of the people, and personal items became more potent in their protective role when art was added to them. Musical items usually served to 'call forth' spirit forces.

	Weapons	Ceremonial and musical items	Tools of the tohunga
Fibre & woven arts	Tauhere and whiri — lash to enhance the appearance of a weapon Taupuhi, puhipuhi, taura kura — attached bunch of feathers Tau — wrist cord	Poi awe, poi tāniko — woven swinging ball for weapon training and dance	Whāriki, takapou — fine mats for ceremonial purposes Tahā — weave-covered calabash
Sculpted & carved arts	Taiaha, taiaha kura, hani — long-handled fighting and ceremonial staff Pouwhenua — long club Tao, koikoi, kotaha — thin spear Tewhatewha — fighting club with blunt axe end	Kōauau — flute Pūtōrino — bugle flute Nguru — nose flute Pūtātara, pūmoana — conch shell trumpet Pūkāea — war trumpet Kōauau pūtangitangi, karanga manu, karanga weka — stone bird flutes	Kōrere — feeding funnel for tattooing, elaborately carved Ipu wai ngarahu — ornate ink pigment container for tā moko Tirou — pronged implement used to feed a chief Uhi, uhi matarau — tattoo chisels Tā — tattoo mallet or striker

	Weapons	Ceremonial and musical items	Tools of the tohunga
	Patu ōnewa, patu pounamu, mere pounamu — short-handled stone weapons *Patu parāora, meremere, patuki, wahaika, kotiate* — short carved bone or wood weapons	*Porotiti, pūrerehua* — twirled wind instruments, carved *Pāhu* — wooden split gong	*Toki tīwara* — heavy adze *Toki pounamu* — jade adze *Toki umarua* — double-shouldered adze *Kakau* — wooden toki handle *Toki* — adze blade for carving *Hōanga* — grinding stone *Hōrete, tuiri* — cord drill
	Tete, oka — dagger *Kotaha, huata* — spears, darts sling	*Rākau whakapapa* — genealogical staff *Tokotoko* — cane or walking stick	*Turuturu whatu* — carved pegs for holding weaving *Paoi, kōhatu, patu muka* — pounders, flax beaters
	Toki kakauroa, patiti — long-handled tomahawk	*Karetao* — ritual puppet to dramatise story telling	*Whakapākoko, rākau atua, tiki wānanga* — carved god stick
	Toki poutangata — ceremonial and fighting adze	*Hoeroa* — chief's ceremonial whalebone staff (also a weapon)	*Whao* — carving chisels named according to use *Whao, whao haehae, whao papa, whao wha rua* *Ripi* — cutting implement *Tākuru, patu whakairo* — mallet
Painted & pigmented arts	*Kōkōwai* — red paint used to coat weapons in preparation	*Pūrerehua* — bullroarer, may be painted both sides	*Wakahuia, papahou* — treasure boxes, may have painted lids
			Awe kapara — tā moko ink *Hōrū, maukoroa* — red clay used for ceremonial purposes.

Table 3 — Food collection

While art could be used to enhance everyday items, the addition of specific design elements helped ensure satisfactory results, whether in terms of abundance of food or greater efficiency in use. The design of tools successfully integrated art with function.

	Fishing	Foraging, hunting	Containers, utensils
Fibre & woven arts	*Kupenga* — knotted dragnet *Kaharua* — seine knotted net *Matarua* — funnel net	*Māhanga* — knotted bird snare	*Poha* — bound bull kelp bag *Papa tōtara* — bark bag
	Hīnaki, hīnaki tukutuku, hīnaki piharau — eel trap *Korotete* — eel storage pot *Tāruke koura* — crayfish trap	*Manutukutuku, manu taratahi* — tukutuku-bound raupō kite used to ward off birds	*Tahā huahua* — woven covered calabash for preserving birds *Tahā wai* — container for water

	Fishing	Foraging, hunting	Containers, utensils
Sculpted & carved arts	*Tōrehe* — fish trap *Kupenga kōaro* — whitebait trap *Kete kāwhiu* — dive basket *Pōhā* — raw flax net	*Rohe kākā* — bird feed bag	*Kono* — small woven bowl *Rourou, kōnae* — raw flax food basket
	Matau — fish hooks *Pā kahawai* — rolling fish lure *Pohau manga* — barracuda hook	*Poria kākā* — bird leg ring *Mutu kākā* — snaring perch for birds *Tawhiti kiore* — rat trap	*Kūmete* — wooden bowl *Paepae* — dish *Ipu* — carved pouring bowl, gourd for storage
	Māhē — fishing sinker in stone *Punga* — anchor stone *patu tuna* — eel club	*Kāheru* — soil, working instrument, stick *Kō* — spade *Teka* — footrest for kō	*Māripi, ulu* — carved knife with shark's teeth, knife
	Rou kākahi — shellfish dredge *Matarau* — eel spear	*Taumata atua* — talisman for crops *Rākau atua* — god stick	*Tīkaro, tīkoko* — scoop for excavating holes

Table 4 — Architectural structures
Tribal prestige was associated with large built structures such as the pātaka, whare whakairo and the waka taua.

	House structures	Vessels	Other
Fibre & woven arts	*Tukutuku (wharenui)* — thatch panels of cross-stitch designs *Tūrapa* — complete lattice panel of tukutuku	*Mōkihi* — raft made of bundles of lashed raupō	*Tūwhara* — coarse mat *Takapau, takapou* — fine mat *Whāriki* — plaited floor mats *Kaupeka* — climbing cord
	Whare raupō — house with bound raupō thatch *Whare puni* — sleeping house *Pūrori, huki* — roundhouse *Whare patutītī* –tītī hunters hut *Whare mānuka* — roundhouse *Whare āpiti* — steep pitched roof house *Whare punanga* — refuge hut built amongst trees	*Ihiihi, hihi* — canoe antennae of mānuka and feathers *Mamaru, rā* — plaited sail *Rā kaupapara* — lateen sail	*Manu tukutuku* — flying kite *Manu kākā* — parrot kite *Manu pākau* — winged bird kite *Manu pākaukau* — swimming bird kite *Manu pātiki* — flounder fish kite *Manu taratahi* — single-pointed plume kite *Manu aute* — bark cloth kite *Horewai* — rectangular kite
	Pōrukuruku — curved sloping roofed house/shed *Pata pūrangi* — round food storehouse	*Wharau, wharau waka* — temporary roofed shelter, waka shed	*Rua kūmara, rua tāhuhu, rua kai, rua kōpiha* — kūmara and food storage pits, raupō roofs

	House structures	Vessels	Other
Sculpted & carved arts	*Whare whakairo, whare tupuna, wharenui* — elaborately carved meetinghouse *Pou tāhuhu, pou tuarongo, pou tahū, poutokomanawa, pou aronui, poupou* — carved posts in house *Maihi* — house bargeboards *Raparapa* — fingerlike ends *Amo* — bargeboard supports *Pare, korupe* — door lintel *Kūwaha, whakawae* — doorway and door jamb *Paepae, pae kai āwhā* — threshold *Tekoteko* — gable figure *Koruru, wheku* — mask *Pakitara* — sidewalls *Tāhuhu* — ridgepost *Heketipi* — bargeboard *Epa* — front porch panels *Pihanga* — window *Mahau* — verandah	*Waka* — adzed canoe, could have prow carving *Waka tīwai* — dugout canoe *Waka tētē, waka pakoko* — fixed prow canoe with carved head *Waka unua, waka hūhunu* — double canoes *Waka ama* — outrigger canoe *Waka taua* — carved war canoe *Tauihu* — prow carving *Taurapa* — stern carving *Rauawa* — canoe sides *Taumanu* — canoe thwarts *Haumi* — canoe bow cover *Tete, pakoko, pākurukuru* — face form on haumi *Kīato* — canoe side float	*Pā* — fortified village *Tūwatawata, pekerangi* — pole or palisade defences of pā *Pūwhara* — fighting platform *Taumaihi* — pā watchtower *Pā korokoro* — fence, partitions *Pā tuna* — eel weir *Kūwaha* — gateway *Pou whakarae, pou whakairo* — stockade posts often carved with figures *Pou rāhui* — carved boundary markers warning trespassers *Waka whakamaumaharatanga* — memorial to chief made from waka hull (painted also)
	Papa tupāpaku — tomb *Hiona* — temple of Rua Kenana followers *Miringa te Kakara* — Pai Mārire temple	*Waka kōiwi, whata kōiwi* — canoe-shaped bone chest *Ipu whenua* — container for afterbirth	*Papahou* — bone chest *Atamira* — burial stage *Toma, rua kōiwi* — caves used for interring bones
	Whatārangi, tāpaturangi, whare kai — food stores *Whare mata* — store for bird snares and spears *Rua kūmara* — kūmara store *Kauta* — cooking house, shack, lean-to *Pātaka whakairo* — elevated food storehouse	*Hoe* — paddle *Hoe urungi* — steering paddle *Tīheru, tatā* — canoe bailer with carved head	*Whata* — elevated platform *Whatā rangi* — elevated storehouse *Whata kōpiha kai* — hākari, feasting stage *Arawhata* — notched ladder *Pā tuna* — eel weir
Painted & pigmented arts	*Poupou (wharenui)* — many houses had painted instead of carved poupou *Hōpara-makaurangi* — painted rafter	*Hoe* — paddles painted with kōwhaiwhai design	*Ana tuhi* — painting on rock shelters and caves of stylised figures and symbols
	Heke, heketipi, Kaho paetara — painted supports in the meetinghouse *Tāhuhu* — painted ridgepole *Maihi* — painted bargeboards	*Taurapa* — some evidence of painted designs *Rauawa* — side strakes, underneath canoe prow	*Waka whakamaumaharatanga* – painted canoe cenotaph, memorial to chief made from section of waka hull

GLOSSARY OF GENERAL TERMS

aho weft thread
aka vine of any climbing plant
akatea *Metrosideros perforata, Metrosideros albiflora*, clinging rātā vine
ana cave
anuhe vegetable caterpillar, markings on the skin of the mackerel
ariki high-ranking noble
aruhe edible rhizome of bracken-fern, fern roots
atua deity, ancestor with continuing influence

haehae parallel grooves between lines of pākati, to lacerate
hahu to dig up, disinter, exhume
haka to dance, perform, a general term for a number of dances
hākari sumptuous meal, feast, banquet, celebration
hanga to make, build, fashion, create, construct
hāpine to scrape flax
hapū kinship group, tribe, sub-tribe
hāpuku *Polyprion oxygeneios*, groper, a large heavy-bodied fish
harakeke *Phormium tenax*, flax with long, stiff, upright leaves and dull red flowers
hāro to scrape clean, separate muka fibre from cellulous outer layer
hiki seams
hīnau, whīnau *Elaeocarpus dentatus*, tall forest tree with long leaves, white flowers and edible berries
hinu oil
hohou bind, lash together
hōrū red ochre, burnt kōkōwai
houhere *Hoheria populnea*, lacebark, small white-flowered tree
huapae joists
huata spear
hue *Lagenaria siceraria*, cultivated plant, calabash, gourd, gourd plant
hui gathering, meeting, assembly
hukahuka thrum or tassel

inanga *Galaxias maculates*, whitebait, a whitish or creamy-coloured variety of pounamu
ira life principle
iwi extended kinship group, tribal group

kaho crossbar, crossbeam, roof batten, fence rail
kahurangi something prized; light-green, translucent variety of greenstone without flaws or spots
kaīnga residence, village, settlement
kākā *Nestor meridionalis*, large olive-brown native forest parrot
kākaho stem of toetoe, flower stalk
kākahu garment, clothes, cloak
kakau handle of a tool
kamu take the pigment, of skin tattooing
kanono *Coprosma australis*, small native shrub with large olive-green leathery leaves and red-orange berries
kānuka *Kunzea ericoides*, white tea-tree with small white flowers
kao dried kūmara
kape eyebrow-shaped, eye socket, to hook out
karakia prayer, blessing, ritual incantation
karamea *Aciphylla squarrosa, Aciphylla colensoi*, spear-grass
karamū *Coprosma lucida, Coprosma macrocarpa, Coprosma robusta*, native with large leathery leaves
karanga formal call of welcome
karapi sticks used to hold reeds or rushes in place
kareao supplejack, a high-climbing woody native plant
karere messenger, message
kārure rolled tag, to twist two strands into a cord
kaupapa floor slabs, groundwork, main body of cloak, matter for discussion
kaupeka climbing cord
kauri *Agathis australis*, largest forest tree, only found in North Island
kauwae, kauae jaw, chin
kawa marae protocol, ceremony to remove tapu from a new house
kāwai lateral tendrils, shoot runners; line of descent, lineage
kawakawa *Macropiper excelsum*, pepper tree small, densely-branched tree with heart-shaped leaves
kererū *Hemiphaga novaeseelandiae*, a large green, copper and white native bush pigeon
kete basket, kit
kiekie *Freycinetia banksii*, thick native vine with long leaves
kiore *Rattus exulans*, small native rat
kōaro *Galaxias brevipinnis*, small spotted freshwater fish, in juvenile form called whitebait
kōeaea young of the inanga, whitebait
koha gift, present, offering
kōhatu stone, rock
kōiwi bone of humans
kōkō tūī, parson bird
kōkōwai haematite or red ochre
kōmuru make supple by rubbing
kōnae small basket plaited from strips of flax
kōrero talk, speak, speech, narrative, story, account, conversation
koropepe eel or fish; type of small pendant ornament
koru a shrubby plant; to fold, loop, coil
kōtuku white heron
kōtukutuku *Fuchsia excorticata*, tree fuchsia with purplish-red flowers and purple berries
kōura freshwater and salt-water crayfish
kōwhaiwhai painted scroll rafter patterns
kōwhiti cross over, cross stitch
kūmara *Ipomoea batatas*, sweet potato
kuta *Eleocharis sphacelata*, bamboo spike-sedge, rush with thick, hollow, bright-green stems

makomako *Aristotela serrata*, wineberry, small native with pink flowers and dark red berries
mana prestige, authority, control, power, spiritual power
manaakitanga generous hospitality, kindness

manawa heart, heart line

mangemange *Lygodium articulatum*, bushman's mattress, climbing native fern

manu bird, kite, winged creature

mānuka *Leptospermum scoparium*, tea-tree, native scrub bush with aromatic, prickly leaves

marae, marae ātea courtyard, open meeting ground in front of the wharenui

marakihau carved ancestor as a mythical sea monster, mermaid tail

mātauranga knowledge, education, wisdom

maukoroa red paint

mauri life principle, life force

miro plying, twining, rolled, twisted cord

moana ocean

moko tattooing, a general term for lizards, mythical creature

nati fastening stitch used for sails and nets

nehu burial ceremony

neinei *Dracophyllum latifolium*, grass tree, spiderwood

niho tooth, tusk, edge

nīkau *Rhopalostylis sapida*, native palm, the fronds of which meet to form a bulbous head

ngākau heart, base plait cord of a net

ngārara lizard

ngore pompoms

ngutukākā *Clianthus maximus*, kākā beak, spreading shrub with clustered large bright scarlet flowers

noa ordinary, free from tapu

ōnewa dark-grey basalt

pā fortified settlement, closed off or screened space

pākake whale

pākati to incise a pattern, notching running between haehae

pākehā New Zealander of European descent

pakipaki cure, preserve by drying, technique for preserving heads

pākohe dark grey stone, argillite

paoi wooden beater, pounder

papa earth floor, board, flax foundation of cloak, width, strip, segment

papa hou treasure box

pāpaka *Ovalipes catharus*, paddlecrab, large strong crab with brownish-grey shell and legs

papakirango fly swat

para waxy epidermis of flax

paru dirt, black mud, earth

pātangaroa starfish

pātiki flounder, lemon sole, turbot

pāua *Haliotis,* abalone, sea ear, edible univalve molluscs of rocky shore

pīngao *Desmoschoenus spiralis*, native plant, golden-orange-leaved sand sedge

pīpīwharauroa breast of the shining cuckoo, a variety of pounamu

pirita *Ripogonium scandens*, supplejack, high-climbing woody native plant

pītau young shoot of the fern frond

poka hole, pit, well, bias shaping in woven garment

ponga *Cyathea dealbata*, tall native silver tree-fern

popoia handle of a basket

poroporo *Solanum aviculare*, native shrub with dark, soft, lance-shaped or lobed leaves

pouākai *Harpagornis moorei*, gigantic Haast's eagle, now extinct

pounamu greenstone, or nephrite jade

poutama stairway

pūhihi plume, antenna, streamer

pukepoto dark blue, dark blue earth, used as a pigment

puketea, pukatea *Laurelia novae-zelandiae*, tall forest tree with large buttress trunk base supports

pukupuku, pauku compact single-twine

punga anchor

pungarehu ashes

pūoro sing, sound

purapura seed

putiputi flower

rāhui to put in place a temporary ritual restriction, ban

rākau tree, stick, timber, wood, spar, weapon, challenge stick

rangatira chief, noble, esteemed, revered, qualities of a leader

raranga plaiting, to plait

rarauhe *Pteris aquilina*, creeping native ground fern, bracken

rātā *Etrosideros robusta* (Northern), *Metrosideros umbellata* (Southern), large hard red timber tree

rau leaf, plume, feather, blade of a weapon

raumoa ridges in carving dividing the rows of pākati

raupō *Typha orientalis*, bulrush, green swamp plant with flowering brown velvet-like spikes

rauru end of the umbilical cord attached to mother, spiral pattern

rautahi *Carex ternaria*, long-leafed sedge

rehu fine dust, chipping to reduce stone

reo voice, speech, utterance, language

rīpeka cross, crucifix, crossroad

rīrīwaka *Scirpus maritimus*, sedge found in swampy, sandy areas

ritorito young flax shoot

roimata tears

rourou small flax plaited basket or platter

rua hole, pit, store

rui shake, sow, scatter, cast away, sort, discard

tā strike, beat, cut, tattoo

tahua heap, pile of food at a feast

tāhuna down from bulrush

taioma white clay

takarangi giddy

tākaou red ochre obtained from yellow earth by burning

takitahi distribution of over-one, under-one for plaiting

tānekaha *Phyllocladus trichomanoides*, celery pine, tall forest tree with long, fan-like leathery leaves

tangiwai translucent form of greenstone with streaks of white

tāniko twining, to ornament the border of a garment

taniwha sea guardian or monster

taonga property, highly prized

tapu under religious restriction

taputapu equipment, goods, property

taro *Colocasia antiquorum*, edible plant with starchy corms and fleshy leaves.

tauhere tie, bind, suspend, hang

tauira pattern, student

taupoki cover, close with a lid

tawhito old, ancient, original

tikanga conventions or rules

tī kouka *Cordyline australis*, cabbage tree, palm-like with long narrow leaves

timo peck, strike with a pointed instrument, pecking of stone

tītī *Puffinus griseus*, muttonbird

tītoki *Alectryon excelsum*, New Zealand ash or oak, spreading branches and a twisted trunk

toetoe *Cortaderia speldens, Cyperus ustulatus*, cutty grass, native with grassy leaves and feathery plumes

tohunga priests or expert practitioners

toroa *Diomedea exulans*, albatross

torotika straight, stiff, vertical

tōtara *Podocarpus*, large forest trees with prickly, olive-green leaves

toto bruising stone, blood

tūī *Prosthemadera novaeseelandiae*, parson bird, glossy-black plumage and two white tufts at the throat

tuitui stitch, sew

tukemata eyebrow

tukutuku latticework of walls of house, technique for making pots

tūmatakahukī upright rods between posts of a house

tūpāpaku corpse, sick person

tūpuna ancestors

tūrangawaewae place to stand

turu charm for flying a kite

turuturu drip

tutu *Coriaria arborea*, poisonous native shrub with blue-black hanging fruit

tūtūā plain face, nobody

uku clay, white clay

uwhikāho *Dioscorea alata*, yam

waha mouth

wāhi place, locality, portion, part

waiata song

wairua spirit

waitumu mordant

waka canoes

whakairo carve, ornament with a pattern

whakapapa recite in proper order, genealogy, lineage, descent

whakarākai adorn, decorate, garnish

whakarua kōpito umbilical cord

whakatipu grow, rear, cherish, bring up, raise

whakawiri twist, wring, screw

whānau extended family, family group, born, give birth

whanaungatanga relationship, kinship, family connection

whao chisel out, chisel, iron tool

whare house, hut, shed, habitation

whatu weave

whau *Entelea aborescens*, cork tree, corkwood

whekī-ponga *Dicksonia Fibrosa, Dicksonia squarrossa*, native tree-fern

whenu warp of a garment, strand of cord

whenua land, placenta or afterbirth

whetū star

whiri braiding, twist

whītau prepared flax fibre

GLOSSARY OF PROPER NAMES

Haematua, Haepuru two sons of Rangi and Papa that along with Whiro obtained knowledge of painting

Hine-ahu-one the first woman fashioned in clay by Tāne-nui-a-Rangi and Io on the beach at Kurawaka

Hine-nui-te-pō deity of death as Hine-tītama she fled to the underworld and receives the souls of the dead

Hine-te-iwaiwa deity of womanhood, regarded as the exemplary figure of a wife and mother

Hine-tū-a-hōanga deity of sandstone, used for grinding stone

Hīona temple of Rua Kenana followers, Zion, the hill of Jerusalem on which the city of David was built

Manuruhe son of Rua-te-pupuke, who offended Tangaroa

Mataora fetched the art of tā moko from Uetonga and taught humankind the art

Māui, Māui-tikitiki-a-Taranga, Māui-pōtiki well-known ancestor who performed amazing feats

Miringa te Kakara temple of Pai Mārire built in 1887 at Te Tiroa, King Country

Ngākau Māhaki meetinghouse built in 2009 at Unitec Institute of Technology, Auckland

Pai Mārire 'Good and Peaceful' Christian faith developed by Te Ua Haumēne in Taranaki

Papa-tū-ā-nuku the earth mother and wife of Rangi-nui, from which all living things originate

Pōtatau Te Wherowhero paramount chief of Waikato, first king of Kīngitanga in the 1850s

Raharuhi Rukupo carver of Rongowhakaata tribe in the 1830s using metal tools

Rangi-nui the sky father and husband of Papa-tū-ā-nuku, from which all living things originate

Rātana religious and major political movement founded by Tahupōtiki Wiremu Rātana

Rehua Antares, the brightest star in the constellation Scorpius and the one associated with summer

Ringatū Māori Christian faith with adherents mainly from the Bay of Plenty and East Coast tribes

Rongo-mā-Tāne, Rongo-marae-roa deity of peace, kūmara and cultivation

Rū-au-moko, Whakarū-au-moko deity of earthquakes and youngest child of Rangi and Papa

Rua Kenana Hepetipa Tūhoe, prophet who established a religious community at Maungapōhatu

Rua-te-pupuke obtained the knowledge of whakairo from the underworld

Tāne Mahuta deity of the forests and humankind

Tangaroa deity of the sea and fish

Tawhiri-ma-tea deity of the winds and weather

Te Ao Mārama world of life and light, Earth, physical world

Te Hau ki Tūranga meetinghouse built by Raharuhi Rukupo in 1852

Te Kooti Arikirangi Te Turuki leader of Rongowhakaata, military prophet and founder of the Ringatū faith

Te Noho Kotahitanga marae at Unitec Institute of Technology, Auckland

Te Poho-o-Rāwiri house built in 1849 at Kaiti, Gisborne, by Raharuhi Rukupo

Te Poho o Rukupo house built by Rongowhakaata, Manutuke, in 1887

Te Tiriti o Waitangi Treaty of Waitangi

Te Ua Haumēne founder of Pai Mārire Christian-derived movement

Tene Waitere carver of Ngāti Tarawhai, learned wood carving in the 1870s

Tiki the progenitor of mankind, the first man created by Tane

Tokaanganui a Noho house built at Te Kuiti by followers of Te Kooti in 1873

Tūhua Mayor Island, renowned for obsidian which is found there

Tū-mata-uenga deity of war and humans, wanted to kill his parents so that the sun might shine

Uetonga grandson of Rūaumoko who lived in te pō, where he taught Mataora the art of moko

Whiro deity of things associated with evil, darkness and death, the eldest son of Rangi and Papa

BIBLIOGRAPHY

General Māori

Beaglehole, J. C. (ed.): *The Journals of Captain James Cook on his Voyages of Discovery,* 3 vols, Cambridge University Press, 1955, 1961, 1967

Beaglehole, J. C. (ed.): *The Endeavour Journal of Joseph Banks 1768–1771,* Angus and Robertson, Sydney, 1962

Beattie, H.: 'Traditions and Legends. Collected from the natives of Murihiku (Southland, New Zealand)', *Journal of the Polynesian Society*, Volume 27, No. 107, pp137–161, Polynesian Society, Auckland, 1918

Best, Elsdon: *The Maori* (Memoirs of the Polynesian Society, Vol. 5), Polynesian Society, Auckland, 1924

Best, Elsdon: *Maori Religion and Mythology: Being an account of the cosmogony, anthropogeny, religious beliefs and rites, magic and folk lore of the Māori folk of New Zealand,* Parts 1 & 2, A. R. Shearer Government Printer, Wellington, 1929

Binney, Judith: *Redemption Songs: A Life of Te Kooti Arikirangi Te Turuki,* Auckland University Press, 1995

Colenso, W.: 'On the Maori Races of New Zealand.' *Transactions and Proceedings of the Royal Society of New Zealand,* Vol. 1, 1868

Cowan, J.: *The Maoris of New Zealand,* Whitcombe & Tombs, Christchurch, 1910

Hiroa, Te Rangi: *The Coming of the Maori,* Maori Purposes Trust Board, Wellington, 1949

Lewis, David and Forman, Werner: *The Maori Heirs of Tane,* Orbis Publishing Limited, London, 1982

Mead, H. M: *Nga Toi Maori: Maori art in Aotearoa New Zealand,* Wellington, 1999 http://www.maoriart.org.nz/features/articles/nga_toi_maori_2, accessed 20 May 2009

Shirres, O. P., Michael P.: *Te Tangata: The Human Person,* Accent Publications, Palmerston North, 1997

Smith, Percy S.: *The Lore of the Whare-wananga or Teachings of the Maori College on religion, cosmogony and history*, Polynesian Society, New Plymouth, 1913

Taylor, Richard: *Te Ika a Maui of New Zealand and its inhabitants,* London, 1855

Tregear, E.: 'The Maoris of New Zealand', *Journal of the Royal Anthropological Institute of Great Britain & Ireland*, vol xix, Blackwell Publishing, Oxford, 1890

General Māori art

Angas, George French: *Early Paintings of the Maori,* A. H. & A. W. Reed, Wellington, 1979

Barrow, T.: *Maori Wood Sculpture of New Zealand,* A. H. & A. W. Reed, Wellington, 1969

Barrow, T.: *An Illustrated Guide to Maori Art*, Penguin, Auckland, 2007

Best, Elsdon: *Tuhoe, the Children of the Mist,* Polynesian Society, Wellington, 1925

Davidson, Janet: *The Prehistory of New Zealand,* Longman Paul Limited, Auckland, 1987

Davidson, Janet (ed.): *Te Ara Tapu: Sacred Journeys, Whanganui Regional Museum Taonga Maori Collection,* Random House, Auckland, 2008

Doig, Fiona (ed): *Taonga Maori: A Spiritual Journey Expressed Through Maori Art*, Australian Museum, Sydney, 1989

Forge, Anthony: 'Problem of Meaning in Art: New Guinea', *Exploring the Visual Art of Oceania: Australia, Melanesia, Micronesia, and Polynesia,* edited by Sidney Mead, University Press of Hawaii, Honolulu, pp278–287, 1979

Green, Dr R. C.: 'A review of the Prehistoric Sequence in the Auckland Province', *New Zealand Archaeological Society*, Monograph 2, Auckland, 1963

Hamilton, A.: *Maori Art*, The Holland Press, London, 1977

Harrison, Paki: *Te Poho o Tipene*, St Stephens College, Auckland, 1983

Hooper, Steven: *Pacific Encounters: Art & Divinity in Polynesia 1760–1860*, The British Museum Press, London, 2006

Jahnke, Robert Hans George: 'He taitaitanga ahua toi: the house that Riwai built/a continuum of Maori art', A thesis presented in partial fulfilment of the requirements for the degree of Doctor of Philosophy in Maori Studies, Massey University, Palmerston North, 2006

Mead, Hirini Moko: *Magnificent Te Maori: Te Maori Whakahirahira*, Heinemann, Auckland, 1986

Mead, Sidney Moko (ed.): *Te Maori: Maori Art from New Zealand Collections,* Heinemann, Auckland, 1984

Panoho, Rangihiroa: 'A Search for Authenticity: Towards a Definition and Strategies for Cultural Survival', *He Pukenga Kōrero: A Journal of Māori Studies,* Volume 2, Number 1, Koanga (Spring), Massey University, Palmerston North, 1996

Phillipps, W. J., revised by John Huria: *Maori Life & Custom,* Raupo, Auckland, 2008

Starzecka, D. C. (ed.): *Maori Art and Culture,* David Bateman, Auckland, 1996

Fibre and woven arts

Best, Elsdon: 'Art. LXV.—The Art of the Whare Pora: Notes on the Clothing of the Ancient Maori, their Knowledge of preparing, dyeing, and weaving Various Fibres, together with some Account of Dress and Ornaments, and the Ancient Ceremonies and Superstitions of the Whare Pora'. *Transactions and Proceedings of the Royal Society of New Zealand* 1868–1961, Volume 31, Government Printing Office, Wellington, 1898

Best, Elsdon: *Fishing Methods and Devices of the Maori,* National Museum, Wellington, 1977

Hiroa, Te Rangi: 'Maori decorative art, house panels', *New Zealand Institute Transactions,* Volume 53, 1921

Hiroa, Te Rangi: 'The Evolution of Maori clothing', *Journal of the Polynesian Society,* Volume 34, No. 133, pp61–92, Polynesian Society, Auckland, 1925

Maysmor, Bob: *Te Manu Tukutuku: The Maori Kite,* Steele Roberts, Wellington, 2001

Mead, Hirini Moko: *Te Whatu Taniko: Taniko Weaving,* Reed Methuen, Auckland, 1973

Pendergrast, Mick: *Te Aho Tapu: The Sacred Thread: Traditional Maori Weaving,* Reed Methuen, Auckland, 1987

Pendergrast, Mick: *Raranga Whakairo: Maori Plaiting Patterns,* Reed, Auckland, 1991

Pendergrast, Mick: *Maori Fibre Techniques: A Resource Book for Maori Fibre Arts,* Reed Publishing, Auckland, 2005

Puketapu-Hetet, Erenora: *Maori Weaving,* Pitman, Auckland, 1989

Reedy, Anaru (ed.): *Nga korero a Mohi Ruatapu: the writings of Mohi Ruatapu,* Canterbury University Press, Christchurch, pp70, 174, 1993

Roth, Henry Ling: *The Māori Mantle,* Bankfield Museum, Halifax, 1923

Taiapa, Pine: 'Tukutuku', *Marae,* Vol. 1, No. 2, pp11–16, 1974

Te Kanawa, Diggeress: *Weaving a Kakahu,* Bridget Williams Books Limited, Wellington, 1992

Tregear, Edward: 'Dress Ornaments etc.' In *The Maori Race,* Archibald Dudingston Willis, Wanganui, 1904

Te Rangihiroa (Sir Peter Buck): 'Maori Decorative Art; No. 1, House-panels (Arapaki, Tuitui or Tukutuku)', *Transactions and Proceedings of the New Zealand Institute,* Vol. 53, pp452–470, J Hughes Printer, Wellington, 1921

Painted and pigmented arts

Beattie, H.: 'Traditions and Legends. Collected from the natives of Murihiku (Southland, New Zealand)', *Journal of the Polynesian Society*, Volume 27, No. 107, pp137–161, 1918

Best, Elsdon: 'Art. XXV.—Maori Eschatology: The Whare Potae (House of Mourning) and its Lore; being a Description of many Customs, Beliefs, Superstitions, Rites, &c., pertaining to Death and Burial among the Maori People, as also some Account of Native Belief in a Spiritual World', *Transactions and Proceedings of the Royal Society of New Zealand* 1868–1961, Volume 38, Government Printing Office, Wellington, 1905

Best, Elsdon: 'The origin of tattooing,' *Journal of the Polynesian Society,* Volume 20, No. 4, pp 167–169, Polynesian Society, Auckland, 1911

Cowan, James: 'Māori tattooing Survivals – Some Notes on Moko', *Journal of the Polynesian Society*, Volume 30, No. 120, pp241–245, Polynesian Society, Auckland, 1921

Cowan, James: 'Moko: The Tattooing Art.' In *The Maori: Yesterday and To-day*, pp136–149, Whitcombe and Tombs Limited, Auckland, 1930

King, Michael: *Maori Tattooing in the 20th century*, Alister Taylor, Auckland, 1972

Lewis, David and Forman, Werner: *The Maori Heirs of Tane*, Orbis Publishing Limited, London, 1982

National Museum of New Zealand and Manawatu Art Gallery: *Ka Tuhituhi o Nehera: The Drawings of Ancient Times*, Auckland and Palmerston North, 1988

Neich, Roger: *Painted Histories: Early Maori Figurative Painting,* Auckland University Press, 1993

Phillipps, W. J.: 'An introduction to Maori pounding implements', *The Journal of the Polynesian Society*, Volume 48, No. 190, pp71–91, Polynesian Society, Auckland, 1939

Phillipps, W. J.: 'Moko or Maori Tattoo', *Te Ao Hou,* No. 9 (Spring 1954), p27, Maori Affairs Department, Wellington, 1954

Phillipps, W. J.: *Maori Rafter and Taniko Designs,* The Wingfield Press, Wellington, 1960

Robert McDougall Art Gallery: *Maori Rock Drawing: The Theo Schoon Interpretations,* Christchurch City Council, 1985

Robley, Major-General H.G.: *Moko or Maori Tattooing,* Tiger Books International, Middlesex, 1998

Roth, Henry Ling: 'Maori Tatu and Moko', *Journal of the Anthropological Institute of Great Britain and Ireland,* Vol. 33, Blackwell Publishing, Oxford, 1901

Simmons D. R.: *Ta Moko The Art of Māori Tattoo,* Reed Methuen, Auckland, 1986

Taylor, Alan: *Maori Folk Art,* Century Hutchinson, Auckland, 1988

Thompson, Paul: *Maori Rock Art: An ink that will stand forever,* GP Books, Wellington, 1989

Trotter, Michael and McCulloch, Beverley: *Prehistoric Rock Art of New Zealand,* A. H. & A. W. Reed, Wellington, 1971

Architectural and structural arts

Best, Elsdon: *Maori Storehouses and Kindred Structures,* A. R. Shearer Government Printer, Wellington, 1974

Best, Elsdon: *The Maori Canoe,* Dominion Museum, Wellington, 1976

Best, S: 'The Maori Adze: An explanation for change', *Journal of the Polynesian Society,* Volume 86, No. 3, pp307–337, Polynesian Society, Auckland, 1977

Evans, Jeff: *Waka Taua: The Maori War Canoe,* Reed Publishing Ltd, Auckland, 2000

Firth, Raymond: *Economics of the New Zealand Maori,* Government Printer, Wellington, 1929

Irwin, Geoffrey: *Kohika: The Archaeology of a late Māori lake village in the Ngāti Awa Rohe, Bay of Plenty, New Zealand*, Auckland University Press, 2004

Phillipps, W. J.: *Maori Houses and Food Stores,* Government Printer, Wellington, 1952

Prickett, N. J.: 'An archaeologist's guide to the Maori Dwelling', *New Zealand Journal of Archaeology,* Volume 4, pp111–147, University of Otago, Dunedin, 1982

Prickett, Nigel: *Landscapes of Conflict: A Field Guide to the New Zealand Wars,* Random House, Auckland, 2002

Simmons, D. R.: *Te Whare rūnanga: The meetinghouse,* Reed Publishing Ltd, Auckland, 1997

Taylor, Alan and Taylor, W. A.: *The Maori Builds: life art and architecture from moahunter days,* Whitcombe and Tombs Limited, Christchurch, 1966

Sculpted and carved arts

Archey, Gilbert: *Sculpture & Design: An outline of Maori art,* Whitcombe & Tombs Limited, Auckland, 1960

Barrow, T.: *The Life and work of the Maori Carver,* Department of Education, Wellington, 1963

Barrow, T.: *Maori Wood Sculpture of New Zealand,* Reed, Wellington, 1969

Best, Elsdon: *The Stone Implements of the Maori,* A. R. Shearer Government Printer, Wellington, 1974

Best, S.: 'The Maori Adze: An explanation for change', *Journal of the Polynesian Society,* Volume 86, No. 3, pp307–337, Polynesian Society, Auckland, 1977

Evans, Jeff: *Maori Weapons in pre-European New Zealand,* Reed Books, Auckland, 2002

Flintoff, Brian: *Tanga Puoro Singing Treasures: The musical instruments of the Maori,* Craig Potton Publishing, Nelson, 2004

Mead, Hirini Moko: *Te Toi Whakairo: The art of Maori carving,* Reed Publishing Ltd, Auckland, 1986

Mead, S. M.: 'The Origins of Maori Art: Polynesian or Chinese', *Oceania* Vol. 45, No. 3, pp173–211, University of Sydney, 1975

Myhre, Stephen: *Bone Carving: A skillbase of techniques and concepts,* Heinemann Reed, Auckland, 1987

Neich, Roger: *Pounamu: Maori Jade of New Zealand,* David Bateman Ltd, Auckland, 1997

Neich, Roger: *Carved Histories: Rotorua Ngati Tarawhai woodcarving,* Auckland University Press, 2001

Prickett, Nigel: *Nga Tohu Tawhito: Early Maori ornaments,* David Bateman Ltd, Auckland, 1999

Simmons, D.R.: *Whakairo: Maori tribal art,* Auckland, 1985.

Simmons, David: *The Carved Pare: A Maori mirror of the universe,* Huia Publishers, Wellington, 2001

ILLUSTRATION CREDITS

Maps on pp 12–13 by Nick Turzynski
The artwork reproduced on the chapter opening pages is with the permission of Learning Media
Drawings on tables pp 21–23 by Kereama Taepa

The other illustrations in this book are reproduced with the permission of the Alexander Turnbull Library and the Museum of New Zealand Te Papa Tongarewa. (identified as ATL and MNZ in the following).

Front cover MNZ: Taiaha kura (long club fighting staff). ME002387

2 ATL: Parkinson, Sydney: The head of a chief of New Zealand, the face curiously tataow'd, or marked according to their manner. T. Chamber sc. London, 1784. Plate XVI. PUBL-0037-16

6 ATL: Unidentified Māori man and woman seated in the porch of a Hawke's Bay meetinghouse between 1890 and 1900. 1/2-055340-G

11 ATL: Children playing inside the Tamatekapua meetinghouse at Ohinemutu c1905. PAColl-5671-04

23 ATL: Carved prow of a waka c1910. 1/2-003479-F

27 ATL: King, Martha: The phormium tenax, or New Zealand flax 1842. Day & Haghe, London, Smith, Elder 1845. PUBL-0011-15

28 MNZ: Patu muka (flax fibre beater). OL000325

29 MNZ: Poi tāniko (percussive device). ME003940

31 ATL: Ahipene Te Tawa between 1880 and 1900. 1/4-022020-G

33 TOP MNZ: Mutu kākā (bird snare). ME004820

33 BOTTOM MNZ: Matau toroa (fishhook). MA_I116809

34 ATL: Māori women from Ōtaki making tukutuku panels 1936. PAColl-5927-60

35 ATL: Māori carvings and tukutuku panels, location unidentified 1903. 1/2-050175-F

36 TOP ATL: Tukutuku panels, wooden carving and kōwhaiwhai 1930s. 1/2-051556

36 BOTTOM Wikimedia Commons http://commons.wikimedia.org/wiki/File:Poumatua2.jpg

39 TOP ATL: A Māori kite, he kahu 1850. NON-ATL-0152

39 BOTTOM ATL: Taylor, Richard: He kahu mauri, a NZ kite c1870. NON-ATL-0054

41 ATL: Elsdon Best and another man holding a fishing net 1921. PA1-q-257-72-1

42 TOP ATL: Photograph of a kete with chequerboard patterning 1921. PA1-q-257-46-6

42 BOTTOM LEFT ATL: Detail of a finely woven flax floor mat (takapau) 1921. PA1-q-257-47-4

42 BOTTOM RIGHT ATL: Detail of a flax kete, probably at Koroniti 1921. PA1-q-257-44-2

43 ATL: Photograph of a person demonstrating the plaiting and weaving of flax 1921. PA1-q-257-42-5

45 TOP MNZ: Tawa berries in kete. ME015880

45 BOTTOM MNZ: Kete. ME013967

47 MNZ: Hīnaki (eel trap). ME008102

49 ATL: Merrett, Joseph Jenner: Four Māori girls and one young Māori man c1846. A-255-005

50 ATL: Pringle, Thomas: Weaving korowai 1905. 1/1-007017-G

52 MNZ: Piupiu (skirt). ME001141

53 TOP LEFT MNZ: Kahu kurī (dog skin cloak). ME002052

53 TOP RIGHT ATL: Atiria Te Hauwaho, wife of Wiremu Broughton 1881. 1/4-022058-G

53 BOTTOM MNZ: Kaitaka huaki (cloak, with double tāniko borders). ME0114433

57 LEFT ATL: Angas, George French: Native tombs. J. W. Giles lith. Plate 50 1847. PUBL-0014-50

57 RIGHT MNZ: Poupou (side wall post). ME002596/6

59 ATL: Māori rock drawing at Craigmore, South Canterbury 1985-8. PA12-2389-08

60 MNZ: Pakakē taiari (amo figure). CT.015219

63 ATL: Richmond, James Crowe: Rafter patterns from Arawa accommodation house, Rotoiti 1868. A-245-010

65 MNZ: Tahā (calabash). ME002832

66 ATL: Inside Te Rauru meetinghouse at Whakarewarewa c1910. PAColl-5671-32

67 ATL: Kōwhaiwhai and painted wood figures on the rafters of Tamatekapua meetinghouse at Ohinemutu c1940. 1/4-001699-F

68 ATL: Godber, Albert Percy: Drawings of Māori rafter patterns Nga Tau e Waru, Te Ore Ore. E-302-q-3-077/079

71 ATL: Bragge, James: Unidentified group of people in front of a meetinghouse in Masterton c1865. PA7-30-16-2

73 ATL: Parkinson, Sydney: The head of a chief of New Zealand, the face curiously tataow'd, or marked according to their manner. T. Chamber sc. London, 1784. Plate XVI. PUBL-0037-16

74 TOP LEFT ATL: Negretti & Zambra: Portrait of Tukaroto Matutaera Potatau Te Wherowhero Tawhiao c1884. PA3-0184

74 TOP RIGHT ATL: Unidentified Māori woman 1860s. 1/2-099475-F

74 BOTTOM ATL: Sainson, Louis Auguste de: Nouvelle-Zelande. 1.2.Vieille femme et esclave de Wangari. 3.Pako, Chef du Cap Reinga. 4.Tatouage de la Cuisse de Pako. 5.Naturel de Reinga. /de Sainson pinxit. Maurin lithographe. J. Tastu, Editeur. Lith. de Lemercier. Plate 57. Paris, J. Tastu, 1833. C-010-025

76 TOP ATL: Sperrey, Eleanor Katherine: Wai-Ringiringi,

a Māori chieftainess. Wife of the celebrated Wahanui. Wellington 1935?. B-059-015

76 BOTTOM MNZ: Uhi tā moko (tattooing implement). ME002349

81 ATL: Smith, William Mein: Waikekeno, East Coast c1865. A-035-033

82 ATL: Heretaunga, a carved house at Taradale. Between 1880 and 1900. 1/1-019377-G

83 ATL: Hurae Puketapu and Te Whenuanui, standing alongside a carved wooden gateway. Photograph taken by William Augustus Neale c1900. 1/2-001948-G

84 MNZ: Interior of a native village or 'pā' in New Zealand. 1992-0035-1744

85 MNZ: Breach at Gate Pā, morning of April 30, 1864. 1992-0035-850

86 ATL: Unidentified Māori group c1910. 1/2-021459-F

87 ATL: Women and raupō whare, Karaka Bay, Wellington c1890s. 1/1-020509-G

88 ATL: Mesnard, Theodore Romuald Georges: Cases du paha (village) de Kororareka (Nouvelle Zelande) / Mesnard delt; lithe par Blanchard. Paris, Thierry freres 1841. B-098-009

90–91 ATL: Sainson, Louis Auguste de: Nouvelle Zelande. Cabane de la Baie Tolaga, 6 pieds de haut; Maison d'un Chef de la Baie des Iles, 6 pieds de haut; Maison du Chef Pomare, a la Baie des Iles, 8 pieds de haut. / de Sainson pinx. et lith.; Tastu, Editeur; Lith de Langlume. Plate 65. Paris, J. Tastu, 1833. C-010-024

92 ATL: Angas, George French: Taupo pā, J W Giles lithog. 1847. PUBL-0014-48

94–5 ATL: Clarke, Cuthbert Charles: A hākari, or food stage, Bay of Islands. September 1849. B-030-006

97 ATL: Angas, George French: Whatas, or pātakas. (Storehouses for food). J. W. Giles lith. Plate 30. 1847. PUBL-0014-30

99 ATL: Angas, George French: Monument to Te Whero Whero's daughter, at Raroera Pah. J. W. Giles lith. Plate 10. 1847. PUBL-0014-10

101 ATL: Paris, Edmond Francois: Nouvelle Zelande. Pirogue de la baie Tolaga pirogue de la baie Bream. E Paris pinx; Laurent lith. Lith. de Langlume. Pl. 60. 1833. PUBL-0038-1-60

102 TOP ATL: Angas, George French: Pītau, or war canoe 1844. A-020-012

102 BOTTOM ATL: Parkinson, Sydney: A war canoe of New Zealand. R. B. Godfrey, engraver. London, 1784. A-111-001-2-a

105 TOP ATL: Angas, George French: Rangihaeata's celebrated house on the island of Mana called 'Kaitangata' (eat man). J. W. Giles lith. Plate 4. 1847. PUBL-0014-04

105 BOTTOM ATL: Koruru figure head from meetinghouse gable, 1933. PA1-f-009-60-321

106 ATL: New Zealand Government Tourist Department:

Photograph of group on porch of Te Whai-a-te-Motu wharenui (meetinghouse), Ruatahuna c1903. PAColl-8449

109 TOP ATL: Rua Kēnana Hepetipa's wooden circular courthouse and meetinghouse at Maungapōhatu c1908. APG-1679-1/2-G

109 BOTTOM ATL: Barraud, Charles Decimus: Interior of Ōtaki Church c1851, Working Men's Educational Union WM 13. 1850s or early 1860s. D-010-002

113 ATL: Pine Taiapa working on a wood carvingca 1940s. 1/1-003882-G

114 MNZ: Toki (hafted adze). ME002284

115 MNZ: Toki pounamu (nephrite adze blade). ME002965

117 LEFT MNZ: Patu onewa (hand club). ME014091

117 RIGHT MNZ: Toki pounamu (nephrite adze blade). ME002040/1

119 TOP MNZ: Mau kakī (shark tooth necklace). ME015858/1

119 BOTTOM MNZ: Mau kakī (reel necklace unit). ME002722

120 MNZ: Matau (fishhook). ME004877

121 MNZ: Matau (fishhook barb). ME011032

122 MNZ: Hei matau (pendant). ME005046

123 MNZ: Pā kahawai (trolling lure). OL000106/10

125 TOP MNZ: Hei tiki (pendant). ME013171

125 BOTTOM ATL: Mutu Brandon and Miriama Te Rangirunga. Photograph taken by William Henry Thomas Partington c1900 1/1-003091-G

126 LEFT MNZ: carved bone. WE001047

126 TOP RIGHT MNZ: Hei tiki (pendant). ME012644

126 BOTTOM RIGHT MNZ: Hei tiki (pendant). ME012842

128 MNZ: Papa hou (treasure box) detail. MA1035074

131 ATL Hoe (waka paddles) between 1880 and 1900. 1/1-019383-G

132 TOP ATL: Carved doorway to Te Rauru meetinghouse in Whakarewarewa 1905. 1/1-007035

132 BOTTOM ATL: Māori carvings and tukutuku panels at Tamatekapua meetinghouse in Ōhinemutu. PA7-05-36

134 ATL: Māori wooden carving featuring spirals and lizard type shapes c1910. PAColl-6585-04

135 ATL: Exterior view of Wairaka meetinghouse, Whakatāne, showing the marakihau (mermaid) carving on the left amo. APG-1040-1/2-G

137 TOP MNZ: Taiaha kura (long club fighting staff). ME002387

137 BOTTOM MNZ: Heru (ornamental comb). ME007851

138 TOP ATL: Brees, Samuel Charles: Study of carved feather box between 1842 and 1846. B-031-013

138 BOTTOM MNZ: Whakapakoko rākau (god stick). ME016181

141 ATL: Wooden Māori carvings which originally formed the ridgepole of Rangitihi meetinghouse in Tāheke, Lake Rotoiti c1890s. PAColl-6585-32

INDEX